The Book of Rookwood Pottery

The Book of Rookwood Pottery

by

Herbert Peck

BONANZA BOOKS · NEW YORK

To my wife Margaret

for her constant encouragement

and helpful criticism

Acknowledgments

The help and cooperation I have received in gathering the material for this book, from almost everyone who had some connection with the Rookwood Pottery, have made the task over the past three years a most pleasant one.

I am particularly indebted to Richard and Robert Herschede for access to such old files and records as were shipped to Starkville, Mississippi, when the pottery was moved there in 1960.

Acknowledgment is gratefully given to Fritz Raymond, photographer at Rookwood from 1900 until the 1940's, who took many of the pictures in this volume; and to his daughter, Mrs. Virginia Cummins, who worked in the salesroom at Rookwood during the 1920's. Miss Melrose Pitman, daughter of Benn Pitman who is credited with starting the interest in ceramic decoration in Cincinnati in 1874, was most helpful in making contacts with friends and relatives of early employees at the pottery. Ruben Earl Menzel, who joined Rookwood in 1896 and followed in his father's footsteps to become the master potter, was helpful and patient in answering my many questions. Margaret Spaulding Stockdale has given me many recollections of her "Uncle Dee" Wareham, and of the pottery in the late teens and early twenties. Henry Gest, son of Joseph Henry Gest, a president of Rookwood, has been generous in providing information.

I wish to thank the Cincinnati Historical Society for the use of its archives and for permission to reproduce some of the material quoted in this book; and particularly Mrs. Lee Jordan, librarian there, for her patient assistance in answering questions, checking facts, names, and dates. Mrs. Alice Hook, librarian, and Dr. Carol Macht, curator of Decorative Arts at the Cincinnati Art Museum, also went out of their way to be helpful, as did John Mullane, librarian on the staff of the Public Library of Cincinnati and Hamilton County.

Where practical, I interviewed those decorators who are still living. All were helpful, and interested to learn that a history of Rookwood was in preparation. Many supplied valuable clippings, photographs, and personal mementos as well as reminiscences and recollections. Special thanks go to Louise Abel, Elizabeth Barrett, Jens Jensen, and Lois Furukawa.

William H. MacConnell was my gracious guide on a visit to the former pottery on Mt. Adams, and showed me through the building as it exists today, remodeled inside into offices and suites, but essentially the same. Edgar M. Heltman, who was the director of Rookwood Pottery in the closing days of the Sperti regime, also gave generously of his time and showed me the famous Rookwood pieces now at the Institutum Divi Thomae.

I am also indebted to Herbert F. Koch of the Cincinnati Historical Society for his help in reviewing the manuscript to check those references to Cincinnati and other matters where I, a comparative stranger to the city, might err.

In addition, more than one hundred friends and relatives of the decorators and other employees of the pottery have given me information and painstakingly answered my questions. The list is too long to name them all, but without their help and assistance, this book would not have been possible.

HERBERT PECK

Woodland, Phoenicia, New York
February 1, 1968

Table of Contents

Preface

Mrs. Maria Longworth Nichols founded the Rookwood Pottery in the summer of 1880.

This book tells the why and how of its start, and details its steady growth and development into the foremost art pottery in America, a position it held for nearly forty years. It outlines the decline and subsequent failure of the firm; the several attempts to salvage it; and its present status.

Separate afterchapters are included for collectors and others interested in more information. One explains the marks and symbols used through the years to identify Rookwood wares; a second gives information about the artists and decorators who were associated with the pottery during nearly three quarters of a century; a third gives details about early Rookwood pieces; a fourth summarizes museum collections of Rookwood; and a fifth outlines the pottery's accomplishments in the architectural field, and lists the major installations of Rookwood architectural faience.

Another afterchapter gives information on the principal competitors to which Rookwood management referred as "those counterfeiters and imitators," the Zanesville art potteries of Weller, Owens, and Roseville. And an afterchapter is included on the general subject of collecting Rookwood.

One point should be explained: the author has exercised a small license in modifying certain quotations. When Maria Longworth Nichols remarried in 1886, she became Maria Longworth Storer (Mrs. Bellamy Storer). Statements made *after* her second marriage referred to her as Mrs. Storer, but frequently described events that occurred before 1886 when she was still Mrs. Nichols. In quoted statements describing events *before* her remarriage, the author has substituted the name Nichols for Storer, where desirable, for the sake of clarity.

Part I

1873–1883

Maria Longworth Nichols

Maria Longworth was born to wealth in Cincinnati, Ohio, on March 20, 1849.

She was the granddaughter of Nicholas Longworth, who had established one of the early and more stable fortunes of the city, primarily through his dealings in real estate, for he had acquired a goodly portion of what is now downtown Cincinnati when the population was but 25,000 and destined to grow to ten times that size in the next fifty years.

Maria's father, Joseph Longworth, backed by ample capital, extended the family holdings into the suburbs, accumulating substantial additional acreage. He was not only one of the wealthiest but also one of the most respected members of the community, a patron of the arts, and one of the principal benefactors of the Cincinnati Art Museum Association and the Cincinnati Art Academy.

Called "Ia" by her friends, Miss Longworth attended Miss Appleton's, where she was a schoolmate of Clara Chipman Newton; studied French under the private tutelage of a governess, Miss Caroline Godell; and was an accomplished pianist. She was small in stature, vivacious, attractive, ambitious for personal success, and, perhaps because she didn't have to be otherwise, a careless money manager. And, because of the indulgence of her parents, she was accustomed to having her own way.

At nineteen, Maria married Colonel George Ward Nichols, by whom she bore a son, Joseph Longworth, and a daughter, Margaret Rives. Her husband was a highly respected member of the community, a veteran of the Civil War, and served as president and general manager of the College of Music when it was established in 1878. But the marriage is reported "not a happy one" and Mrs. Nichols did indeed spend much time away from home.

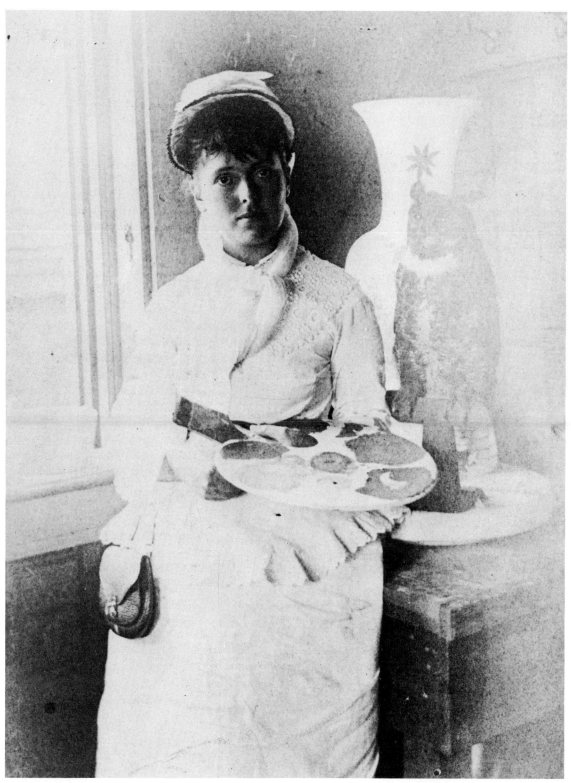

Maria Longworth Nichols, founder of Rookwood Pottery, Cincinnati, Ohio, 1880.

Chapter 1

THE earliest record of Mrs. Maria Longworth Nichols' interest in decorating ceramics occurs in the summer of 1873 when a neighborhood boy named Karl Langenbeck, who "earned his pocket money making pen and ink drawings," received a set of china-painting colors from an uncle in Frankfort, Germany. Mrs. Nichols and another neighbor, Mrs. Learner Harrison, captivated by this new art, joined young Langenbeck in his china decoration and used his colors until they could import some of their own.

The following year, Benn Pitman, younger brother of Sir Isaac Pitman, the inventor of shorthand, and himself a phonographer and an instructor in wood carving at the Cincinnati School of Design, secured a supply of materials for painting on china while on a visit to Philadelphia. On his return, he called together a group of socially prominent young women and suggested they might form a class for instruction in the art. The enthusiasm of the group was quickly expressed, and it probably resulted in the origin of the widely quoted remark that ceramic decoration was "an amusement of the idle rich." The class was organized, and out of his own pocket Mr. Pitman hired as teacher Miss Marie Eggers, who had had some experience in the art at Dresden.

By 1875 the interest in china-painting had spread to the point where a committee was formed, not only to promote it as a "promising field for the lucrative employment of women," but also as a means for raising funds needed for participation in the forthcoming Centennial Exposition in Philadelphia. Designated as the "Women's Executive Centennial Committee," this group furnished the china for decorating, and the amateur decorators gave generously of their time and talent. An exhibit and sale of their work was held in Cincinnati on May 25, 1875; included were pieces decorated by Mrs. Nichols, Mrs. Dodd, Miss Newton, Miss M. Louise McLaughlin, and several others. Miss Newton recalled later that she worked three days a week for three months and produced only two cups and saucers that she considered well enough executed to be shown. In all, thirty-five pieces were sold[1] for a total of $385, a rather princely sum for those days.

Those pieces not sold, together with subsequent work by this group of Cincinnati porcelain painters, were exhibited at the Centennial the following year and were said to have attracted considerable attention. Other ceramic exhibits at the Centennial also impressed those attending from Cincinnati. Miss McLaughlin was particularly charmed by the display of Haviland's Limoges, which was being exhibited for the first time, not having been previously shown in Europe. Mrs. Nichols was greatly attracted by the Japanese pottery that was on view for the first time in this country, and her husband, an early enthusiast of Oriental art, was so favorably impressed by both the Japanese and Chinese exhibits that in his book, *Art Education Applied to Industry*, which was published the following year, he predicted they would "exert a wide and positive influence upon American art industries." Mrs. Nichols' interest in Japanese design was further heightened by books on the subject brought her from London by a friend. This interest exerted a strong influence on her work in later years. In fact, she relates that one time she asked her father if she might import an entire Japanese pottery, workmen, equipment and all, but, she said, "He only laughed at my idea."

By 1877 the popularity of ceramic decoration by amateurs was spreading rapidly. One author of

[1] Both cups and saucers by Clara Chipman Newton were auctioned. One set was purchased by the Governor of Rhode Island, the other by an unnamed buyer.

the time described it as "the ceramic mania sweeping the country"; another said it was no longer "the amusement of the idle rich," but had become a decided art industry; a third declared that it had "become a mark of inculture to be wholly ignorant of ceramic art." Miss McLaughlin published the first of several books on the subject, *China Painting—a Practical Manual for the Use of Amateurs in the Decoration of Hard Porcelain*, and was acknowledged an authority. In September of that year she also began experimenting to discover the "secrets" of Haviland Limoges faience, which had attracted her interest at the Centennial. Up to that time, all her work had been done over the glaze. Now she concentrated on underglaze decoration, working at the pottery of P. L. Coultry and Co. in Cincinnati. Early the following year she exhibited the first of this work. The *Cincinnati Enquirer* for February 20, 1878 reported:

> Miss McLaughlin's vases are certainly the sensation of the hour for she has produced the first pottery of the kind in America. Mr. John Bennett's faience[2] is all done under the glaze, a different process from Miss McLaughlin's. His process is to decorate an unglazed vase, bake it, then glaze and bake it again, while Miss McLaughlin's is like the process at Limoges. That is, she takes a common stone vase and paints it with clay and enamel mixed. This thick coat of clay, enamel and glaze is then baked and the whole surface becomes a glaze, full of color, brilliancy and beauty.

In 1879, Miss McLaughlin organized the Women's Pottery Club. There were twelve active and three honorary members. In her words, "It was composed of the best workers in different branches of ceramic decoration and did much to uphold the standards of good workmanship during the eleven successful years of its existence." The list of members—it never changed during these eleven years—was: Miss McLaughlin, president; Clara Chipman Newton, secretary; Alice B. Holabird, treasurer; Mrs. E. G. Leonard, Mrs. Charles Kebler, Mrs. George Dominick, Mrs. Walter Field, Miss Florence Carlisle, Miss Agnes Pitman, Miss Fannie M. Banks, Mrs. Andrew B. Merriam, and *one vacancy*; honorary members were Mrs. M. V. Keenan, Miss Laura A. Fry, and Miss Elizabeth Nourse.

Contrary to the statements of several writers, Mrs. Nichols was never a member of the Pottery Club.[3] An invitation to the organization meeting on April first had been sent to her, but somehow the message miscarried and was not delivered. Irritated by what she considered a personal slight, Mrs. Nichols would never join the club, which explains why the *one vacancy* was carried on the membership roster for eleven years.

The members of the club met three days a week at the Coultry Pottery, where they practiced and experimented in all phases of the art: overglaze painting, incised decoration, relief design, and decoration under the glaze.

Mrs. Nichols, meanwhile seeking a place to work independently, visited the Hamilton Road Pottery[4] of Frederick Dallas. She stopped there in May, 1879, accompanied by a friend, William W. Taylor, and remarked later that it was the first time either of them had ever been inside a pottery. She met Joseph Bailey, the superintendent, and through him, the owner, to whom she explained the purpose of her visit. Dallas consented to have pieces made and fired for her, and also agreed to rent her a small room for a "studio" in which to work. This she shared with a co-worker, Mrs. William Dodd, who had been a member of the initial class in china-painting organized by Benn Pitman five years before.

The studio was a room about ten by twelve feet in size, located on the second floor of the wagon shed in the pottery yard; through the cracks in the floor one could look down on the horses below. A crude fireplace with a few loose bricks to serve as andirons, a workbench, and two chairs constituted the furnishings. Here Mrs. Nichols began her serious experiments in clay, glaze, and color.

[2] John Bennett came from Doulton's, Lambeth, London, to New York, where he opened a studio for underglaze decoration. In 1878, efforts were made to secure him as instructor in Cincinnati. He turned down the offer, not wishing to reveal the process he used.

[3] Ripley Hitchcock, *Century Illustrated Monthly Magazine*, August, 1886, in an article "The Western Art Movement," states Mrs. Nichols was a member of the Pottery Club. This inaccuracy was undoubtedly the source of the error repeated by later writers.

[4] Hamilton Road is now McMicken Avenue.

Many times that summer she drove to the pottery in her cart, pulled by her small yellow Indian pony. The pony was tethered in an unoccupied corner of the yard while Mrs. Nichols worked upstairs. Almost from the start she was discouraged by the harsh fire of the Dallas "graniteware" kilns that destroyed or burned out most of the colors she attempted. Only cobalt blue and black seemed to survive the high temperatures successfully. Mr. Bailey added a dark green to this limited palette, but the effects were cold, dark, and hard.

For her, the daylight hours were too short and too few. Vases of "green" clay and biscuit were carried up to her studio from the hands of the thrower below. On them she practiced every style and technique from "incised designs as delicate as the spider's web" to painting under the glaze or Cincinnati faience, as it was called locally. Later it was referred to as "Limoges" decoration. A rapid worker, she turned out vases of all sizes. A majority of the larger ones, some thirty and thirty-two inches in height, were "Japanese grotesque" in design with the "inevitable dragon coiled about the neck of the vase, or at its base, varied with gods, wise men, the sacred mountain, storks, owls, monsters of the air and water, bamboo, etc., decorated in high relief, underglaze color, incised design, and an overglaze enrichment of gold." This was the influence of the Japanese work she had admired at the Centennial.

In the fall of that year, the Pottery Club also rented space in the Dallas Pottery, as the Hamilton Road Pottery was more commonly called. The club had started working at the Coultry Pottery because Miss McLaughlin originally wanted to conduct her experiments on the yellowware produced there, but other members of the club felt that it restricted their work, which they thought would be more flexible on the clay and biscuit ware of the white bodies available at Dallas.

The room the club occupied was approximately fifteen by twenty-four, and had windows on three sides, the east, south, and west. It was in a building of the establishment that had originally been the country home of Mrs. Frances Trollope during her residence in Cincinnati, and was light and airy, with walls of whitewashed brick. A continuous shelf some two feet wide was placed in front of the windows to serve as a worktable. A few plain chairs, modeling stools, a stove, and a washstand completed its furnishings.

When the high temperatures of the "graniteware" kilns were found unsuited to the delicate colors of the underglaze work attempted by the club members, Miss McLaughlin arranged to have a special kiln for firing this work built at her own expense. Not to be outdone, Mrs. Nichols too had a special kiln built to order for the firing of overglaze work. It was said to be "the largest in the country."

Entrance to the two rooms the women used was through the pottery yard where the kilns were located. But the two groups remained independent of each other; Mrs. Nichols and Mrs. Dodd worked in one, the members of the Pottery Club in the other. A sense of rivalry was evident between the groups, or at least between Miss McLaughlin and Mrs. Nichols, and it was to come to a more heated controversy years later at the time of the World's Columbian Exposition in Chicago in 1893.

Earlier, in an effort to avoid the harsh fires of the Cincinnati kilns, Miss McLaughlin had sent some of her work all the way to Thomas C. Smith & Sons' pottery at Greenpoint, Long Island, to have it fired. Consequently Mrs. Nichols sent some of her wares to be fired at Lycett's in New York, that city's foremost establishment for pottery decoration.

And it was at Lycett's that Mr. Nichols obtained much of the material for *Pottery and How It Is Made*, which was published in 1878, shortly after the appearance of Miss McLaughlin's treatise on *China Painting*. His full title read *Pottery, How It Is Made, Its Shape and Decoration, Practical Instructions for Painting on Porcelain and All Kinds of Pottery with Vitrifiable and Common Oil Colors.* The book contained six pages of sketches of "Japanese designs, figures and motifs" signed by "M.L.N." (Maria Longworth Nichols).

Interest in pottery decoration was not confined to Cincinnati women. Ladies from Dayton, Hillsborough, and more distant points throughout the state came to the city for lessons, or sent there for clays and biscuit ware, and returned their decorated work for firing and glazing. It was reported that work from as far away as New York, Kentucky, Iowa, Michigan, Indiana, and Minnesota was also sent to Cincinnati to be fired. The number of amateur decorators whose work was fired at the Hamil-

ton Road Pottery alone was said to be more than two hundred, all but two of whom were women.

In writing of this period, an author in *Harper's New Monthly Magazine* observed:

> It is curious to see the wide range of age and conditions of life embraced in the ranks of the decorators of pottery: young girls of twelve to fifteen years of age find a few hours a week from their school engagements to devote to over or underglaze work, or to the modelling of clay; and from this up through all the less certain ages, 'til the grandmother stands confessed in cap and spectacles, no time of life is exempt from the fascinating contagion. Women who need to add to their income, and the representatives of the largest fortunes, are among the most industrious workers; and it is pleasant to know that numbers of these self-taught women receive a handsome sum annually from the orders for work, from sales, and from lessons to pupils.

Mrs. Nichols continued her experiments and productions at the pottery of Frederick Dallas into the spring of 1880. With the help of the superintendent, a practical potter of long experience, she succeeded in developing a light blue and a light green that would withstand the heat of the kiln. But she still had no reds, no pinks, no yellows. The clay bodies on which she worked were Rockingham, or a mixture of Rockingham and white clay, which formed the bodies of the regular "graniteware" production—ideally suited to the manufacture of household and kitchen utility items but rather inflexible as a base for art pottery production.

At the same time, Miss McLaughlin and the other members of the Pottery Club continued their activities, and by sheer weight of numbers produced a considerable quantity as well as variety of work. It was during this period that Miss McLaughlin decorated her famous "Ali Baba" vase, which was thrown at the Hamilton Road Pottery and was publicized as the largest made up to that time in America.

Interest in the work of the women at the Dallas Pottery grew to a point where a constant stream of visitors tended to interrupt the decorating activities. To end this annoyance, the members of the Pottery Club decided to hold an exhibit at their workrooms, which would be open to the public, but to limit the number of visitors at other times. This event was scheduled for April 1, 1880, the first

anniversary of the club. Five hundred invitations were issued, and were "eagerly sought."

The club workroom was decorated, its brick walls hung with fine rugs, and great masses of fruit blossoms, palms, and dogwood strategically placed to give the appearance of a "floral bower." The day was ideal. The kilns in the yard were arranged in different stages of operation—some closed for the firing, some open to be drawn. In describing the event, Miss Newton wrote, "Up and down the narrow stairs, the art and fashion of the city surged from 12 to 5 o'clock. Hamilton Road had never seen such a sight. Triumphant and exhausted when the guests were all gone, Mr. Dallas dashed into the room to tell us that the carriages had been standing up and down both sides of the street and clear around the corner. Nothing meant so much to the old gentleman as those carriages—they were to him the outward and visible sign of whatever inward grace the Pottery possessed."

At the eighth Cincinnati Industrial Exposition held in September, 1880, the work of several local decorators was exhibited. That much of it was prepared or fired at the Dallas Pottery is indicated by the following newspaper notice, which appeared coincidentally with the show:

Card of Thanks

We, the undersigned ladies, amateur decorators of china and pottery—portions of whose work are on exhibit at the present Exposition—desire to express our sincere thanks to the potters of Cincinnati, and especially to Mr. Frederic Dallas, proprietor of the Hamilton Road Pottery, and to Mr. Jos. Bailey, his very efficient practical manager, for the kind assistance they have at all times rendered us, in preparing, glazing and firing our work, as well as for the lively interest they have manifested in its development, knowing as we do that they are entitled to no small share of the many flattering commendations we have been receiving from the public press.

Mrs. Maria Longworth Nichols
Mrs. Jane P. Dodd
Louise McLaughlin
Mrs. Frank R. Ellis
Miss K. DeGolter
Florence Leonard Kebler
Henrietta D. Leonard
Mrs. M. V. Keenan
Mrs. Dr. Meredith

Chapter 2

Mrs. Nichols still dreamed of having a pottery of her own where she might control the entire process: the clay mixtures, the colors, the glazes, and particularly the temperature of the fires for the kilns. Dallas was a commercial pottery—commercial wares came first, and art pottery production was decidedly a secondary consideration. Mrs. Nichols envisioned a place where the emphasis would be on art pottery and primary attention devoted to fostering and developing it; commercial wares would be secondary, produced only to help defray expenses. She was perhaps also a bit envious of Miss McLaughlin and the success of the Pottery Club exhibit, in which—by her own choice—she was not a participant.

In any case, she was feeling discouraged one day in the latter part of April, 1880, when her father said to her, "If you are really in earnest in wanting to have a pottery of your own, you may take an old schoolhouse that I bought at a Sheriff's sale last week, and fit it up to suit yourself."

Greatly delighted, Mrs. Nichols decided this was the opportunity she had sought, the solution to her problems. Promptly she consulted Mr. Bailey about what should be done, and he entered into her plans with interest and enthusiasm, supplying her with lists of the equipment, materials, and personnel that would be needed at the start. There was machinery to be bought: wheels and lathes for throwing and turning, engines for running the mills needed to grind the clays, frits, and glazes. Tools and utensils were required: brushes, sponges, sieves, strainers. Kilns had to be built. Necessary raw materials had to be secured: coal for fuel, colors for decoration, chemicals for glazes, and, of course, the clays. And there were the people needed to do the work: clay handlers, throwers, turners, moldmakers, kiln men, and firemen had to be hired. Some arrangement had to be made to sell the ware if the operation was to be a successful commercial enterprise, even if it concentrated on art pottery production. It was indeed quite an undertaking.

Somewhat overwhelmed by the magnitude of the task, but undaunted in her determination to proceed, Mrs. Nichols asked Mr. Bailey to join her new enterprise as superintendent. He explained that since he had been associated with Mr. Dallas for fifteen years, he felt he should not leave as long as the old gentleman continued the business. He suggested, however, that she might hire either or both of his sons, who had considerable experience in the operation of a pottery. So Joseph Bailey, Jr., became the first employee of the new enterprise, and with the continued guidance of his father directed the task of transforming a schoolhouse into a pottery.

Years later, in recalling this period, Mrs. Nichols wrote:

> The first thing I bought was a second-hand engine, and it was installed with great pride for the grinding of the clay and glaze, and to turn some of the wheels used in making bowls, cups and plates. For some of our vases we had plaster moulds and also a potter's wheel. This first wheel of ours was turned for the potter's use by woman power, this being more easily controlled than steam. At the present time [1895] steam is the more docile, and a potter's wheel is now run by steam power at the Rookwood Pottery.

The building was located at 207 Eastern Avenue, not far from the crossing of the Little Miami Railroad track, on the bank of the Ohio River and to the east of the city in what was then the suburb of Fulton. Today the street has been renumbered and the building razed, but the location is marked by the Pennsylvania Railroad crossing over Eastern Avenue, still known as "Rookwood Crossing."

The entrance from the street was into a center hall, which had a stairway leading to the second story. On the right of the hallway were two rooms: the one to the rear was designated the decorating where the finished pieces would be offered for sale; the one to the rear was designated the decorating room for the artists. To the left of the entrance was a large room where the potters would work, making molds and fitting handles to pitchers and jugs.

On the second floor and again to the right of the stairway were two rooms: one would serve Mrs. Nichols as a combination office and studio; the other was assigned to Edward Cranch, a retired lawyer, friend, and occasional decorator, who combined all manner of chores at the start, from assisting in keeping the books to handling personnel. Joseph Bailey, Jr., and his family were to occupy the rooms at the left of the stairway on the second floor and live at the pottery. This arrangement would make it possible for him to serve as night watchman and assist as night fireman if and when extra help was needed for the kilns.

From the street, the ground sloped sharply to the river. The basement in the rear was at ground level. It contained the machinery for grinding and the tubs and vats for storing the slips and glazes. Two kilns were erected in the yard behind the schoolhouse, protected from the weather by wooden sheds. The yard itself, enclosed by a high board fence, would serve as storage space for the raw clays and coal.

Work went ahead rapidly and in September, when the transformation was nearly complete, Mr. Longworth deeded the property to his daughter. But there was still much to be done. A name was needed, and a trademark. Stationery, journals, and ledgers had to be obtained, and a bank account had to be opened.

In selecting the name Rookwood, Mrs. Nichols said:

I called the pottery "Rookwood" after due

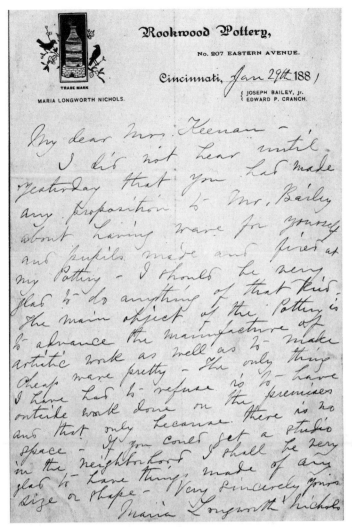

Rookwood's first letterhead shows the first trademark designed by H. F. Farny.

deliberation, because in its length and last syllable it reminded one of Wedgwood, and because the word had a pleasant association in my memory, since it was the name of my father's country place on Walnut Hills, where I lived from one year old to twenty.[1] I have had many letters from all kinds of strangers asking and giving information about the pottery. One was from a lady who thought she and I must be related to one another because

[1] Her father's country place was named Rookwood because of the large number of crows that inhabited the area. In 1848 when it was built, it was fifty minutes' carriage drive from Fountain Square in downtown Cincinnati.

"her maiden name was Rookwood." I had to explain to her that the crows in an old dead elm tree had *begun* the Rookwood Pottery.

Henry Farny, well-known Cincinnati artist, was commissioned to design the trademark. He developed a mark with a framed kiln symbolizing the pottery, superimposed against a spray of fruit blossoms on which two rooks were poised. This was adopted and used on the pottery's first letterhead, and was also used for a short period to mark some of the early ware.

A supply of stationery was secured, as were books and record forms for keeping accounts and listing sales. A bank account was opened in the city at the Commercial Bank, where Mrs. Nichols also kept her personal checking account.

During this period two efforts were made to dampen Mrs. Nichols' enthusiasm. The first was a letter from old Mr. Dallas in which he advised against the whole undertaking, pointing out that there was not enough business in the art pottery field to make it a paying proposition and that as a business venture it must surely fail.

The other was a threatened injunction from Thomas J. Wheatley, an artist who had worked at the Coultry Pottery experimenting in underglaze painting when Miss McLaughlin and other ladies of the Pottery Club were working there. He had fired his first pieces there in April, 1879, and then formed a partnership with Coultry for the production of underglaze faience. This ended in a disagreement, and a lawsuit followed over the division of the large number of vases that constituted the assets of the partnership. Wheatley then set up his own pottery, secured a patent on the underglaze process, and attempted to establish a monopoly. The following account is quoted in part from the Cincinnati *Daily Gazette* of October 7, 1880:

WAR AMONG THE POTTERS

T. J. Wheatley Secures a Patent On American Limoges

And Warns His Rivals to Make No More of it—His Pretensions Derided by Mrs. M. L. Nichols, Miss McLaughlin and The Professional Potters—Legal Aspects of the Affair

Among those who allow their love of art to find expression in dabbling in Limoges ware, there is at present a very lively agitation. Most of those interested are ladies, and the person who has caused all the commotion is a man—and a young man at that. He has actually taken proceedings which threaten to put a stop to a most delightful and all consuming occupation so far as making the ware for sale by these ladies is concerned. Indeed with a commendable spirit of independence the ladies who have the taste and ability to manufacture Limoges ware in Cincinnati have built up quite a market in that article of household ornamentation, driving out, to a great extent, the imported goods. Many of the ladies form articles in the rough from the plastic clay with their own fair fingers, no matter how difficult the designs or what the size may be, and they then draw and paint on them according to their fancy, and give them afterwards to a professional potter to glaze and burn. Others do not care to soil their fingers with the clay, and so they are content with putting on the colors only. All of the several potteries throughout the city have a room sacred to these devotees of the ceramic art. Here, on some days, may be seen a dozen or more ladies, single and married, with aprons on, deep in the mysteries of molds and "slips," mixing colors, daubing, sketching, and painting, glazing and burning. Those even whose work shows a woeful lack of ability to draw and paint have the satisfaction of knowing that it will be eagerly sought after for parlor ornaments, for it has become the fashion to admire the ware, whether good or bad. But a great deal is made of real artistic merit.

There is a great deal of doubt as to when, exactly, Limoges ware was first discovered. Some say the knowledge of manufacturing it was lost for 100 years, until a comparatively short time ago, when it was revived in France. Others say the art has been practiced all along in England, and, indeed, that the characteristic of Limoges ware—color under a transparent glaze—has been known to every boy who worked in a pottery in this country for years back—the only difference being that in Limoges ware, paintings by the brush are produced. If a pure color be applied to pottery and a glaze be put on, and the ware then burned, the color will run off. And for years and years admirers of the ware in this

country had failed in their attempts to imitate the French ware, because they used pure colors. It never occurred to them to mix clay with their colors. Miss McLaughlin, of this city, has, by unanimous consent, been awarded the honor of being the first in this country to successfully solve the problem. She kept it a secret for some time, when it leaked out. Now it is nobody's secret.

But a modest young man from the East now comes forward and claims to be the discoverer of the process for making Limoges ware. And, what is more, he has actually secured a patent right. His name is T. J. Wheatley. He has a pottery on Hunt Street, where he turns out Limoges ware to order.

"Oh, yes," Mr. Wheatley said in reply to a question the other day, "I discovered the method of making Limoges ware. I struck the idea three years ago at New York but the colors did not come out right because of imperfect burning. I started this pottery six months ago. The application for a patent was made on the 21st of June, and the patent was issued on the 28th of September. I now employ four artists but soon I will have two more. A Cincinnati capitalist has advanced me money and I am going to enlarge my pottery."

In after conversation Mr. Wheatley said that as he now had the protection of the law he could afford to employ the best artists. The result of the issue of a patent to him would be that all the Limoges ware work in the United States would be concentrated at his pottery.

Mr. Wheatley has notified a number of manufacturers of the ware that he would institute proceedings against them did they not stop operations.

It is safe to say that Mr. Wheatley's warnings will be very little heeded, if at all, for there is no apprehension that his patent letters will stand.

Yesterday morning, Mrs. George Ward Nichols was visited at her private pottery, described before in these columns. Mrs. Nichols . . . was found in an upstairs room painting some little clay articles which to the unsophisticated eyes of the visitor looked like soup ladles with the handles broken off short.

The pleasant little lady put down her brush and her eyes twinkled merrily as she listened to how Mr. Wheatley was going to make her close down her Limoges ware pottery.

"Why," she laughed, "Miss McLaughlin used to do Limoges work before Mr. Wheatley ever thought of such a thing. I knew the secret before he did. I don't see how he could get out a patent. He might as well get out a patent for wood carving. I might with better reason get out a patent for drawing dragons on vases, as I believe I was the first to do that here. . . ."

"Do you feel afraid of Mr. Wheatley instituting proceedings against you?"

"I don't care if he does," Mrs. Nichols said. "I shall go on building my pottery and I hope to have the first fire in the kiln in a month's time. While my principal object is my own gratification, I hope to make the pottery pay expenses."

The reporter then went to the Coultry Pottery where, in the absence of the proprietor, he interviewed the foreman, who stated that ladies had been making Limoges ware at Coultry's ever since the Centennial, and that if anybody was entitled to a patent on the process, it was Miss McLaughlin, whose experiments had led to its discovery He then interviewed George McLaughlin, Miss McLaughlin's brother, who was secretary of the Firemen's Insurance Company of Cincinnati, and who was able to produce records showing that the first successful piece of Limoges ware made by Miss McLaughlin was taken from the kiln at Coultry's in October, 1877. When Coultry went into partnership with Wheatley to produce Limoges ware, Miss McLaughlin had felt these men pirated many of the techniques she had developed —another reason for the transfer of her activities to Dallas' Hamilton Road Pottery. The article ended with the sentence: "It will now be in order for Mr. Wheatley to assert his legal right if he has any." Thus was the case tried in the newspapers before it ever got to court, and apparently the matter was dropped, for no more was heard of it.

Seven weeks later, on Thanksgiving Day, 1880, the first kiln was drawn at the Rookwood Pottery.

Chapter 3

No record has been found of the contents of the first kiln. It is quite likely that it contained three general types of ware.

The first was art pottery designed by Mrs. Nichols. This undoubtedly included her "Aladdin Vase," one of which was sold to Tiffany in 1880. The Aladdin vase became shape No. 1 in the Rookwood line—a large vase ornately decorated with fish, crabs, lobsters, and other sea creatures, both painted and in applied relief. It is probable also that the "soup ladles with the handles broken off short" described by the reporter in the Wheatley story were included in the first kiln. These may well have been oven-to-table baking dishes, which were later assigned shape No. 198. A number of vases cast from two molds purchased in 1880 from the Hamilton Road Pottery may have been included too. Mrs. Nichols could have decorated only a limited number of "art pieces" in the time available—certainly not enough to fill a quarter of the kiln. And, as far as is known, no other decorators were employed at Rookwood until the following year.

The second type of ware in the first kiln (it probably made up the largest part of Rookwood's initial production) was an assortment of commercial pieces and plain undecorated ware.[1] The records list a "foot tub [made of] yellow clay 1880," and a "water bucket, yellow ware," among the first pieces made at the pottery. This second group may have included a "scalloped bowl and saucer," pressed pieces later noted as "not decorated and not saleable," a hot water pitcher made in two sizes, and a chocolate pot "made in white ware with gilt and colored bands."

The third type of ware presumably included in the first kiln was that fired for outsiders, independent amateur decorators who arranged to have their work "burned" in Rookwood's kilns. Mrs. Nichols was approached almost immediately by amateur decorators interested in doing their work at her pottery. These she reluctantly turned away for lack of space, but she did offer to supply "green" or biscuit shapes for decoration, and to fire their wares. For example, Mrs. Keenan had spoken to Mr. Bailey, Jr., about the possibility of using the pottery's facilities. When Mrs. Nichols learned of this, she wrote Mrs. Keenan that the pottery would be glad to make and fire pieces, but that no working space was available, suggesting, "If you could get a studio in the neighborhood, I shall be very glad to have things made of any size and shape." This letter is reproduced in Chapter 2.

It is known that a part of the contents of the first kiln was shipped to Briggs & Co., a leading Boston retailer, who represented Rookwood in that city for many years. Edward Atkinson, a well-known industrialist and professional lecturer from Boston, had visited Cincinnati in the fall of 1880 and became interested in "the formation of a new art industry on the banks of the Ohio." He offered to publicize Rookwood in his home city when he lectured on his "Western Tour," and promised to display the wares to illustrate his talk. Accordingly,

[1] Few unmarked pieces exist today. Except for those in museum collections, it is doubtful they would be recognized or could be authenticated as early Rookwood production.

it was arranged for him to borrow a number of pieces from a shipment to Briggs & Co.

From the files of the Massachusetts Historical Society is the following letter sent to Mrs. Nichols describing the arrangements:

Dec. 13, '80

DEAR MRS. NICHOLS:

Your intention to send examples of your work to Briggs will just meet my case. I am assigned a half hour at the meeting of the Thursday Club Jan. 20th. This will give you ample time and as I like to have the club get the first view I suggest that you send to Briggs all that you intend for him with instructions to him to put the ware a my disposition before he shows it publicly. I will then tell him to whose house to send it.

If this plan pleases you I shall doubtless be able to show much more than I should have dared to expect on my own account.

Let me have some little plan or sketch of your work to submit and tell me whether to give your name or not.

Very sincerely yours,
EDW. ATKINSON

This was probably the first of many instances where Rookwood was judiciously loaned or given in order to secure favorable publicity.

Some of the pieces from the first kiln were unquestionably offered for sale in Cincinnati. By March, 1881, John A. Mohlenhoff's on Fountain Square in the business center of the city displayed this small announcement:

ROOKWOOD POTTERY
Goods of Maria Longworth Nichols,
made at these works, are now on
exhibition and for sale. You
are kindly invited.

A large increase in correspondence (all letters and records were handwritten in those days) and the accumulating administrative details began to encroach on Mrs. Nichols' time to the virtual exclusion of her artistic work. For this reason, she hired as "secretary" Miss Clara Chipman Newton, a long-time friend and former schoolmate. Of this arrangement Miss Newton wrote:

My connection with Rookwood began in the spring of 1881. Mrs. Nichols and myself never assumed the relationship of employer

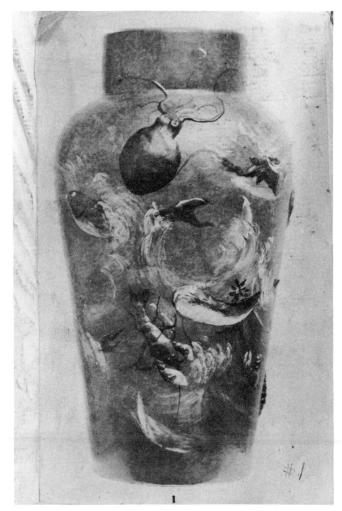

"Aladdin Vase" decorated by Mrs. Nichols became Shape No. 1.

and employee. Our deliberations as to ways and means would to an outsider have carried the conviction of equal financial interests. How clearly I remember the discussion of how we should define my exact position, and how pleased we were when we decided that Secretary was a title that sounded impressive so far as the Pottery was concerned, and to ourselves might be a sufficiently elastic term to cover the many-sided work that really came under my supervision.

At the start Miss Newton received $27.00 per week, an extremely generous salary for 1881 when the average weekly wage was nearer to $5.00.

Edward Cranch also assumed more of the administrative detail. He had no regular salary but

was paid intermittently, perhaps on the basis of the time spent on Rookwood business. For example, he received a check for $50.00 one month and another for a similar amount about six weeks later.

All other wages were paid by the week in cash.

Miss Newton, who joined the staff in April, and Mr. Cranch devoted a part of their time to decorating, and augmented the output of art pottery produced by Mrs. Nichols. About this time Ferdinand Mersman, James Broomfield, and Henry Farny, the artist who designed the trademark, all helped with the decorating, although they were never officially listed as Rookwood decorators.

Mersman made vases decorated in high relief during the summer of 1881, in preparation for the first formal exhibit of Rookwood, which was scheduled for the Cincinnati Exposition to be held in September. One was a vase with a relief portrait of

President James A. Garfield, who had been wounded by an assassin on July 2. According to Miss Newton, these Garfield vases were made of red clay and fired only in the biscuit. In 1905, Miss Newton recalled, "I do not know whether any of these are in existence—if so—aside from their artistic merit—as a feature of early Rookwood, they are very rare."

In October, after the President's death, Mersman made the Garfield Memorial Pitcher, which carried the same ribbon mark used on a commercial run of beer tankards produced for the Cincinnati Cooperage Company and mentioned by E. A. Barber in his *Marks of American Potters*. Miss Newton recorded in 1905, "These pitchers were made of sage-green clay in a dull or 'smear' glaze. They were of two sizes. Less than a hundred were produced. Of this number but a few were sold at the Pottery—so that these pieces also are historically valuable. The remaining number sank into the oblivion that comes to over-production of all manufactures." One of these Garfield Memorial Pitchers can be seen in the collection at the Western Reserve Historical Society in Cleveland.

Broomfield was an Englishman who specialized in painting border designs over the glaze on white

Cincinnati Art Museum
Garfield vase with relief portrait of the President, modeled by Mr. Mersman in the summer of 1881.

The Western Reserve Historical Society
Garfield Memorial Pitcher made by Mr. Mersman after the death of the President in the fall of 1881.

tea sets. They were the forerunners of the sailing-ship design tableware later produced and expanded into a complete table service. The only distinction between the originals and the later "reproductions" is possibly a slight difference in the shade of blue and the fact that the earlier pieces carried no name or mark. At this time the larger volume of the output was commercial ware—breakfast and dinner services, pitchers, wine coolers, ice tubs, umbrella jars, and the like, not marked or identified as Rookwood. Miss Newton reported that if these shapes were decorated, the name of the pottery was usually painted or incised on the bottom of the piece by the decorator, and "umbrella jars and vases, especially those decorated by Mrs. Nichols were, as I remember it, at the time our best selling items."

Henry Farny suggested that the pottery produce some pieces with "Indian designs," and in the Shape Record Book is the notation, "189. Red clay plaque. Pressed. Decorated by H. Farny. Could not be fired hard enough to set the colors in manner desired by artist without destroying effect."

During 1881, Rookwood was apparently groping for an appropriate identification, and a variety of marks were used on the hand-decorated wares. In 1882, the word ROOKWOOD in block letters, accompanied by the date, was adopted as the standard mark.

An example of the unmarked pieces is the "printed ware" produced during 1881. According to Miss Newton, this was the only attempt made to use a printed design. It was undertaken by Mrs. Nichols in the hope of cutting costs through the use of "mass-production" methods. Miss Newton described the effort as follows:

> Mrs. Nichols thought that printing instead of painting these [commercial type] wares would be desirable. The first steps of this process, engraving the copper plates, were exceedingly expensive. Finally the matter was adjusted on a somewhat more economical basis than was at first supposed possible, and the designs of birds, fishes, lobsters, etc., carefully selected from Japanese books were prepared. Everybody with the exception of Mr. Valentien and Mr. Mersman connected with the pottery, Mrs. Nichols, Mr. Cranch and myself, Annie Hennegan, who had by this time taken charge of the ware room, little

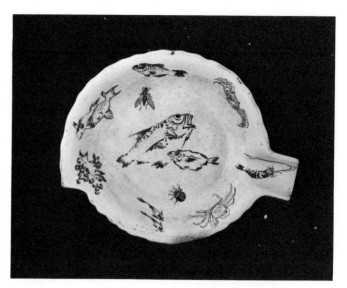

City Art Museum of Saint Louis
Gift of Laura A. Fry, 1911
Example of the "printed ware" produced by Rookwood.

Fanny Auckland, the daughter of Mr. Auckland who made the ware on the wheel, Andrew Steinle, the general utility boy, assembled in the kiln shed to help with the new experiment.

> The two Baileys, Jr. and Sr., rubbed the colors, blue or brown, into the engraved copper plates; we all cut tissue paper that held the design, rubbed the detached pieces which each to her own taste, applied to the ware. I with a subdued excitement plunged the plate into the waiting tubs of water, and with breathless emotion watched the paper float away, leaving the design clearly revealed. You may not believe me but the situation was tense. I can never quite look back to those early days without feeling a little tingle of excitement that seemed to fill the atmosphere which was so full of the unexpected.

Old Mr. Dallas died on June 9, 1881, and Joseph Bailey was freed from his self-imposed obligation to remain at the Hamilton Road Pottery. He promptly joined Rookwood, where he and his son remained until 1885, when they moved to Illinois. However, the elder Bailey returned to Rookwood two years later and resumed his position as superintendent. He came from a family of potters in England where he had served his apprenticeship. One of this uncles was Taylor Booth, son of Ward

Booth, both of whom were prominent members of the craft in that country. Bailey had come to the United States in 1848, entered the pottery of R. Bagnell Beach in Philadelphia, where he stayed for six months, and then had gone to a pottery in East Liverpool, Ohio. In 1850, he came to Cincinnati and became associated with Frederick Dallas when the latter took control of the Hamilton Road Pottery in 1865.

In speaking of Mr. Bailey, Sr., Miss Newton said, "His extensive experiments in clays and glazes contributed in no small degree to the beautiful productions that have made the pottery famous. Mr. Bailey's efforts, true to his English training, all tended toward perfection and he never tolerated inaccuracies which his trained eye discovered in the moulding of a vase or the placing of a handle on a piece of ware."

During the summer of 1881, two new structures were built to enlarge the already crowded facilities and provide additional space where outside or amateur decorators might work. One was located south of the original building facing the street. The wareroom, as the salesroom was then called, was relocated on the first floor of this new building, and Miss Hennegan was placed in charge. On the second floor was a large airy room, lighted by windows on all sides. This was fitted with worktables, a wheel, and shelves for use by Mrs. Nichols and Miss Newton. The room vacated by Mrs. Nichols in the original building was rented to the Pottery Club.

The second building was erected directly behind the first but at a slightly lower level. It also had two rooms, one above the other, each occupying an entire floor. The lower one was planned for the use of the decorators; the upper was used for the "Rookwood School for Pottery Decoration" during the brief period of its existence.

Mrs. Nichols believed that operation of such a school would help support the pottery, both financially and by providing training and experience for the development of future artists. Concerning the school, one of the Cincinnati newspapers reported at the time:

The Rookwood school of decorative art as applied to keramics will open on Monday next, October 17, in the building adjoining the pottery. . . . On one day in each week

Miss Clara Chipman Newton, a most successful and accomplished artist in pottery decoration, will give class instruction in under or overglaze painting from 9 till 12 in the morning, and from 1 to 4 in the afternoon, the class of fifty students being divided into two sections for greater convenience. Another day each week Miss Laura Fry will instruct in modeling and Limoges. Miss Fry has done admirable work in these departments, and as an instructor possesses remarkable qualifications. . . . The terms of instruction, including lessons and the use of the rooms, are $3 per week, payable in advance. Private lessons are at the rate of $1 per hour. Articles for decoration are furnished to the students at 25 per cent. discount on retail prices, and finished articles which receive the approval of the committee who examine the work—Mrs. Maria Longworth Nichols, Miss Newton, and Miss Fry—will, if desired, be offered for sale with the Rookwood Pottery wares. The demand for these from dealers in all parts of the country is double the present production, and makes their ready and remunerative sale assured. . . .

True, Rookwood's sales were enjoying increasing demand in Cincinnati and New York, but to say that the demand "from dealers in all parts of the country [was] double the present production" was a considerable exaggeration. It was typical, however, of a great amount of Rookwood publicity given out to the press and to magazine writers in the early years. At the time the above was written, the operations were deeply in the red and the pottery was several years away from breaking even.

In 1881 the decorating department was formally organized. In September, Albert R. Valentien joined the pottery as the first "regularly employed" member of the decorating staff, meaning, apparently, that he was the first full-time decorator to be hired. Some years later he recalled:

In 1879 I happened to be associated with Mr. Wheatley and it was from him that I received the first rudiments in underglaze pottery decoration. Previous to this I hadn't even painted on china, but was devoting my time to studies at the Art Academy, and in decorative design and interior decoration. Everything then was in the crudest form of development indeed; but very little was known

besides the simple knowledge of application of slip on the clay or raw material. The very simplest palette of colors was used, in fact only those being put to use that we knew could stand the severest heat.

Early associates of Valentien in the decorating department were Laura A. Fry and Harriet Wenderoth, both skilled wood carvers; Alfred Brennan; Fannie Auckland, the twelve-year-old daughter of the thrower; and W. H. Breuer. In addition, of course, Mrs. Nichols, Miss Newton, and Mr. Cranch did decorating in their own "studios."

From the first, a visit to the Rookwood Pottery proved a popular attraction for both Cincinnati residents and visitors to the city. Initial publicity had brought many to see this new art industry where the motive of profit was subordinate to the desire for genuine artistic creation. Leading citizens and prominent visitors were encouraged to come to the pottery where they would see the artists at work, hear the philosophy expounded, and usually end by making a purchase in the salesroom.

Of one such early visit Miss Newton, some years later, wrote:

Time will never dim my recollection of the visit of Oscar Wilde to the pottery. In the absence of Mrs. Nichols, it fell to my lot to receive Mr. Wilde, who was accompanied by Mrs. Devereux.[2] I was not even at that time, when every newspaper contained accounts of his vagaries, prepared for the calla-lily leaf green overcoat and the shrimp pink necktie of the individual who was shuddering visibly over a vase which he was pronouncing "too branchy" as I entered the room. I did not claim the vase which heretofore had appeared to my unenlightened eyes, a very good and desirable piece of work. As the party started on its tour of inspection through the pottery, we were joined by Mr. Bailey who had not *much* sense of humor and *no* comprehension of figures of speech. I have always been positively sure that there was one spot in America where the then fashionable disciple of the Aesthetic met his match with counter statements of cold, practical, hard facts. The next day in his lecture, Mr. Wilde scored the pottery to the intense amusement of Mrs. Nichols, who has a sense of humor and fully appreciated that artistically we had much to learn.

Another early famous visitor to the pottery was Seymour Heyden, the English etcher. Realizing that under the eye of a trained critic Rookwood's artistic weaknesses would be readily apparent, the staff awaited his visit with some trepidation. He came accompanied by several leading Cincinnatians, and though he was courteously critical of the painted underglaze pieces he examined, he was full of praise for some simple vases decorated by Miss Auckland. These had impressed patterns made by using as a die the head of a nail into which a design had been cut or filed. The nailhead was pressed into the wet clay body in a series of circles or bands, leaving the imprint of its design. The patterns thus formed were then filled in with color or finished in a "smear" glaze. Heyden selected one of these vases to be sent to his home in England. Before he left Cincinnati he was escorted to the Longworth estate, Rookwood, where he mentioned his visit to the "nice little pottery," apparently unaware of any connection.

The frequent visits of prominent persons probably suggested keeping a "guest register," a practice faithfully maintained until the 1940's. In the heyday of the pottery in the 1920's when a visit to Rookwood atop Mt. Adams was widely promoted as a tourist attraction, thousands of visitors made the trip each year and left their signatures in the visitors' register.

It is estimated that during 1881 the pottery produced several thousand pieces in from seventy to ninety different shapes or patterns. Some shapes were abandoned when they proved difficult or impossible to fire successfully; others were discontinued when they were found to be "completely unsaleable."

William Auckland, the thrower, created most of the new shapes. These were then thrown, cast, or pressed in quantity as "green" pieces, to be individually decorated by the artists. Miss Fry designed several new shapes, including the two cake plates shown on page 18. Two small thrown jugs, one round and the other flattened on the sides, proved extremely popular. Between 1881

[2] Clara Anna Rich Devereux was a newspaper writer for the *Commercial*. Later she became society editor of the *Cincinnati Enquirer*, and was coeditor of *WHO'S WHO?—A Society Register*, published in Cincinnati in 1892.

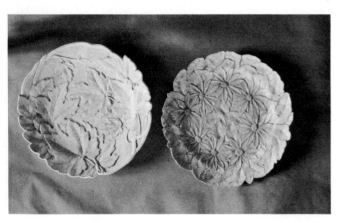

City Art Museum of Saint Louis
Gift of Laura A. Fry, 1911

Two plates carved by Miss Fry. Left has leaves out-lined in gold on blue-gray background, 10½ inches in diameter, marked "ROOKWOOD 1883." Right is out-lined in gold on tan ground, marked "Cin. Pottery Club 1883."

and 1883, over five thousand of them were sold, decorated either in the "Limoges" style of under-glaze painting or with carved designs. Several customers purchased them in gross lots, and one account, identified today only by the initials "G. L. & Co." in the pottery records, purchased a total of 1,056 of the flattened shape and 3,633 of the round-shaped jug. These were Nos. 60 and 61 in the shape-numbering system, and production of them was continued for several years. They were used for the packaging of toilet water and cologne, the reason why they were purchased in large quantity.

Pitchers, plates, vases, jugs, and tea "jars" or caddies provided the bulk of the new shapes added to Rookwood's production during the first year. Many of these early shapes were incorporated in the line and continued to be made over the years as the demand from the salesrooms dictated.

Chapter 4

The Rockwood Pottery would have had difficult financial sledding had it not been for the initial generosity and continued patronage of Joseph Longworth, Mrs. Nichols' father. He not only supplied the original building and paid for most of the equipment, but he continued to act as Rookwood's financial backer and unofficial treasurer until his death on December 29, 1883. When the pottery ran short of money or the checking account needed bolstering, Mr. Longworth would provide more funds. At least once during 1882 when the bank balance was skirting precariously close to zero, Mr. Longworth deposited $1,000 in the account.

Characteristic of most new business ventures, expenses at the start were considerably greater than income. An early book of check stubs from the account at the Commercial Bank covering the period of eleven months from March 27, 1882, to February 24, 1883, tells the story. Wages were the largest item of expense. By the second year of operation they averaged nearly $200 per week, and as will be shown, the balance in the bank was not always large enough to cover them. No record is available as to the exact number of employees on the payroll during 1882, but the total wages paid during these eleven months was $8,704.14, excluding those of Mr. Cranch and Miss Newton.

Next to wages, the largest item of expense in 1882 was for sales. Charles Wellington Withenbury[1] was engaged as a traveling salesman in June, 1882. His compensation was on the basis

of salary, plus commission, plus expenses, and was, for the time, a rather liberal arrangement. The cost of keeping him on the road for six months totaled $1,265.17.

Fuel for the boiler and kilns was the third largest item, averaging $100 per month. Coal was also supplied to fuel the parlor and kitchen stoves in the premises occupied by young Joseph Bailey and his family, but this was charged to his personal account at the rate of $3.00 per load.

The next item was the salary of Miss Newton, a total of $861 for the eleven months. Her rate of pay was adjusted downward from $27.00 to $20.00 per week as of June 24, 1882, about the time she moved into the Nichols household so that she might work more closely with Mrs. Nichols.

The purchase of chemicals, colors, and glaze materials was the fifth item of expense. Two major sources, J. Marshing & Co. and Feuchtwanger & Co., supplied most of these materials—to the amount of about $500 annually.

Other expenses are of interest. These included a trunk bought for $28.00, which was specially fitted up to transport the Rookwood samples that were shown by Charles Withenbury on his travels; $29.00 paid for harness; and $80.00 for repairs to the boiler made during August when the pottery was closed for vacation. The first telephone at the pottery was installed in the last part of October, 1882; the cost was $100.00 per year, payable quarterly in advance. Two payments were made to the old Hamilton Road Pottery ($149.12 and $190.40,), but no details were given. They may have been for the purchase of clays or for molds.

For convenience, Mrs. Nichols kept both her

[1] Withenbury may have been related to Miss Newton, for she had a stepsister named Annis Withenbury.

personal account and the pottery account at the Commercial Bank. As she signed the checks on both accounts, the bank was sometimes confused and charged her personal checks to the pottery account and vice versa. To complicate matters further, Mrs. Nichols would sometimes pay pottery expenses from her personal account when the balance in the pottery account was insufficient; she would also draw checks on the pottery account with which to pay her personal bills—with the result that the total shown on the pottery's books was frequently incorrect.

To add to the confusion, checks on the pottery account were signed not only by Mrs. Nichols, but also by Miss Newton, Mr. Cranch, and occasionally, in the absence of all three, by Mr. Bailey. Furthermore, no record of deposits made to the pottery account was entered in the checkbook prior to October, 1882. Even after the deposits were recorded and an attempt was made to keep the book balanced, it seldom was. Mistakes in addition and subtraction were written over and corrected until it became almost impossible to decipher the figures.

One result of this laxity in keeping accounts is shown by the following letter from Mr. Bailey to Miss Newton while she was vacationing with Mrs. Nichols in the East:

ROOKWOOD
Saturday July 29 1882

DEAR MISS NEWTON

We are getting along very well but nothing to boast of the dailey attendance is tolarabel Considering the Season. By the way we have had several Hot days. Rarthe a straing circumstance happened to day I got Mr. McVay to look into the bank account — he Reported all Right their would be about 8000 [$80.00] in bank wen I had drawn to day then he told me theire would be more for he had not taken into account some 6000 [$60.00] that we deposited after.

On the Strength of this i Sent andrew to bank they told him their was not enough to pay the check the poor fellow Returned a perfect pictur of despair. I Sent him to Mr. McVay telling he McVay to have book fixed up and what do you supose. Instead of all this wealth their was 2709 [$27.09] in bank we have not got anything from Dume yet so I went home and got the money to pay wages

McVay asked me for 2500 [$25.00] dollars Which I have Paid him

I came to the conclusion to day Considring that we are looked upon as smartish sort of foulks in our way we dont know much about finance and dont seem to be abel to get anybody that doze. however It aint very serious. I did not ship the goods to denver after trying all means and et to get Special Rate I Landed at 800 [$8.00] Dollars per hundred pound Feeling Satisfied that Mrs Nichols would not feel like paying such a price and Run all the risk of not having them Exhibited in good Shape and phrapes have to bring them back I think very likely it would of been well to have given them a few pieces as an advertizment If I dont take in Enough next week will go to Dume but not if I can get along without

I have had Several Interviews with Mr. Withenbury he as sold about Fifteen hundred Dollars worth at nett rates and I believe he as made a good Impression in new york and with proper Judgment on our part will be lasting

Our young men are doing well and improving dailey i believe i think too much of them they are so kind and agrebel and profatabel. Yet it seem a Burlesque to talk about profit wen it as been all going out, but we will hop for the better It must be Better we make fine goods and must have a markett Let me Conclude By Wishing your safe return and the fullness of Enjoyment While you remain I shall Be as you say on the lookout for you about the 7 of the month

Respectfully
JOSEPH BAILEY SR.

P.S. All Join in their Regards to you and Mrs. Nichols

Bailey was certainly sincere and faithful, even if not a facile correspondent. The "our young men" mentioned in the letter were the newcomers in the decorating department. William P. McDonald and Matthew A. Daly came in 1882. N. J. Hirshfeld, Martin Rettig, and Albert Humphreys also joined the department about this time.

The bank deposits recorded in the checkbook beginning October 28, 1882 reveal information about the source of Rookwood income at that time. Rookwood customers who made payments to the pottery included: Tiffany, $52.00; Collamore &

Co., $654.20 and $348.13; Geo. W. Smith & Co., $238.16; Ovington Bros., $228.78; Hertz Bros., $45.88; Bedell & Co., $48.33; Duhme & Co., $202.13; Welch & Bros., $103.00; James, McDuffee & Straton, $360.08; Cincinnati Cooperage Co., $38.00; and James H. Laws & Co., $223.61.

When cash was deposited, it was classified as "Money" or "Bank Notes" for paper money, and as "Silver" or "Gold" for coins, any copper pennies being grouped with the silver. A deposit made November 25, 1882 listed:

Money	$ 92.00
Silver	16.06
Check	2.94
	$111.00

on December 16:

Money	$100.00
French, Potter	
& Wilson	11.00
Gold	8.50
	$119.50

Even though a $1,000 check from Joseph Longworth was deposited on December 23, 1882, by February the balance had dropped to $619.79. Expenses exceeded income at the rate of approximately $500 per quarter for the years 1882 and 1883, or a loss of about $2,000 per year on an estimated gross sales volume of not over $16,000.

In the fall of 1882, in an attempt to increase sales locally, "exhibition rooms such as one finds in the East" were opened nearer the downtown business section of Cincinnati. The parlors of a residence on East 4th Street were rented and fitted up with custom-built showcases to display Rookwood to advantage. Miss Kate Wood was placed in charge. But the location was not the best. It was still outside the main shopping district, and though sales were reported as fair, it was soon apparent that purchasers preferred either to go to the pottery or to buy through an established place of business such as Duhme & Co., Cincinnati jewelers, who handled the sales of Rookwood for nearly fifteen years.

At Christmas, 1882, the employees at Rookwood received a bonus. The checkbook shows that $30.50 in gold was withdrawn along with the regular wages for December 23, for use as "presents" to the workers.

Part II

1883–1889

William Watts Taylor

William W. Taylor, Mrs. Nichols' Manager

William Watts Taylor was born in Opelousas, Louisiana, March 19, 1847. His paternal grandfather was a member of the Provincial Parliament of Quebec; his great-grandfather on his mother's side was Seth Lewis, Chief Justice of the Territorial Supreme Court of Mississippi.

William was still a boy when his family moved north to Cincinnati, where his father established a business under the trade style of Taylor and Brother.

Young Taylor entered Harvard College in 1864 but left because of illness without finishing his freshman year. By the following autumn his health was nearly restored. However, his physician advised so strongly against returning to the harsh New England climate that he abandoned his intention of going back to college and, instead, entered his father's firm of commission merchants as a clerk.

His father's death in June, 1869, caused a reorganization of the firm, and the following January 1 William formed a copartnership with his uncle, S. Lester Taylor, but continued to use the former name of the firm, Taylor and Brother.

He continued in this position until he became manager of the Rookwood Pottery for Mrs. Nichols in 1883.

Chapter 5

Whether the idea of going with Rookwood originated with Mr. Taylor, who had been a long-time friend of Mrs. Nichols,[1] and saw in the pottery an opportunity for development, or with Mrs. Nichols, who felt the need for a strong hand to assist with the management, is not recorded. Perhaps it was Joseph Longworth who suggested the move because he recognized that a capable executive was needed to direct the enterprise.

In any case, Taylor knew nothing about the pottery business when he joined the organization in the spring of 1883, but he did possess three valuable talents: he was an able administrator with an orderly approach to business problems; he had good judgment and a keen public relations sense, which he used with remarkable effect over the next thirty years; and he had considerable artistic and creative ability, which he demonstrated in designing and selecting the shapes Rookwood would produce.

The major problem was immediately evident—there was too much red ink on the books. The new manager set out to find the cause at once, and he learned the practical side of the pottery business as he went along. He examined costs, resources, and production methods; he isolated production problems and analyzed sales.

One of his first recommendations was to discontinue the Rookwood School for Pottery Decoration. Although this was one of Mrs. Nichols' favored projects, he soon convinced her it was a money-losing proposition. The income from fees charged to pupils barely offset the time the Misses Fry and Newton had to take away from their decorating for Rookwood. Moreover, income from the sale of biscuit pieces might very well increase, as former students would continue to buy but without the 25 per cent discount they then enjoyed. Then, too, the expectation that the school would be a training ground for future decorators was fallacious because anyone able to afford the $3.00 weekly tuition was unlikely to go to work for Rookwood for the same amount.[2] There was also the fact that the space occupied by the students could be used more profitably for other purposes. These were convincing reasons, and the Rookwood Pottery School came to an end.

Since the space rented to the Pottery Club produced a modest income, that arrangement was continued. But Taylor apparently formed a dislike for Miss McLaughlin, the club president. Perhaps he sensed that she was a potential rival to Mrs. Nichols in the art pottery world of Cincinnati, and as such, a potential challenge to the prestige he envisioned for Rookwood. Whatever the reason, the friction that developed between the two was to cause trouble at a later date.

[1] James Albert Green, local observer of Cincinnati history during this period, recorded that Miss Maria Longworth had had three suitors for her hand: Bellamy Storer, Jr., William W. Taylor, and Col. George Ward Nichols.

[2] Rookwood decorators were paid about $3.00 to $5.00 per week at the time, the female members of the staff usually receiving the lower figure.

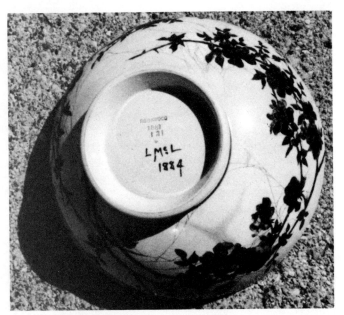

Courtesy T. A. Langstroth
Salad bowl, dated 1883, decorated by Louise Mc-Laughlin in 1884, is an example of Rookwood wares painted by persons not employed at the pottery.

The sale of biscuit pieces for decoration by members of the Pottery Club and by others outside the Rookwood staff was continued, though it was beginning to cause confusion. All pieces were stamped with the Rookwood name and date when they were thrown, cast, or pressed in the potting department. Those finished in the Rookwood decorating department were usually signed or initialed by the artists on the staff, a practice that was encouraged because the signed wares were more popular and sold more readily. But the pieces sold to amateur decorators and members of the Pottery Club were also frequently signed by the person who decorated them, and although marked "ROOKWOOD," these were not entirely Rookwood creations. Unless a buyer knew the Rookwood decorators of the period, he could not be sure that a particular piece was decorated by a member of the pottery staff.

This situation still causes confusion today. Many pieces marked "ROOKWOOD" that were produced between the years 1882 and 1885 were decorated by persons not employed at the pottery. These were signed by members of the Pottery Club (other than Misses Newton and Fry) and by independent decorators of the period such as Mabel

Thrall, L. Johnson, and others. An interesting example of the marks on such a piece is the salad bowl signed by Miss McLaughlin, illustrated here. Today, it is only by knowing the decorators employed at the pottery during this period that one can be certain of a Rookwood-decorated piece.

Taylor was also conscious of the inefficiency of the production layout. "Green" pieces, fresh from the hands of the thrower or from the casting room, required careful handling. Yet they had to be carried to another building or upstairs to be decorated. They could not be moved by handcart or conveyor. And, after they were decorated and this most costly part of the work was completed, they had to be carried back downstairs and packed in saggars (air-tight fire clay containers) for loading in the kilns. The journey might be repeated two, three, or more times if a piece underwent subsequent decoration, glazing, and firing. Breakage of ware in the process was high—too high, Taylor felt—but nothing could be done about it at the moment except to caution the workers again and again.

Although breakage in handling was costly, the loss in firing was even worse. Sometimes as high as 50 per cent of a kiln load was deemed unfit for sale. Since many of these pieces were decorated wares, the loss was heavy. Breakage, kiln cracks, blisters, and crazing were common occurrences; colors were unpredictable, some burning out or fading in the fire without apparent reason. Taylor encouraged Bailey to increase his experiments to learn the causes of these problems and to develop remedies.

The location of the pottery on Eastern Avenue was far from ideal. Too close to the tracks of the Little Miami Railroad, it was both noisy and dirty. Nor had the proximity to the Ohio River proved the advantage Mrs. Nichols thought when she envisioned the economy and convenience of bargeloads of clay being brought to the pottery. Only one load was ever brought in by water, and it arrived when the river was so low that the barge could not reach the dock and the cargo had to be hauled ashore at considerable expense.

The site on the riverbank presented another hazard—flood! The melting snows of the winter of 1882–83 sent the Ohio over its banks, the river cresting at sixty-six feet on February 14. The high

Pottery yard behind schoolhouse on Eastern Avenue was enclosed by high board fence. Tops of kilns can be seen at left center; behind them is one of the new buildings added in 1881.

waters lapped at the base of the kilns and threatened the clay storage sheds in the lower part of the yard.

Taylor next examined sales.

Locally, they were doing well both at the pottery salesroom and through Duhme & Co. Cincinnati was the number one market.

Nationally, sales were also showing progress. Rookwood was selling well through Tiffany, Davis Collamore & Co., and D. B. Bedell & Co., in New York; George W. Smith & Co. in Philadelphia; Welch & Bros. in Baltimore; and other eastern cities. Chicago was proving a good market with Ovington Brothers handling the line, and outlets were being opened in other midwestern cities. Some wares had been shipped as far as Denver and the West Coast.

Withenbury was obviously doing a highly cred-

itable job. But keeping him on the road was costly and ate into the profit margin. Why could he not be replaced by a sales agent who received no salary and paid his traveling expenses out of his commissions from actual sales? If sales were restricted to one outlet per city, would not that store be encouraged to put more effort behind the line, give it better display, and otherwise push Rookwood sales? Taylor asked himself these questions and came up with answers.

The employment of Withenbury was terminated. Davis Collamore & Co. was appointed Rookwood's national sales agent. By 1885, a selective policy of retail distribution—one outlet per city—was put into effect. Tiffany kept the retail franchise in New York City. In Cincinnati, Duhme & Co. was offered the exclusive right to sell Rookwood (except for the pottery salesroom) on the

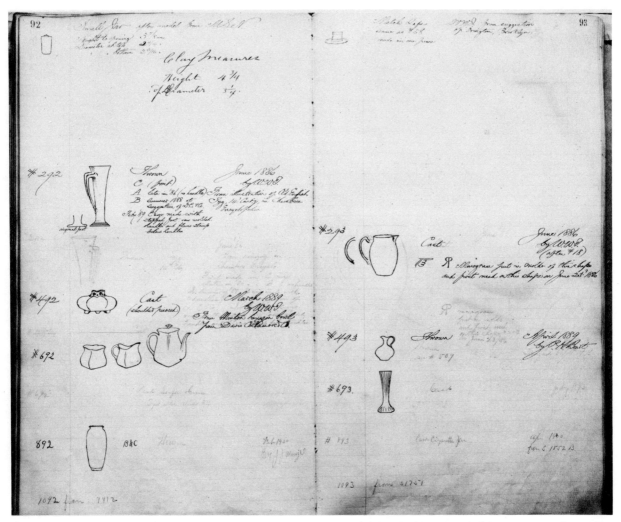

Details of each art pottery shape were recorded in the Shape Record Book during the period from 1883 to about 1900.

condition that they install a permanent display of the ware near the main entrance. From Duhme's point of view, since sales and profits on the line were good, and the merchandise was offered on consignment so that no cash had to be tied up in inventory, it was an attractive proposition and they willingly accepted.

Retail sales at the pottery salesroom were also examined. Some pieces were found to sell almost as rapidly as made, some moved more slowly, and some on display for over two years had not sold at all. To improve this situation, Taylor determined to discontinue pieces that did not sell well or proved difficult to fire successfully, and concentrate on those that could be fired without trouble, and were of shapes and decoration popular with the buying public. To this end, he assigned Miss Newton the task of compiling a detailed record of past sales and listing current ones as they were made.

When the sales analysis was started in September of 1883, there were about two hundred shapes in the Rookwood line with assigned numbers. These were the items intended for decoration as art pottery pieces. Pieces classed as commercial production, such as the printed plates and the hand-painted ship-design tea service, were not given shape or pattern numbers.

Miss Newton procured a large journal, which became the official Shape Record Book kept at the pottery for the next twenty years. Each of the 200 numbered pieces was listed and described on the

correspondingly numbered page of the journal, sometimes together with the sales of each. For example, Mrs. Nichols' "Aladdin Vase," which was assigned No. 1 in the list of shapes, was entered on page 1 along with a record of sales made up to that date. The complete entry, in Miss Newton's handwriting, was as follows:

Aladdin Vase. 1880 M.
Ht. 2½ ft. Greatest diameter 17½ in.
 ″ base 11¾ in.
 ″ top 10¾ in.
October 1882 1 Vase sold D. Collamore, Commission
 1880 sold one vase to Tiffany
 1882 sold one vase to Duhme
 1883 April, salesrooms—Mrs. Hoey
 1883 June, salesrooms
 —Mrs. Powers

One additional sale was added to the record at a later date: April, 1884, 1 vase glazed—D. B. Bedell & Co. $25.00.

Thumbnail-size photographs about an inch square were used to illustrate some of the shapes, but most were shown by a small pen-and-ink sketch. Each shape up to No. 200 was entered on the page of the same number. Some pages were left blank, indicating no shape of that number was then in the Rookwood line; perhaps the missing numbers were discontinued items, or the numbering system had not been consecutive up to that time. These blank pages were filled in later as the numbers not previously used were assigned to new shapes.

Also, occasionally production of a shape was discontinued and the number originally used was reassigned to identify a new shape. No. 141 is an example. A small photograph shows a vase elaborately decorated with a bird perched above its nest against a background of budding fruit branches. The accompanying notation reads: "Single piece. Ht. 22 in., greatest diameter 14½, foot 10. Vase finally sold from old stock for $5.00 April 1884." In red ink a later notation appears: "Number cancelled and transferred as below," followed by a small photo of a new vase shape and description: "Thrown. Designed by W. W. T. February 1885."

Thus, sales of each shape were analyzed. Those that did not sell well or apparently could not be produced successfully were dropped from the line. The numbers originally used for them were usually reassigned to new shapes. (More details of each of the first 200 Rookwood shapes are given in Afterchapter III on the Shape Record Book.)

In most cases, the description of a piece and the list of sales did not occupy more than a few lines at the top of the page. The space below was used to list new shapes as they were created and added to the line. Shape No. 201 was entered on page 1, No. 202 on page 2, and this sequence continued until No. 400 was entered on page 200. The series then started again with No. 401 appearing below No. 201 on page 1. When the pages of the book were filled, the shape record was transferred to a new system combining a card index and photographic record.

The Commercial Club of Cincinnati, of which Mr. Taylor was an active member, was founded in 1880, "for the purpose of promoting commercial prosperity by social intercourse and exchange of views. . . ." The Cincinnati club had early formed a liaison with the Commercial Clubs of Boston, Chicago, and St. Louis. A dinner attended by members of the four clubs was held in Cincinnati on October 13, 1883, and "a memento for each member was a little earthen jug, made at the Rookwood Pottery, from clay obtained near Cincinnati. Similar jugs were sent to those members who were unable to attend."[3] Although an individual member's name was inscribed on each of these pieces, they were probably considered a commercial order as the shape was not assigned a number and entered in the Shape Record Book. A sample with the incised name of Wm. H. Waters is in the Cincinnati Art Museum collection.

In July of 1883, a device similar to a mouth atomizer that was employed for spraying fixative on charcoal drawings was first used by Laura Fry to apply colored slips to the green clay body of a piece she was decorating. She found the evenness of application and delicate shading of color far superior to that possible with a brush. Matt Daly experimented with the device and found it highly effective for blending one color into another. Others tried it and liked it, and the method became widely

[3] *The Week—Illustrated*, Vol. 1, No. 8, October 20, 1883.

used, particularly for applying background colors. Miss Fry also used it for applying colors on biscuit and glazed wares, first heating the pieces to dry the spray more quickly and thus prevent it from "running" on the less porous, less absorbent surfaces.

The year 1883 had been a busy and productive one, but it ended with a sorrowful note. On Decem-ber 29 Joseph Longworth died at the age of seventy. He had been financial mentor and principal supporter of Rookwood during its first three and a half years. It was a sad time for Mrs. Nichols and a depressing one for the pottery employees, who foresaw the end of the business. The rumor that Rookwood would close persisted for some months.

Chapter 6

In 1884, Cincinnati experienced the worst flood in its history. The Ohio rose seventy-one feet, five feet above the crest of the preceding year, and the pottery was almost completely shut off from the city. The only way it could be reached during the worst of the flood was by walking from the Walnut Hills car line down Kemper Lane to the main building, which was on an elevated section of Eastern Avenue and remained above water. The basement of the pottery was inundated as well as the kilns in the yard. Clay stored in sheds in the yard was soaked and muddied, and full production could not be restored for some time. Again, it was brought home to Taylor that the location had disadvantages.

When operations returned to normal, Taylor took over the general supervision of the workers from Miss Newton. Regularly he made the rounds of the pottery talking to the men, chatting with the decorators, inquiring about the work, and creating the awareness of his presence that helped morale and made discipline unnecessary. By eliminating items difficult to fire, he increased the percentage of salable pieces that came from each kiln. But the colors and glazes were still limited.

Mr. Bailey, Sr., carried out more and more experiments in an attempt to get greater compatibility between glazes and body materials. New clay mixtures were tried and glaze formulas were varied and tested, but there was no way of telling in advance what result would come out of the fire. Biscuit pieces and decorated wares without glaze were usually fired at one temperature in the biscuit kiln, and glazing was done in the glost kiln where lower

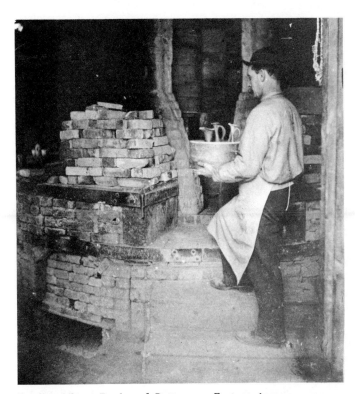

Loading kiln at Rookwood Pottery on Eastern Avenue.

temperatures were used. However, it was not possible to control kiln temperatures as accurately as desired. Firing was a craft operation that depended largely on the skill and personal experience of the operator.

Bailey would look into a kiln and judge its temperature by the "color of the fire." Temperature-indicating Seger cones, later used to measure kiln temperatures within a definite range, had not yet

31

been perfected; and the pyrometer, an instrument for measuring temperatures that would melt most metals and glass, was still several years away from development. Gradually, largely by trial and error, experiment after experiment served to increase the knowledge of the process.

Sales moved upward as Davis Collamore & Co. opened new retail outlets, and demand in cities where Rookwood was already on the market continued to increase. By midyear the company had reached the point where, in some months, income actually exceeded expenses. The situation was encouraging—the business was moving in the right direction.

The responsibilities for purchasing, directing research, handling correspondence, and approving designs for new shapes were undertaken by Taylor. Miss Newton left the pottery in June. Mrs. Nichols, now able to turn her full attention to decorating, was completely absorbed in that work. Albert Valentien was in full charge of the decorating department, and Bailey, Sr., supervised the other workers and conducted the trials and experiments.

Then came an unexpected event destined to have a far-reaching influence on Rookwood's future. Out of one kiln came seven pieces of ware with a result never seen before—streaks of golden crystals glowing deep beneath the glaze, like striations of pure gold embedded deep under the surface! It was a remarkable new effect, unexpected and unexplained, and was named "Tiger Eye."

What had caused this "fortunate accident" in the fire? Every known factor was examined.

Colored glazes, blue, green, yellow, and "fawn" colors, had been used for some time on decorated wares, over differently colored clay bodies. The combination that produced the Tiger Eye effect proved to be the yellow glaze used on red clay. But attempts to reproduce the effect were only partially successful. Some pieces had it; others had it to varying degrees. The results could be neither predicted nor controlled with certainty. Was some unidentified chemical in the clay reacting with one or more of the materials in the glaze?

Perhaps. Rookwood spent years trying to find the key to unlock this secret. A whole series of tests was conducted without producing a definite answer.

When the effect was only partially successful and small golden-like flecks appeared beneath the glaze, the pottery attempted to capitalize on the ware by naming it "Goldstone." But here, too, the effect could not be produced at will, and both the term and attempts to make the ware were discontinued in a few years.

As late as 1891 the secret of Tiger Eye was still eluding the searchers. In one of the technical notebooks kept at that time, under the formula for "Bailey's Green" appeared the following notation in Taylor's handwriting:

> April '91 To make sesquioxide of chromium take
>
> Chromate of Potash 1 lb. 1 oz.
> Sulphur 1 lb.

Calcine in experimental kiln until sulphur fumes disappear. Bailey thinks this used without the Blue & Uranium is what is wanted to tend to Tiger Eye.

So far as is known, the answer was never found. Years later, in 1920, Rookwood attempted to revive the interest in Tiger Eye, but the new wares did not compare with the original.

Rookwood's Tiger Eye of 1884 was probably the first of the crystalline or aventurine glazes produced. Within two or three years after the accidental discovery at Rookwood, crystalline glazes were produced in several potteries in Europe; the effects, though similar, were not identical. After leaving Rookwood, Albert Valentien claimed in 1910 to have developed a formula for producing this effect at will, but it was never revealed.

The accidental development of Tiger Eye impressed Taylor with the fact that more technical knowledge was necessary. The limited effects that had been produced to date were, he felt, only the beginning of the possibilities that existed. He therefore engaged Rookwood's first chemist—Karl Langenbeck, from whom Mrs. Nichols had borrowed the china-painting colors she used in 1873.

Chapter 7

Karl Langenbeck joined Rookwood in December, 1884, or January, 1885. A graduate from the College of Pharmacy in Cincinnati in 1882, he had also attended laboratory courses and lectures on chemistry at the University of Cincinnati. He was employed because of his technical training and because "he knew how to make analyses." When the Baileys left for Illinois, Langenbeck was appointed superintendent. He is credited with becoming the first "ceramic chemist" in America.

We are fortunate that in the comparatively short period Karl Langenbeck was at Rookwood he wrote down at least a part of what he observed, and that his notes have been preserved. Methodical in his habits, he recorded his information carefully.

Starting with the clays, he noted in each case that it was "J. Bailey's description" (to which someone else has added a pencil note: "The Bailey quoted below and elsewhere is J. Bailey, Jr." with the "Jr." underscored three times for emphasis). The sample entry that follows is typical:

Chattanooga Clay

Mr. J. Bailey's description.
Sold by Franklin (Ohio) Pottery Co. for $8.00 a ton at the mine. It is the best clay in the west, but can only be bought in lumps fresh from the mine, unweathered. Ware made from it without the addition of plastic [more pliable] clay would shiver.

Similar information was recorded for eight other clays in use at that time, which were known as Mandel, Cape, Huron, Red, Yellow, National, Diamond, and Golding Clay. Only the Red Clay from Buena Vista, Ohio, and the Yellow Clay from Hanging Rock, Ohio, were native to the state; the others were secured from Tennessee, Missouri, Kentucky, Indiana, Pennsylvania, Delaware, and New Jersey. Usually, no one of these was used alone (Yellow Clay was an exception for a short period), and they were never used in the raw state. Langenbeck also described seven clay bodies or mixtures in use during 1885 and gave the formula for each. For example, he noted:

Cream Colored Body

350	parts	Mandel Clay
300	do	Huron Clay
450	do	Cape Clay
500	do	Flint
250	do	Spar
——		Water

Mix, cut and sift the slip through No. 16 lawn.

Other body mixtures listed include those for Red, Sage Green, White, Yellow, Ginger, and Pink. Most Rookwood bodies relied on the natural color of the clays for their tint, but Sage Green and Pink were artifically tinted with mineral colors.

It was the custom at the time to stamp on the bottom of each piece a letter identifying the color of the body. These were later listed in Rookwood promotion literature as W for white, R for red, Y for yellow, S for sage, and G for ginger. Neither the Cream Colored nor Pink Body was mentioned, so in all likelihood they were in use for only a short time. An Olive Body identified by the letter O is also listed by Barber in his *Marks of American Potters*, published in 1904, but no reference to it has been found in the existing records of the pottery.

The composition of all Rookwood body mix-

33

tures was frequently changed as trials produced improvements. These changes were recorded over the years but are of small interest today except that they illustrate the almost endless experiments the pottery undertook in an effort to improve results.

Langenbeck gave details about the sources and uses of flint, spar, whiting, and white lead—the non-plastic materials used for strengthening the clay mixtures or fluxing the glazes. He also recorded formulas for colored slips—blue, pink, and white—and described the mineral colors and tinted or colored glazes in use at the time. His notebook gives the modern reader an indication of the tremendous amount of detail involved in operating even a small specialty pottery such as Rookwood. Bear in mind that this was 1885—there were no automatic processes and every step was performed by hand. Each detail of measuring, weighing, mixing, sifting, and straining through the lawn was performed by a worker in the potting department. And the preparation of the raw materials was only one part of the entire operation!

At this time also, Rookwood was experimenting in trying to get "color and more color" into its wares. Color was added to the ware at every logical opportunity, and in December, 1885, Mrs. Nichols applied for a patent covering "the chromatic ornamentation of pottery" by the incorporation of color or pigment in the body material or in the glaze in addition to applying color to the surface of the ware itself. On April 12, 1887, she received patent No. 361,231 covering the process.

After Karl Langenbeck left Rookwood at the close of 1885, entries in his notebook were continued by others. One writer, obviously trained in chemistry, is identified only by the initials "W.S.C." with which he signed his notations. They are of interest, however, because in them is found the key to one of the "esoteric marks" listed by Barber in 1904. In one entry, W.S.C. wrote:

Peacock Blue Glazes

KNO_3	808	
Na_2CO_3 cryst	852	Fire in Gold Kiln
BaCO_3	1182	on flat ware.
SiO_2	420	
H_3BO_3	248	
$Na_2B_4O_7$ calcined	4881	

CuO	159
Feldspar	4275
	12725[1]

KNO_3	808	
Na_2CO_3 cryst	852	Fire in Gold Kiln
BaCO_3	1182	on flat ware.
SiO_2	420	
H_3BO_3	248	
$Na_2B_4O_7$	4881	
CuO	159	
Cornish Stone	2138	
	10688	

See & Experiment Book W.S.C.

The "Experiment Book" referred to has not been found and may be presumed lost, but the entry unquestionably refers to details of glaze tests. The and given opposite each formula identify glazes made for trials. It seems logical to assume, therefore, that a piece bearing a number in an incised diamond like those shown is a specimen on which new glaze tests were conducted.

When Karl Langenbeck left Rookwood he was instrumental in forming the Avon Pottery in Cincinnati, which planned to produce a line of art pottery. Taylor worried that the new enterprise would have access through him to Rookwood's trade secrets. His fears were unconfirmed—Avon went out of business within a year and a half. Later, however, Langenbeck went to Zanesville, Ohio, where he is reported to have been identified with both the S. A. Weller and J. B. Owens potteries. In 1895, he wrote *The Chemistry of Pottery*, which became the standard text on the subject. In it, he gave his version of the cause of Tiger Eye, at a time when the Rookwood staff was still seeking the cause themselves.[2] Langenbeck remained a prominent figure in the ceramic industry and served as president of the American Ceramic Society in 1900 and 1901.

[1] The total was incorrectly recorded; it should have been 12825. Apparently W.S.C. was not good at addition for he made a similar mistake in the next column but corrected his error by writing over the figures in ink.

[2] Langenbeck, Karl, *The Chemistry of Pottery*, Easton, Pa.: Chemical Publishing Co., 1895.

Chapter 8

By the beginning of 1885, the period that was characterized by the earliest type of Rookwood came to an end. During this time the variety of subjects painted was limited by the small selection of available colors. Many pieces were simply carved or modeled in high relief. Smear glazes were often used, mainly for carved or stamped designs, and gilding was so frequently employed that it was one of the marked characteristics of the period.

The early styles executed by Mrs. Nichols under the influence of her admiration for Japanese art were discontinued. The curious and fanciful designs drawn by Mr. Cranch, which were purely the product of his imagination, appeared less frequently. The early work of Laura Fry in designs carved and incised on gray clay and filled with blue color was discontinued; so also were the stamped designs executed by Fanny Auckland.

Colored glazes were used with greater frequency and better effect. The atomizing method of color application was widely employed, and decorative designs were based more on floral subjects. The underglaze ware, earlier called "Limoges," became the Standard Rookwood as the pottery developed a more distinctive style.

In the period from 1885 to 1889, many developments took place at the pottery. Listed chronologically, the more important were:

1885

A number of the female decorators complained that the mouth atomizers were "disagreeable to use," and as they were also thought to be a cause of throat irritations among the staff, Taylor had a piping system installed to supply steam pressure for mechanical atomizers. But the water content of the steam diluted the slips, making them difficult to control, so a transfer to "air pumps" was made and the system became a true airbrush operation.

Members of the Pottery Club were still doing their work at Rookwood, and the pottery continued to sell them and other amateurs biscuit pieces that carried the Rookwood name. Taylor disliked the confusion this caused, and also regarded the presence of "outsiders" in the pottery as a nuisance. When he found a tub of white slip "spotted with blue color, probably from the ladies' biscuit decoration," he decided the time had come to terminate both arrangements. The Pottery Club was asked to vacate their quarters, and the sale of undecorated biscuit pieces bearing the Rookwood name was stopped.

Taylor gathered a number of early examples of Rookwood production for "deposit" at the Cincinnati Art Museum. He wanted to be sure the ware was well represented in this art center of the city.

About the same time, he asked William McDonald to make a list of the members of the decorating staff who had already left the employ of the pottery. McDonald's list named Mary A. Taylor, N. J. Hirschfeld, Hattie Horton, Albert Humphreys, Martin Rettig, Harriet Wenderoth, Fanny Auckland, Albert Brennan, and W. H. Breuer.

On September 15, 1885, Col. George Ward Nichols, Mrs. Nichols' husband, died at the age of forty-eight. Again the rumor was circulated that the pottery would close, and again it proved false. But

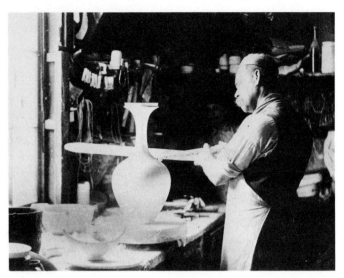

Potter smooths a cast vase on the whirler after its removal from the mold.

following her husband's death, Mrs. Nichols came to the pottery with less frequency.

During the year forty new shapes were designed, and the list in the Shape Record Book reached No. 278.

At the close of the year, the pottery showed black ink on the books for almost the entire twelve months' period.

1886

Joseph Bailey, Sr., returned from Chicago and resumed his former post as superintendent. He had charge of directing the clay mixing and prepared the glazes himself. He was always reluctant to reveal anything that he considered a trade secret, even to employees of the pottery. It is reported that when the decorators, naturally curious as to what went into the colors and glazes they used, repeatedly asked about them, he would reply in his booming voice and British accent, "Y'ere not supposed to know!" As little information as possible was given out, even to trusted employees—a policy continued into the 1950's. Ruben Earl Menzel, who came to Rookwood as a boy in 1896 and for many years was the master potter before his retirement in 1959, answered many of my questions, "We were never told. Such information was considered secret."

Laura Fry left in June as a regular employee but continued on a free-lance basis for the next

year or two. Caroline Steinle came to work at Rookwood. She was a sister of Andrew Steinle, the general utility boy, and daughter of Caroline Godell Steinle, the French tutor and governess in the Nichols' household.

A young boy named Charlie Williams is reported to have visited Rookwood each Saturday about this time. His purpose was to sell "insurance" to members of the pottery. As he was not in school that day and it was the day after payday, his visits were well timed. He had an older relative who sold Masonic Insurance to members of that order at ten cents a week, and though he himself kept the ten cents a week feature, he did not restrict his sales to any single group. Fifty years later, Charles F. Williams, president of the Western and Southern Life Insurance Company, Cincinnati, was elected a director of the Rookwood Pottery.

On her thirty-seventh birthday, March 10, 1886, approximately six months after the death of her first husband, Mrs. Nichols married Bellamy Storer, one of her girlhood suitors. He was a Cincinnati lawyer and active in local Republican politics. The couple left promptly for a protracted honeymoon in Europe. But Mrs. Storer did not forget Rookwood. She sent Mr. Taylor a drawing of a suggested water carrier, a large pitcher-shaped jug with attached hinged brass handle, and this was duly produced by the pottery and entered in the Shape Record Book as No. 318 in October, 1886.

Eighty new shapes were added to the line that

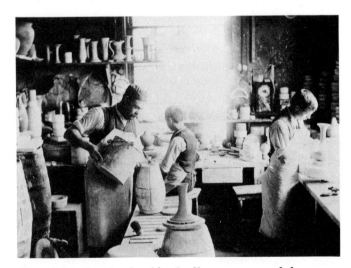

The casting shop in the old schoolhouse was crowded.

year. In his desire to keep putting something new before the public, Taylor created a number of new designs himself and encouraged everyone in contact with the pottery to submit suggestions. Pitts Harrison Burt, a prominent Cincinnati stockbroker and personal friend of Taylor's, started making regular visits to Rookwood to give expression to his creative talents. He designed many "artistic and fanciful" shapes during the next decade, and was second only to Taylor in the total number of new shapes he added to the Rookwood line.

Sources that suggested other shapes are also interesting. A modified amphora vase was inspired by an illustration in an article on pottery in the *Encyclopaedia Britannica*. Laura Fry submitted a drawing of a vase from the Metropolitan Museum of Art in New York. Perhaps adopted in the hope of attracting favorable publicity, another vase was "thrown after his design, and under his eye for A. W. Drake (of Century Co.) June 1886."

It was about this time that Taylor made the acquaintance of Edwin Atlee Barber at the Pennsylvania Museum and School of Industrial Art in Philadelphia. As Dr. Barber was probably the country's leading authority on pottery and porcelain, Taylor overlooked no opportunity to encourage his interest in Rookwood, and presented him with several early specimens for the Pennsylvania Museum's collection of American pottery.

When the year drew to a close, the financial picture had improved to the point where operations for all the twelve months were recorded in black ink. Sales had grown steadily and special orders had begun to come in unsolicited.

1887

Although Mrs. Storer returned to Rookwood after her trip to Europe, she devoted less time to her decorating interests. She was now occupied with other matters, and as the pottery was progressing satisfactorily, her visits became less frequent as the year went on.

Kataro Shirayamadani, a Japanese, joined the staff, the first of the decorators who was not American-born. Albert Valentien and decorator Annie Bookprinter were married on June 1; theirs was the first of the many romances at the pottery that were to end in marriage.

Taylor continued his cultivation of Dr. Barber, and was pleased to learn the Pennsylvania Museum had acquired additional pieces of Rookwood by purchase from its Temple Fund.

That fall the pottery won the first of many honors in international competition: a "Special Mention" at the Twelfth Annual Exhibition of Paintings on China held in London.

Fifty-one new shapes were recorded in the Shape Record Book, from No. 328 to No. 378. Taylor and Burt were responsible for most of them, but a number were suggested by other sources. Davis Collamore, close to the firing line of sales across the country, suggested five. Others included a cylindrical mug "with handle shaped like a door-handle," suggested by a salesman for Gorham Manufacturing Company; and three pocket flasks in styles strongly reminiscent of the later Prohibition era, first made as samples for W. B. Durgin of Concord, N.H., and later turned into stock.

1888

Taylor wrote Laura Fry suggesting that she take out a patent on her method of decorating vases by the use of the atomizer or airbrush. He pointed out that patents had already been issued to Messrs. Abner Peeler and Liberty Walkup for devices called airbrushes and described as "machines employed in the distribution of pigments in the art of painting." If she could obtain a patent covering the application of colored slip to pottery, "it would be useful to the pottery to hold such a patent as an obstacle to dishonorable competition by former employees, from which the pottery has already suffered." He promised that Rookwood would pay all expenses in connection with procuring the patent.

Miss Fry, out of friendship for Mrs. Storer, expressed willingness to have the process patented if she might continue to use it, as she was no longer officially employed at Rookwood. However, when she was subsequently asked to sign the patent application and a paper assigning her interest to the pottery for a nominal consideration, she declined to do so, and proceeded to apply for the patent in her own name through lawyers in New York.

Further correspondence ensued, discussing what

might be a fair consideration for the assignment to Rookwood of an interest, to give it the right to exclude competitors from using the process. But the parties were unable to reach an agreement. Nothing was said at the time about Miss Fry's wanting payment or a license arrangement for the use of the process. Five years later, after she had obtained her patent, she sued Rookwood and Taylor for infringement.

In November, Rookwood won two First Prizes at the Pottery & Porcelain Exhibition held at Memorial Hall in Philadelphia, sponsored by the Pennsylvania Museum and School of Industrial Art. Taylor's cultivation of E. A. Barber had not been in vain.

Of eighty-two new shapes introduced during the year, Messrs. Taylor, Burt, and Auckland, the thrower, did approximately sixty. Others were taken from various sources such as "modeled after a Devonshire pitcher brought over by Mrs. Storer," or "from a Danish ware imitation of a small copper piece from Hildesheim Treasure."

Mr. Morris or Mr. Galbreath of Duhme & Co. came to the pottery regularly each month to select the wares to sell at the store in Cincinnati.

By the end of the year Rookwood showed a substantial profit. Although exact figures are not available, it was probably almost enough to reimburse Mrs. Storer for all the losses sustained during Rookwood's first five years in business.

Photo by Judit Kárász
Iparmuveszeti Muzeum, Budapest

Two vases in the Museum of Decorative Arts, Budapest. The one at the left, broken during World War II, has been repaired; the one at the right is Tiger Eye.

1889

Winning the Gold Medal at the Exposition Universelle in Paris was the big event of 1889, overshadowing the First Prize Gold Medal received the same year at the Exhibition of American Art Industry in Philadelphia. At the Paris Exposition, Rookwood did not have its own exhibit; a section of the exhibit space taken by Davis Collamore & Co., Rookwood's national sales agent, was devoted to a display of Rookwood.

At first the judges were hesitant about giving the award to Rookwood, believing that the wares shown were an accidental rarity in the kiln and could not be duplicated. Collamore cabled to Cincinnati for additional samples, and when these arrived the judges were satisfied and awarded the first prize to Rookwood.

This award and the world-wide publicity Rookwood received as a result are often cited as a turning point in the operation of the pottery. Mrs. Storer's statement that "from that time the demand has more than equalled the supply" has been widely quoted. At a later date, she also wrote:

The question of financial success, although looked down upon from artistic heights, has to be considered gravely when one desires to establish a solid foundation for a permanent industry. It is also more philanthropic in the end to give sure and steady employment to people of talent and skill than to indulge only in spasmodic and intermittent fits of generosity. One of the pathetic things in the pursuit of beauty in art is, that it is so hard to get a living by it. . . . The Rookwood Pottery has been a fortunate exception.

Workers photographed about 1890. Left to right, front row: *Grace Young, Harriet Wilcox, Sallie Toohey, Carrie Steinle, Louella Perkins, Emma Foertmeyer, Mary Shanahan (in charge of the salesroom), and Amelia Sprague;* back row: *Matt Daly, Albert Valentien, Anna Valentien, and Artus Van Briggle.*

This statement and other widely publicized statements, such as: "The Pottery is managed on lines opposite to the prevailing factory system, as the effort is to attain a higher art, rather than a cheaper process," created an impression not entirely correct.

Probably no enterprise received more gratuitous advertising or publicity over these years than did Rookwood because it was started by a woman in days when there were few women entrepreneurs. But, as Albert R. Valentien said after he had been at Rookwood for twenty-four years, "Writers do not always tell the absolute facts in their articles, generally using such material as is handed out to them from different sources, whether reliable or not, and again, for strictly advertising purposes, in which case much is left unsaid. I assure you that much has been written and said from time to time in different magazine and newspaper articles that has been absolutely absurd in reference to Rookwood, and which has been treated as huge jokes by the employees of that institution."

Valentien was referring to Rookwood's publicity, which stressed that the pottery was primarily interested in developing a higher art. It is quite true that it was interested in art, but *not* to the exclusion of profits! The management at Rookwood believed that the two were not mutually exclusive, but that more profitable operation would be a logical sequel to the creation of better art pottery.

In this year, during which the first electric trolleys were introduced to replace the horsecars and cable cars in Cincinnati, sixty-seven new Rookwood items were recorded in the Shape Record Book.

One unusual piece was a candy box made in the shape of a melon, which was actually cast from a large Persian melon at the suggestion of Mrs. Storer.

It is not generally realized that very few Rookwood shapes were designed by the decorators during the first twenty years. In addition to those created by Taylor and Pitts Harrison Burt, Messrs. Auckland and Yelland (the throwers) designed many, for they were practical potters and sensed intuitively what would survive the heat of the kilns. Bailey designed a few and John Menzel, who was named master potter a few years later, contributed several. Many shapes were suggested by outside sources, but very few originated in the decorating department; the artists were kept too busy decorating to find time to add new shapes to the line.

Mrs. Storer spent progressively less time at Rookwood; her interests focused elsewhere: the idea of living in Washington appealed to her and she encouraged her husband in his plan to run for Congress. She also kept up her interest in music.

With increasing demand and improved profits, her ambition to establish a "permanent art industry" seemed assured of fulfillment. Therefore she "turned her interest" over to Mr. Taylor, and withdrew. Details of the transaction are not known. Whether he bought her out, or whether she gave him her interest in the pottery, is not clear. He referred to himself as her "partner," but she designated him as her "manager." In any case, she transferred the ownership of the Rookwood Pottery to William W. Taylor, reserving only the right to have a studio there for her own use.

Part III

1890–1913

**William W. Taylor, President
The Rookwood Pottery Company**

STATE OF OHIO

These Articles of Incorporation of The Rookwood Pottery Company, Witnesseth, that we the undersigned, all of whom are citizens of the State of Ohio, desiring to form a Corporation, for profit, under the general corporation laws of said State, do here certify:

First: the name of said corporation shall be The Rookwood Pottery Company.

Second: Said corporation is to be located in Hamilton County, Ohio, and its principal business therein conducted.

Third: Said corporation is formed for the purpose of the manufacture of clay, pottery, or porcelain ware glazed and unglazed, glazes and articles of a kindred nature.

Fourth: The capital stock of said corporation shall be Sixty Thousand Dollars ($60,000.00), divided into Six Hundred (600) Shares of One Hundred Dollars ($100.00) each.

In Witness Whereof, we have hereunto set our hands, this twenty-fifth Day of April, A.D. 1890.

Bellamy Storer	Herman Goepper
Thomas T. Gaff	Pitts H. Burt
L. G. Weir	Albert G. Clark
Harley T. Procter	W. W. Taylor

* * *

United States of America
State of Ohio, Office of
the Secretary of State

I, Daniel J. Ryan, Secretary of State of the State of Ohio, do hereby Certify that the foregoing is a copy carefully compared by me with the original now in my legal custody as Secretary of State, and found to be true and correct, of the Articles of Incorporation of The Rookwood Pottery Company, filed in this office on the 3rd day of May, A.D. 1890 and recorded in Volume 51, page 129, of the Records of Incorporation.

In Testimony Whereof I have hereunto subscribed my name and affixed my official seal, at Columbus, the 3rd day of May, A.D. 1890.

(s) Daniel J. Ryan
Secretary of State

(SEAL)

Chapter 9

This document officially recorded the formation of The Rookwood Pottery Company, successor to the Rookwood Pottery of Maria Longworth Storer.

In addition to the eight incorporators, there were five other stockholders: Mrs. Susan Longworth was owner of ten shares and was represented by Bellamy Storer under power of attorney; the others were Lucien Wulsin, William Worthington, John L. Stettinius, and C. B. Matthews, all prominent businessmen interested in the arts in Cincinnati, and friends of Taylor's.

Of 600 shares authorized, 490 were issued. Taylor held effective control with 380 shares; Messrs. Matthews and Goepper 5 shares each; the remaining stockholders 10 each.

At the organization meeting on May 31, 1890, a board of directors was elected and, being duly sworn in, proceeded to the election of officers. W. W. Taylor was named president and treasurer; Bellamy Storer, vice-president; and Albert Clark, secretary. A comittee of three was then appointed to draft a set of bylaws. On motion, it was voted that the directors "should purchase for $40,000 the real estate, personal property, goodwill, patents, trade-marks, and all the property, real and personal, of every kind and description of the Rookwood Pottery, now the sole property of William W. Taylor."

In the meantime, business at the pottery went on briskly. Production of ware continued six days a week. Bailey pursued his experiments in clay mixtures and glaze formulas. At least three or four new decorators were added to the art staff, and five new men were hired in the potting department. Albert Cyrus Munson started work in the casting room, where he served faithfully for the next fifty years. Theodore C. Van Houten was employed as bookkeeper and office manager. The plant facilities at 207 Eastern Avenue, inefficient and already overcrowded, became even more so.

Taylor had long thought of a day when new facilities might be procured. Now, with business growing and the new company off to a sound financial start, the time seemed propitious. Ever since 1884 when the Ohio River overflowed its banks, he had visualized a new location on higher ground. Of several sites considered, the top of Mt. Adams, directly overlooking the downtown business district of the city, offered many advantages. It was high ground, and would be convenient for shipping because it was a downhill run for the horses to any of the more than a dozen railroad freight offices in

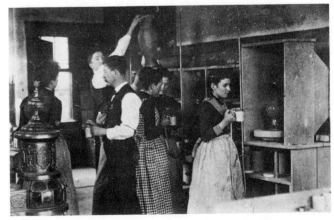

Decorators at work at the Eastern Avenue location, about 1890. Girl at the right is Harriet E. Wilcox.

the city. There was also the incline railway, already established as a tourist attraction, which would bring still more visitors to the pottery. If Rookwood aspired to artistic heights, this location would also put it close to the Art Academy and the Art Museum.

At the directors' meeting on November 22, 1890, Mr. Weir was designated "to secure, for the purposes of a new plant, the property owned by the Mt. Adams and Eden Park Inclined Railway Company on Mt. Adams—being part of that to the north of the 'incline'—at a price not to exceed $7500 and to make all arrangements necessary to complete the purchase or lease."

During 1890 sixty-six new shapes were added to the line. A prize for ingenuity must go to John Menzel in the casting department for his suggestion to combine pieces "part *thrown* and part *cast*." The first of these was made as T501, a trial piece. Found successful, it was assigned No. 553 and put in the regular line.

It was standard practice at this time to make a pencil sketch of each proposed design. These sketches were identified by the letter "S". When a sketch was approved for production, a sample or trial piece of the new design was made, which was marked with the letter "T" and a number for identification. If the trial piece proved successful on firing, it was then assigned a regular shape number and entered in the shape record. If a trial piece developed kiln cracks or warped in firing, it was changed or modified and tested again. Usually the fault could be corrected, but each new shape had to pass the test of the fire before it was approved for regular production. At this time it was still impossible to predict with accuracy what might happen in the kiln.

Another interesting item is No. 564, a tall, tankard-shaped pitcher from a Haviland Gres tankard, "first made without shape number in fall '89." Alongside the entry is the notation in pencil, "Number erroneously given to cuspidore, afterwards made as No. 570," indicating that 564 was put on a "cuspidore" by mistake. To minimize errors in numbering the shapes, the pottery instituted a fine of 25 cents for any worker responsible for a mistake, a discipline kept in effect until the 1930's.

Total sales for the year ending January 31, 1891, were 10,121 pieces having a gross value of $48,680, "both up slightly from the previous year." Net profit is not given, but the amount must have been satisfactory for the company declared its first dividend of 2½ per cent on February 7, payable on March 1.

Weir completed negotiations to purchase the land on Mt. Adams, and Messrs. Procter, Gaff, and Clark were appointed a committee to supervise the building and grounds at the new location. Taylor drew plans for a new structure that would include all the necessary pottery facilities. H. Neill Wilson, architect, of Pittsfield, Massachusetts, formerly of Cincinnati, was engaged to refine the plans, make drawings, and supervise construction.

By early 1891, work was under way. Materials were selected for inclusion in a copper box to be placed in a cornerstone. So far as is known, the cornerstone lies undisturbed, its contents unlisted, awaiting removal at some future date.

Three of the latest-type kilns were installed. They were designed to burn oil and "vaporated the fuel by air pressure." It was anticipated that the use of the new fuel would make the fire more certain than the coal used at Eastern Avenue.

Space in the basement was provided for clay storage and for its preparation by specially designed machinery. The throwing and casting room was made large enough to meet present and future requirements. Completing the basement layout were the engine and boiler room and the "damp room," where green shapes were held at the correct degree of moisture while awaiting decoration.

On the ground floor were the salesrooms, served by the main entrance. Next to them was the "dry room," where decorated wares were kept several days before being packed in saggars in preparation for the fire. A chemical laboratory, primitive by modern standards, was equipped for Mr. Bailey's experiments. It adjoined his office, also on that floor.

The second floor housed the president's office, a "showroom" where key buyers and prospects were entertained, and the office where Mr. Van Houten kept the accounts and prepared the payroll. The remainder of the second floor was assigned to the decorating department, except for the space occupied by the kilns, which extended from the base-

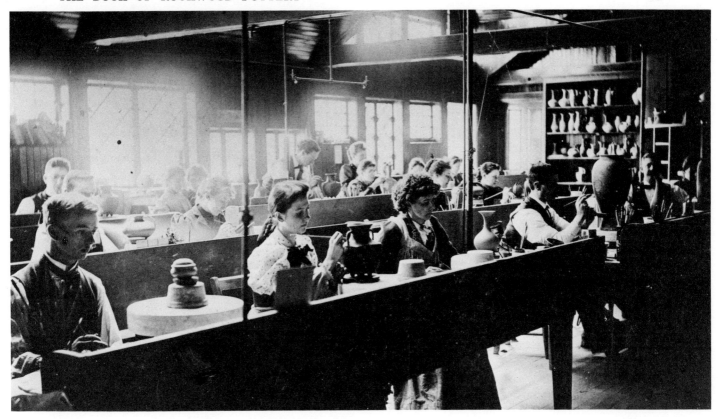

Decorating department at the pottery on Mt. Adams in 1892.

ment through the roof. All the "seniors" or long-time artists—the Valentiens, McDonald, Daly, Grace Young, Shirayamadani, Artus Van Briggle, Amelia Sprague, and Sallie Toohey—were provided with individual studios. The newer members of the department shared a large decorating room.

From the first, visitors flocked to see the new pottery. A regular conducted tour was arranged to acquaint them with the operations and indoctrinate them with the quality and perfection of Rookwood. The first room shown on the tour was the clay room, where the clays were mechanically mixed and then wedged by hand to eliminate all trace of air bubbles that might cause trouble in the kiln. From the clay room, visitors were next taken to watch the thrower magically shape a lump of clay on the wheel, or the turner smoothing and finishing a piece freshly taken from the mold. Then came the damp room with the green shapes, and finally the decorating department, where the artists were seen at work.

Sometimes the slip decorations were flatly painted, sometimes in low relief. Only about five

colors were then in use, but the effect of shading was obtained by the concentration of color in the slip. After the ware was decorated and thoroughly dried, it was ready to be fired in the kiln. Most pieces were sealed in saggars to protect them from the smoke, soot, and flame while they baked for twenty-eight hours at temperatures of about 2200°. Cooled gradually for three days after the first firing, the ware was removed as "biscuit" ready for more decoration or for glazing. Then followed a second firing in the glost or glazed-ware kiln at 1700° to set the glaze. Sometimes a second glaze and third firing were required. Most visitors were impressed when it was explained that a single piece of Rookwood might pass through the hands of as many as twenty-one people before it reached perfection as a finished piece.

Natural floral underglaze motifs proved most popular in the salesrooms and were encouraged by the management. A flower garden in the yard not only added to the attractiveness of the setting, but also provided an ever-changing supply of specimens for the decorating department. The garden was

tended with loving care for many years by Frances A. Taylor, Mr. Taylor's mother. It was one of the first examples of industrial landscaping.

A few sculptured pieces, introduced about this time by Anna Valentien, did not fare too well in the impartial verdict of the salesroom, and additional pieces of this type were not encouraged. For the next decade, floral decoration remained the most characteristic Rookwood style.

Only twenty-five new shapes were designed during 1891. Preoccupied with building and getting production organized at the new location, Taylor found time to design but twelve. Characteristic of his work that year was the adaptation of new shapes from parts of old ones. One example was a vase with the body from No. 383, mouth from No. 588, and handles modified from No. 350.

During 1891, 11,268 pieces were sold and the gross income to the pottery climbed to $52,365. However, because of the expense of the new building, no dividend was paid for the fiscal year ending January 31, 1892.

The year 1892 had opened with fifteen decorators employed at the pottery, but by December the staff had increased to twenty-four. Mr. Cranch died in December, 1892, in his eighty-third year, mourned by all who knew him.

Production figures for 1892 were not recorded, but sales climbed to $64,630, more than 20 per cent above the preceding year.

Of forty-eight new shapes added during the year, nineteen were by P. H. Burt, fourteen by W. W. Taylor, three by A. G. Clark, secretary of the company, and three made from samples of other wares submitted by Harley T. Procter, one of Rookwood's directors.

In September, 1892, another style of Rookwood first appeared—wares embellished with silver overlay. The overlays were added by the Gorham Manufacturing Company, wares being sent to Providence, Rhode Island, for the purpose. The silversmiths at Gorham probably applied the overlay to their own designs. Between September, 1892, and July, 1893, Gorham embellished 918 pieces and reshipped them directly to Rookwood accounts.

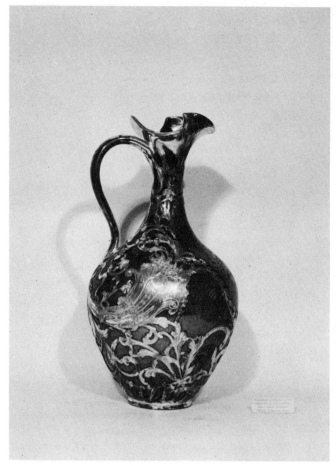

Kunstgewerbemuseum, Berlin

Ewer with chrysanthemum decoration underglaze by Kataro Shirayamadani and silver overlay applied by Gorham Mfg. Co.

Davis Collamore & Co., Duhme & Co., Cincinnati, Richard Briggs & Co., Boston, and other Rookwood agents received quantities of silver overlay pieces, including vases, bowls, and tea, coffee, and chocolate cups and saucers. The name Gorham Mfg. Co. and the order number were engraved in small letters on the overlay; some later pieces also carried the designation "999/1000 FINE." How long Gorham continued this work has not been established, but a silver-mounted Rookwood pitcher is pictured in a Gorham catalog for autumn, 1894.

Chapter 10

The big event of 1893 was the World's Columbian Exposition, more popularly known as the Chicago World's Fair. Authorized by Act of Congress to commemorate the discovery of America, it was officially dedicated on Columbus Day, 1892, but did not open to the public until May 1, 1893. Its impact on Rookwood's history was far-reaching.

The products of the pottery on Mt. Adams were displayed in at least five exhibits at the fair. First, having been selected as an outstanding example of American art pottery, Rookwood was honored with an invitation to exhibit its ware in the Palace of Fine Arts. Second, Rookwood "art pottery and faience" were shown in the collective exhibit of the United States Potters' Association in the Ceramics and Mosaics section of the Manufacturers and Liberal Arts Building. Third was Rookwood's own display, also in the Manufacturers and Liberal Arts Building, but in the Jewelry section, along with exhibitors of silver, gold, jewelry, and ornaments.

The fourth place where examples of Rookwood were shown at the Fair was the exhibit of the Gorham Manufacturing Company, which displayed pieces embellished with silver overlay. And, finally, Rookwood could be seen in the Cincinnati Room in the Women's Building, an exhibition of arts and crafts executed by the ladies of Cincinnati. Examples of Rookwood decorated by Mrs. Storer were displayed, as were pieces done by members of the Pottery Club. The original Pottery Club had been disbanded in 1890, but it was re-formed and officially renamed the Cincinnati Pottery Club, to prepare an exhibit for the fair, its membership being increased from thirteen to twenty.

A description of the club's activities that appeared in a catalog describing the exhibits in the Cincinnati Room contained the following statement:

> Miss McLaughlin, the President of the Club, is the discoverer of the method of decorating under the glaze that is still used as the foundation principle of the work at the Rookwood Pottery. The same method was used at the other Art Potteries of Cincinnati during their existence.

As soon as Mr. Taylor saw this, he objected to it and suggested it be deleted and the catalog reprinted.

Miss McLaughlin, when she heard of his reaction, sought to learn his reasons. He advised her that although he was himself unfamiliar with the early history of the underglaze development in Cincinnati before the advent of Rookwood, he was acting as he was sure Mrs. Storer would wish, and that Rookwood was indebted only to Mrs. Storer for its methods of underglaze decoration—the application of colored slips on unfired clays.

Annoyed at what she felt was a denial of her just due, Miss McLaughlin wrote to Mrs. Storer:

WALNUT HILLS, July 9th 1893

MY DEAR MRS. STORER

In the Catalogue of the Cincinnati Room at the World's Fair, a statement was made to the effect that the method of underglaze decoration introduced by me in 1877, was the foundation principle of the Rookwood and other art potteries of Cincinnati.

While in Chicago a week or so ago I saw this catalogue for the first time and also learned that an objection had been made to the statement by Mr. Taylor. I wrote him in regard to the matter and he has answered that in making the objection he was carrying out what he knew to be your wish and that you were unwilling to admit that the Rookwood was indebted to me for the method.

As to the catalogue, I did not know what was to appear in it before its publication. The statement as made, however, seemed to me absolutely true and having been made, I could see no reason for its withdrawal. The advisability of making the statement is one thing but the question of its truth is another, and I could not believe that you should so soon have forgotten the early history of the affair. I would like to take this opportunity of telling you as I have told Mr. Taylor, that I depreciate the popular misunderstanding which associates me with Rookwood, and have taken every opportunity to deny ever having any connection with it. I do not wish to usurp any of the credit due you for founding and carrying on the work until it resulted in both an artistic and a financial success. I do claim, however, that it is indebted to me for the original idea and that my process is the foundation principle of that now in use there.

When the workmen whose experience had originally been gained from my experiments, were taken from the Dallas Pottery, and when finally the Rookwood pottery declined to do outside work, I had no feeling of resentment. That was a matter of business in which sentiment could not be expected to hold a place. I turned my attention to other matters, not very much dissatisfied that the temptation to dabble in pottery had been removed.

I feel, however, that any true history of the introduction of this pottery into Cincinnati must give me credit for having furnished the idea upon which the industry has been founded. Believing, as I do, that common justice should grant me that, I must since the question has come up, inform you of my feeling in regard to the matter.

I am—Very Truly Yours,

M. Louise McLaughlin

In answer, Mrs. Storer took a position in support of Mr. Taylor. Indicating that she did not remember the facts too well, or that she did not choose to, she wrote:

WASHINGTON
Sep. 3rd, 1893

My Dear Miss McLaughlin

Your letter of July 9th has just been sent to me, with others which were kept during my absence in Europe.

I am surprised at what you say about the Rookwood Pottery. I did not suppose that you misunderstood the matter—and since you ask me, I must set you right. I have always admired your work as a decorator—but the method of decorating wet clay with slip was familiar to me in Ceramic Books, in Galle's work at Nancy, in pieces done at Limoges and imported by Briggs of Boston as early as 1874 and in the Philadelphia Exposition of '76. Wheatley took out a "patent" for the process in Cincinnati and he enjoined me when I first started my pottery. I laughed at the idea that the method was anything new or original and heard nothing further from him.

As to my having taken workmen whose experience had been gained from your experiments—(which you say in your letter), this assertion is an entire surprise to me. I always supposed that your work was done at Coultry's yellow ware Pottery. I can hardly suppose as a practical potter, that you could have fired your colors in Dallas's white granite ware heat. I myself found it impossible, and hence came my desire to have kilns of my own. All of my work in delicate colors was done at Rookwood—not at Dallas.

I have really never *known* how or where your work was done, and I must plead guilty to not having read your book on underglaze decoration. Your reputation can rest so well upon what you yourself have done that it is not necessary that you or anyone else, for you, should seek it in outside things with which you have had absolutely no connection.

Most Sincerely Yours

Maria Longworth Storer

With that, Mrs. Storer seems to have dismissed the matter. In raising the objection originally, Taylor had undoubtedly been motivated by his interest in suppressing anything that he felt might detract from Rookwood's prestige.

Impressed by the interest created by the Fair, the grandeur of the buildings, the beauty of the landscaping and the sculpture, Taylor decided that it would be good artistic education and good employee relations to have all Rookwood employees visit the Fair. Though such a tour represented a considerable expense, he was convinced it would pay off handsomely in increased enthusiasm, fresh ideas, and higher standards.

The crowning honor at the Fair was the presentation of "Highest Award" to Rookwood. Actually, only one class of awards was made—symbolized by a bronze medal and parchment certificate. So the claim of "Highest Award," as Rookwood thereafter listed it in promotion literature, was artfully expressed—true, but misleading.

This added recognition accelerated the purchase of Rookwood by European museums. In commenting on the pieces acquired by the Industrial Art Museum in Berlin, Professor Julius Lessing, a well-known German lecturer of the time, said:

> In American art pottery the collection of acquisitions contains some precious pieces, pitchers and vases from the Rookwood Pottery in Cincinnati; a wonderful effect is produced in them by the harmonious arrangements of color in refined graduations of tone; from beneath the glaze appear charming decorations in leafwork, and often also flowers and animals naturalistically handled.

The reference to "refined graduations of tone" recalls another incident of 1893, which was to rankle for some time to come. Laura Fry brought suit in Federal Court against the pottery and Mr. Taylor as codefendants, charging infringement of her patent on the atomizing method of pottery decoration. In filing their defense, Rookwood's attorneys first claimed that they were not infringing and did not require a license, since the patent covered a method that had been developed at the Rookwood Pottery. Later, however, the defense was changed to contest the validity of the patent itself. Even in 1893 the Federal Court calendar was overcrowded, and the case was to drag on for nearly six years.

Another set of events occurred during 1893 that illustrated Taylor's alertness in looking after Rookwood public relations. His friend, Dr. Barber, published *Pottery and Porcelain in the United States,* and became recognized as the country's leading authority on the subject. When Taylor learned that Dr. Barber also planned to issue a catalog of the pottery in the Pennsylvania Museum collection, he saw an opportunity to have Rookwood dominate the list of American pottery. He sent a number of additional examples of early Rookwood to the museum, and when the catalog was issued, twenty-eight pieces were described.[1]

Taylor had met a student at the Art Academy who particularly impressed him, and he persuaded the young man to try decorating at Rookwood. Thus, John D. Wareham started his career at the pottery, where he remained for over sixty years.

The fiscal year closed with sales up to $73,475.96. Production during the period totaled 14,259 pieces valued at $70,635.

[1] Unfortunately, this early collection of Rookwood has been dispersed. It was sold at public auction by order of the trustees of the Philadelphia Museum of Art, successor to the Pennsylvania Museum, on various dates from 1941 to 1954.

Chapter 11

While good progress was being made in other directions, technical problems continued to handicap production. Crazing, cracking, spotting, staining, surface roughness, and color fading caused trouble in kiln after kiln. Many pieces were damaged beyond hope of sale and had to be destroyed; others with minor imperfections were downgraded to second quality and offered, in the pottery salesroom only, at reduced prices. This continuing loss cut heavily into profits.

Foreign potteries did not appear to have these difficulties, certainly not to the extent they were encountered at Rookwood. European wares, at least those exported to the United States, showed little evidence of crazing, and the colors produced in Japanese pottery were well beyond the range available to Rookwood.

Believing that the solution lay in more adequate technical knowledge, Taylor explored every channel he thought might provide an answer.

Stanley Gano Burt, the son of Pitts Harrison Burt, following his graduation from Yale where he had concentrated on chemistry, joined Rookwood in July, 1892. He was placed under the wing of Bailey to learn the practical side of pottery production. The superintendent accepted young Burt with a tolerant attitude, but remained skeptical of the value of his schoolbook knowledge. On one occasion when Bailey was grinding a frit in an open mill to which he had added borax, the longer he ground and the more the water evaporated, the larger the crystals grew. In disgust he remarked to Burt, "The longer you grind, the worser it gets. Now I suppose *you chemists* know all about that."

In 1894, no specialized courses in ceramic chemistry were available in the United States, so Stanley Burt was given a two-year leave to study at the Königliche Hochschule in Berlin. He would also have the opportunity to visit and observe European potteries.

At the same time, Artus Van Briggle was sent to Europe for further study and was "maintained at $605.10 in Paris" for the next year. In July, Albert Valentien was also "paid for over three months in Europe in the Pottery's Artistic Interests, and $200 contributed in addition to salary for the period."

A fourth member of the staff to travel abroad was Kataro Shirayamadani. In the fall of 1893 he was sent back to Japan to visit potteries in his homeland and find out if their techniques would be helpful in solving any of Rookwood's problems. His birthplace was Kanazawa, the home of Japanese Kutani ware. When he left Cincinnati he took with him "several exquisite examples of Rookwood as gifts to his Emperor."

Whether "Shirayami," as Taylor called him, discovered information of value is not recorded. However, on his return early in 1894, he was accompanied by a Japanese friend named E. H. Asano, a worker in metals who wanted to find employment in America. Aware of the popularity of the silver overlay pieces embellished at the Gorham factory, Taylor thought the pottery might undertake this work. He recommended that "experiment might be tried in mounting the ware in metals for lamps, jugs, etc.," but as this was virtually a new department, he asked the advice of the board, and was authorized to proceed with the work.

While technical answers were sought abroad,

research also went on at home. Taylor looked to outside consultants for advice. One was Dr. W. S. Christopher, chairman of the Section on Children's Diseases at the American Medical Association in Chicago, whose counsel was sought on problems of controlling reactions in the kilns. That certain of these experiments were productive is shown by an excerpt from a report to the stockholders for the year 1894:

> During the last three months, new styles of ware have been developed known as "Iris," "Sea Green," and the "Aerial Blue." The commercial success of some of these seems quite certain from the reports of dealers and they add freshness to the standard production and wide opportunities to the decorators. In the improvement noted, praise is due especially to Mr. Bailey, the Superintendent, and to Mr. McDonald, who had charge of the decoration room since June,[1] though others might also be mentioned.

These new styles were in marked contrast to the dark warm colors that had come to be recognized as standard Rookwood. "Iris" was characterized by bright decorations on backgrounds of light warm grays frequently blending into rich deep blue tones. "Sea Green," as the name implied, had background colors ranging from warm greens to cooler bluish-green shades, reminiscent of the changing colors of the sea, usually with decorations in lighter colors. "Aerial Blue" is described as "a delicate mono-chromatic ware with a quiet decoration in celestial blue on a cool, grayish white ground." All three were finished in a high glaze.

Although the introduction of any new style or technique tended to slow down production, Taylor found that the number of pieces produced in 1894 had actually increased to 14,751, up from 14,259

the year before, but the total value had declined to $61,285, down from $70,635 for the prior year.

He sought the reason for this decline in value through a series of cost analyses, classifying production by the size of the pieces, and estimating the approximate cost of each piece. Records were kept of each decorator's productivity, and an attempt was made to evaluate the contribution of each decorator based on his output, not only in *quantity* but in *quality*—as measured on an empirical basis.

Until 1894, the *size* of a piece had been the primary factor in determining its price: the larger the piece, the higher the price. But the analysis showed that actual cost depended more on who did the decoration. The pay of the decorators varied widely. A "junior," as Taylor called a newcomer, received a starting wage of $3.00 per week, whereas a decorator of ten years' experience might get as much as $150 per month.

Taylor recommended that the basis of pricing be changed, with *cost of decoration* becoming the major consideration, the work of the more highly paid decorators being set at higher prices. Valentien, McDonald, and Daly were the highest paid members of the staff, and their work thereafter commanded top prices.

Taylor outlined the proposed change in pricing and presented his cost studies to the stockholders with these comments:

> The decline in value arises mainly from the smaller size of pieces produced to accord with the times, and from the slow work involved in the experimental stage of new styles of ware. Further than this, there has been the strong pressure brought upon the decorators during the last six months for quality rather than quantity. The commercial and artistic success of the company is involved in the steady lifting of the quality of the wares. . . .

During 1894, sixty-three new shapes were introduced.

[1] William P. McDonald was placed in charge of the decorating department when Albert Valentien left for his European trip.

Chapter 12

The five years between 1895 and 1900 saw many changes at Rookwood.

1895

On March 27, the firm received an unexpected jolt when the Commerical Bank failed. Pottery funds in the amount of $11,010.31 were on deposit when the bank closed its doors. Although it was expected that sixty cents on the dollar would be recovered, the loss could have been a major one.

As if in anticipation of questions about the pottery's financial well-being, Taylor presented these figures at the next board of directors' meeting:

Net worth on organization, February 1, 1890	$42,789.72
Net worth as of February 1, 1895	86,781.57
Showing an increase of	$43,991.85

Rookwood still owned the old factory buildings on Eastern Avenue, which were rented to C. Crane & Co. When the tenant made an offer to buy the property for $4,500, "the president was authorized to sell same at $5,000," and the deal was consummated by the end of the year.

As if to guard against other unexpected losses, insurance coverage on the pottery was also examined. That for the Mt. Adams location was listed as follows:

Mt. Adams Ins^CE	
Bldg.	$18000.
Kilns	1400.
Machinery	4000.
Boiler & Engine	1300.
Heater & Pipes	1000.
Oil Service	600.
Office & Lib'y	1200.
Stk. in process	7500.
	35000.
Boiler Explosion	10000.
Employer Liability	10000.

Van Briggle stayed in Europe for the entire year of 1895, the pottery paying an additional $605.59 toward his expenses. Matt Daly was also sent to Europe for three months. His salary was continued during his trip and $227.44 was contributed to his travel expense.

In the metal work department experiments were continued by Asano. As difficulties were encountered in working the harder metals satisfactorily, it was decided to import hard metal castings from Japan and to make only soft metal fittings at the pottery. The cost of running this department was difficult to isolate, but it was estimated to have operated at a $300 loss for the year. However, it was felt that the department would improve its contribution in time and that the experiment was worth continuing.

In November was printed a new edition of 20,000 copies of the pamphlet describing Rookwood. This was the second or third pamphlet to be issued, briefly outlining the history, describing the ware, and listing the decorators and the marks used. Although the pottery was meticulous in dating every piece of Rookwood produced, it was equally careful *not* to date any of the art pottery sales literature, the single exception being "The Rookwood Book," a thirty-six-page booklet issued

to promote mail-order sales and dated by the notice "Copyright 1904."

But the smaller pamphlets were never dated because it was customary to print them in quantity and use them as long as the supply lasted. A copy was given to each visitor, and for a number of years a pamphlet was packed with every piece of Rookwood that left the plant. Every few years a new edition was printed. The list of decorators was updated by adding the names of new artists and deleting the names of some who had left during the interval, but the names of better-known decorators continued to be listed after they had left the employ of the pottery.

As the text and list of awards were also brought up to date in each new edition, it is possible to arrange the various editions of the pamphlets in chronological sequence so that they provide a guide to the periods when certain decorators were employed at Rookwood. Although the names of a few decorators who were employed for only a short period between the printing of one edition and of the next were never listed, these pamphlets are the best available source of information as to when a decorator worked at the pottery.

On November 27, the pottery arranged for a lecture by William Hamilton Gibson on the subject of "The Fertilization of Flowers by Insects." This was held in the amphitheatre of the Art Museum, and the "works were closed that afternoon, free tickets being given to stockholders and employees. The lecture was appreciated and was no doubt beneficial to the decorators especially." Mr. Gibson received $67.00 for his services.

During the year only 10,975 pieces passed through the decorating department, but the value increased to $66,904. Thus, though 3,776 fewer pieces were produced, the value was $5,619 greater than the preceding year, a result attributed to the new method of pricing and an average larger size.

Payments received from the account at the defunct Commercial Bank amounted to 60 per cent by the end of the year, and further payments were expected. With a surplus of cash available, and a net profit of $10,597 for the fiscal year ending January 31, 1896, a cash dividend of 8 per cent was declared.

As Christmas approached each year, instead of a bonus, the decorators were allowed time and given the material with which to make Christmas gifts. Some beautiful items were created: dishes, cups and saucers, tea and chocolate sets from the regular line were favorites; but new and unusual things were invented too: cuff links fashioned to look like cameos, toys, and miniatures, for instance. Carrie Steinle designed a doll-size table decorated on the top with a chessboard, and made a full set of miniature chessmen to match. Grace Young and Albert Valentien modeled miniature vases, pitchers, and doll dishes. Mary Nourse painted exquisite dishes of delicate proportions. Each holiday season was a gay and happy time, enjoyed by all.

1896

During the year eight students from the Cincinnati Art Academy completed their training and joined the Rookwood decorating department. In addition to their learning the pottery's techniques by observing the work of the more experienced artists, Taylor felt these juniors needed more formal instruction. He therefore made arrangements with O. W. Beck of the Art Academy teaching staff to visit the pottery once a week during the school year (for a fee of $300) to offer criticism and help the decorators in their work. Taylor considered Beck's service especially valuable because it gave the pottery some connection with the Academy where "pupils showing peculiar aptness and desiring to enter the pottery might have their studies directed intelligently to that end."

However, this arrangement seemed to work two ways. The following year, Arthur Goetting finished his studies in June and was steered to Rookwood. But before the end of the summer, Professor Beck offered young Goetting a scholarship for further study if he wanted to return to the Academy that fall. So Goetting left the decorating staff after a stay of only three months.

Artus Van Briggle returned to the pottery in June after nearly two and a half years in Paris. Recognized as one of the most talented of the Rookwood artists, he also had a good working knowledge of ceramics gained not only at Rookwood but also at the Avon Pottery and through his studies abroad. One of his first efforts on rejoining the decorating department in Cincinnati was to initiate experiments toward the development of a

mat or dull glaze similar to finishes he had seen in Europe.

Stanley Burt completed his study in Berlin and returned to Cincinnati, bringing to the United States the first Seger cones.[1] He assumed more responsibilities, taking over a major part of the work load from Bailey, whose health was beginning to fail. In turn, Bailey was given a vacation trip to Europe in appreciation of his long and faithful service.

The metal work department was continued, but limited to making pewter mounts for jugs and pitchers and to fitting lamps and vases with the

[1] A series of clay cones named for the inventor. They were prepared to melt at specific temperatures and used to measure the degree of heat in the kiln before the invention of the pyrometer.

bronze mounts imported from Japan. The results were judged not commercially profitable, and unless the situation changed, it was planned to discontinue the department.

Pleased with the lecture by Mr. Gibson the previous year, the pottery arranged for another. Professor E. F. Fenollossa, described as "the greatest living authority on Japanese art," spoke at Levassor Hall in Cincinnati. The lecture was held mainly for the benefit of the decorators, but the public was admitted for a small fee and the affair was considered quite successful.

Wages of the decorating department amounted to $19,794.10 for the year, an *average* of $55.00 per month per decorator. Although not overpaid, the decorators thoroughly enjoyed their work; morale was extremely high, and a spirit of camar-

Early Rookwood lamps, with and without metal mountings.

aderie prevailed, which added a psychic dividend to their take-home pay.

Separate folders were issued to advertise the three new styles of Iris, Sea Green, and Aerial Blue.

The land adjoining the Mt. Adams property to the north was purchased to meet future expansion needs.

Severe losses were incurred during the year from "slip-peeling" on the ware, "estimated to be $2500 of the net at least." This, together with lower sales, reduced the net profit to about $2200, but a dividend of 8 per cent was declared for fiscal 1896. Production for the year was 11,637 pieces valued at $71,817.

1897

Duhme & Co., leading retail jewelry firm, which had handled Rookwood in Cincinnati since 1881, went into bankruptcy in March, owing the pottery over $1500. There was considerable interest as to who would replace them and secure the Rookwood franchise. The Rookwood agency was highly desirable, and Taylor undertook negotiations with the several firms bidding for the business. He narrowed the choice to Frank C. Herschede, a well-established jewelry firm, and Loring Andrews & Co., a leading department store. He told his associates that he was inclined to favor Andrews but preferred to leave the decision to the board. After the board had considered the possibilities, they named Messrs. Taylor and Clark a committee to make the "arrangements with Loring Andrews & Co., on condition that in addition to a window, the store would agree to display an additional stock in a case on the ground floor." The terms were accepted and Loring Andrews was appointed.

The pottery was fortunate in having Stanley Burt to take over the responsibilities of Bailey, whose ill health forced his continued absence. Young Burt, who had improved on reading "the color of the fire" by the use of Seger cones, now introduced the new pyrometer that had been developed in Europe, and was able to obtain even more accurate temperature control. These advances, plus a modification in the clay body, led Taylor to the cautious prediction that "there seems a prospect of ultimately producing a non-crazing ware but the

Loading kiln with the wares sealed in saggars, which are numbered according to size.

problem presents many difficulties and is likely to take some time."

In the decorating department, special efforts were made under the direction of William McDonald to raise the standard of quality among the juniors, so that decorators with more experience could spend a larger part of their time in developing new styles of decoration. Portraits, landscape scenes, heads and figures of animals, and copies of

Group about 1897 shows John D. Wareham seated at the extreme left. Standing (left to right) are: T. C. Van Houten, office manager; Albert Valentien, Sallie Coyne, Amelia Sprague, Stanley Burt, and O. Geneva Reed Pinney; seated are Sallie Toohey, Anna Valentien, and Margaret Coyne, who worked in the office and was Sallie's sister.

old masters were among the styles introduced about this time. They proved popular and became so widely used during the next decade that they may be considered characteristic of the period, along with the floral designs that continued to predominate. It was even contemplated that individual portraits might be executed in colored slips on clay, much as a person would sit for his or her portrait in oils on canvas.[2] Other new styles followed the trend toward *art nouveau*, but they were not popular either with Taylor or in the salesroom.

Another joint meeting of the Commercial Club with its contemporaries in Chicago, Boston, and St.

Louis was held in Cincinnati, for which occasion Clement Barnhorn, a rising young sculptor, designed a special vase. Four figures on its standard were symbolic of the four cities. Copies were reproduced by the Rookwood Pottery and presented to each club. One is still in possession of the Commercial Club of Cincinnati.

A further cost study was made, revealing that 11,238 pieces with a value of $83,734.25 required a total of 8,303.95 man-days to pass through the decorating department. This indicated that, *on average*, a decorator completed one and one-third pieces per day with a value of $7.42 per piece. That figure included all costs: decoration, labor, materials, overhead, and margin for profit.

The metal work department failed to prove commercially successful and was discontinued during the year. But Mrs. Storer, who still kept her

[2] The only known examples of this work are the portraits of four former presidents of the Lafayette South Side Bank, St. Louis, Missouri, made some years later.

Platter, 17¾ inches long, painted underglaze; marked "Rookwood" and "M.L.N." on back in gold paint over the glaze. Undated, it may have been from first kiln.

Scalloped dish marked "ROOKWOOD 1882" has black spiders and gold trim underglaze, by Hattie Horton. Orange-brown two-handled vase is marked S-599, denoting a special shape; it has a mouse design by Albert Valentien, and is signed ARV/D. The dark green covered jar with butterfly handles was decorated by Mrs. Storer in 1888.

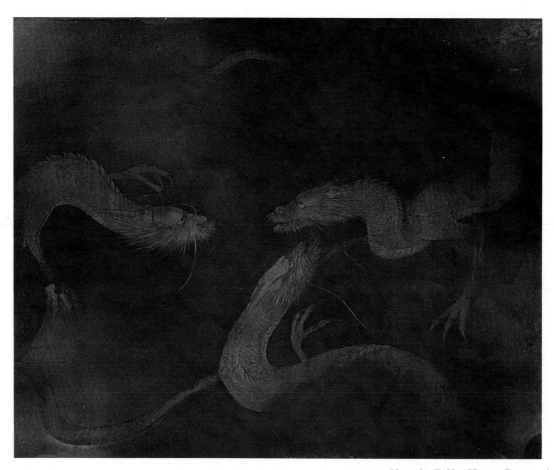

This large plaque, nearly three feet wide, decorates the wall above the fireplace in the studio occupied by John D. Wareham at the Rookwood building on Mt. Adams. It is unquestionably the work of Kataro Shirayamadani.

Photo by Teigen
Kunstindustrimuseet, Oslo

Acquired by the Museum of Industrial Arts, Christiania (now Oslo), Norway, at the Paris International Exposition, 1900. Dated 1899, it is signed on the decorated surface by Albert Valentien.

Photo by Hans-Joachim Heyden
Museum für Kunst und Gewerbe, Hamburg

Iris-type vase decorated in 1899 by Amelia B. Sprague. Acquired by the Museum of Art and Industry, Hamburg, Germany, at the Paris International Exposition, 1900.

Chrysanthemums were flatly painted under glaze by Albert Valentien in 1899. The vase was sold for $150 when it was acquired by the Museum of Art and Industry, Hamburg, at the Paris International Exposition in 1900.

CLOTILDA ZANETTA

WILHELMINE REHM

K. SHIRAYAMADANI

LORETTA HOLTKAMP

ELIZABETH BARRETT

KAY LEY

E. T. HURLEY

JENS JENSEN

HELEN M°DONALD

Photo by F. Van Houten Raymond

The work of the decorators during the 1945 period shows the trend toward the use of brighter colors, lighter backgrounds.

Photo by Hans-Joachim Heyden
Museum für Kunst und Gewerbe, Hamburg

Chrysanthemums were flatly painted under glaze by Albert Valentien in 1899. The vase was sold for $150 when it was acquired by the Museum of Art and Industry, Hamburg, at the Paris International Exposition in 1900.

CLOTILDA ZANETTA

K. SHIRAYAMADANI

WILHELMINE REHM

LORETTA HOLTKAMP

ELIZABETH BARRETT

KAY LEY

E. T. HURLEY

JENS JENSEN

HELEN MCDONALD

Photo by F. Van Houten Raymond

The work of the decorators during the 1945 period shows the trend toward the use of brighter colors, lighter backgrounds.

An assortment of Rookwood pieces made after World War II.

Photo by F. Van Houten Raymond

Photo by F. Van Houten Raymond

The pieces shown are typical of the period immediately following World War II.

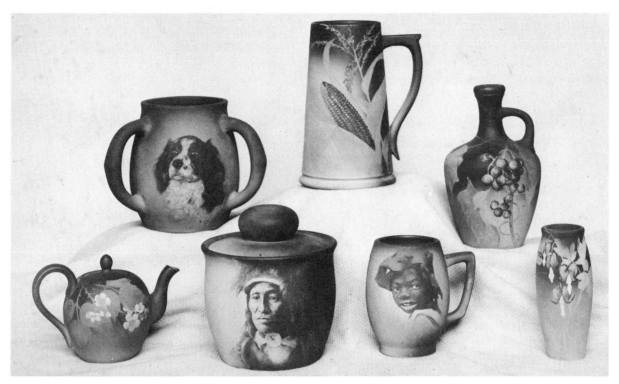

For a few years portraits vied with flowers in popularity with the artists, but they did not sell as well.

studio at the pottery for occasional use and admired Asano's work, engaged him to teach her the craft. When her husband was appointed Minister to Belgium by President McKinley later that year, Asano accompanied her to Brussels, where she continued to pursue her interest in working with metals.

By the end of the year, President Taylor was considering Rookwood's next expansion. He advised the stockholders, "Whenever times permit, I am anxious to extend the warerooms and to add a number of private studios for the advanced decorators. I am positive that these will give positive returns beyond their cost."

An additional payment of 25 per cent was received on the Commercial Bank default, leaving 15 per cent still due.

Net profit for the twelve months ending January 31, 1898 was reported "about $6,100," and a dividend of 5 per cent was declared.

1898

At the start of the year, Taylor took a long-

The Metropolitan Museum of Art
Gift of Wells M. Sawyer, 1945
American Indian portrait decoration by William P. McDonald in 1898.

delayed vacation for an extended trip to Mexico from which he did not plan to return until mid-March. William McDonald was given a seventeen-week leave of absence with pay, plus $200, for a trip to Europe. John Wareham was given $250 for the same purpose, but his salary was not paid during his absence.

Joseph Bailey died on July 15. The following, recorded in the minutes of the company, is written in Taylor's hand:

> He was a man of sterling character, loyal and faithful. Almost entirely self trained, he possessed an intimate knowledge of the practical details of potting, while his strong self-confidence and unusual dignity gave him considerable command over men. It was he, who, through his son, Jos. Jr., and then himself, settled the practical potters side of Rookwood in its earliest years. He was one of the pioneer potters of the west and the service he did for Rookwood was eminently that of the pioneer and one which should never be forgotten. I make this brief record of him with strong feelings and gratitude.

The patent infringement suit instituted in 1893 by Laura Fry was finally brought to trial in October before Judge William Howard Taft of the Circuit Court of the Southern District of Ohio. Judge Taft's decision was "very strongly" in favor of the defendants. He ruled that the Fry patent was invalid on the grounds that it did not cover a basically new method but merely the adaptation of an old one to a new material. Miss Fry then served notice of appeal. She was also suing the S. A. Weller Company in Zanesville for infringement, and that case could collapse if she accepted this decision. However, Rookwood's attorneys were of the opinion that final steps in her appeal would not be taken and that Judge Taft's decision would ultimately be accepted.

Experiments were continued in the development of the mat glaze finish suggested by Artus Van Briggle two years earlier. Two early mat glaze pieces dated 1898 are now in the collection of the Hermitage Museum in Leningrad, which has seven pieces of Rookwood, in all. The two are examples of the attempt to portray a landscape in this type of finish.

Profit for the fiscal year was $11,079.82. A dividend of 5 per cent was declared, and 20 per cent of the cost of the Mt. Adams building and machinery was written off as depreciation. No federal regulations limited bookkeeping adjustments in those days.

1899

The need for more space at the pottery was discussed early in the year. The directors authorized Taylor to have plans prepared and to secure estimates for an extension to the present building that would afford additional showroom facilities, more studio space, and additional office and storage rooms. Within a month, he had had plans prepared by the Cincinnati architectural firm of Elzner & Anderson, and obtained construction estimates of approximately $8,400.

On March 29, ground was broken, and on Monday, May 8, the official laying of the cornerstone was held. A copper box "containing three biscuit tiles, copies of the larger and smaller illustrated descriptive pamphlets (containing historical and other matter) and of the pamphlet containing the article about Rookwood by Rose G. Kingsley (reprinted by the pottery from the London, England, *Art Journal* by their consent), together with a list of those present on the occasion," was placed in the foundation. So far as is known, this cornerstone remains undisturbed to this day.

An early carbro print of the biscuit tiles put in the Corporate Minute Book yields an accurate record of the personnel then employed at Rookwood. The copy on the tiles reads as follows:

℞ ROOKWOOD POTTERY CO.
CINCINNATI, OHIO
Organized under the laws of Ohio, May 1890, and first conducting business at crossing of Eastern Avenue and Little Miami Railroad. Original Building . . . N.W. of this extension . . . occupied February 1892 . . . cornerstone of same being in N.E. angle of N.W. Tower. This extension began March 29, 1899 and this cornerstone laid May 8, 1899.
Architects, Elzner & Anderson

OFFICERS SINCE DATE OF
ORGANIZATION
William Watts Taylor President and Treasurer
Bellamy Storer Vice-President
Albert Gardner Clark Secretary

DIRECTORS FOR 1899
Pitts Harrison Burt John Longworth Stettinius
Levi Gandee Weir William Worthington

OTHER STOCKHOLDERS
Thomas Truman Gaff Herman Goepper
Susan Walker Longworth Isabelle Thompson
Harley Thomas Procter Lucien Wulsin
Frances Anne Taylor

ROOKWOOD POTTERY CO.
CINCINNATI, OHIO, MAY , 1899

EMPLOYEES AND DATE OF EMPLOYMENT
Stanley Gano Burt,
 Superintendent and Chemist 1892

— CLAY DEPARTMENT —
John Jacob Menzel,
 Foreman and Modeler 1884

Ralph Hammersley, Casting Room	1881
William Henry Menzel, Casting Room	1891
Albert Cyrus Munson, Casting Room	1890
Edward Ira Risling, Casting Room	1892
Ruben Earl Menzel, Casting Room	1896
Charles John Mahar, Thrower	1890
Arthur Dovey, Turner	1890

— KILN DEPARTMENT —
George Kirchenberger
 Head Kilnman and Dipper 1883
William Auberger, Kilnman 1892
George Joseph Muchlamann, Kilnman 1892
Willoughby Colby Morgan, Kilnman 1891
Catherine Cook,
 Biscuit Ware Room Assistant 1894
Sara Elizabeth Cook,
 Biscuit Ware Room Assistant 1894

— POWER AND HEATING DEPT. —
Albert Preyer, Engineer 1882
Albert Van Ness, Assistant to Engineer 1890

— OFFICE AND SALES DEPT. —
Theodore Condell Van Houten, Chief 1890
Margaret Coyne, Stenographer 1893
William Alonzo Deek, Bookkeeper 1898
Mary Shanahan, Saleswoman 1896
Emily Marie Cook, Wareroom Assistant 1893

State Hermitage Museum, Leningrad

Experimental mat glaze landscape by Sallie Toohey. Base shows experimental marking X413X.

Michael Joseph Toohey,
 Packer and Driver 1897
Newton Bartholomew, Nightwatchman 1892

 ROOKWOOD POTTERY CO.
CINCINNATI, OHIO, MAY ,1899

— DECORATORS —

Albert Robert Valentien	1881
William Purcell McDonald (in charge)	1882
Matthew Andrew Daly	1882
Anna Marie Valentien	1884
Grace Young	1886
Harriet Elizabeth Wilcox	1886
Kataro Shirayamadani	1887
Amelia Browne Sprague	1887
Artus Van Briggle	1887
Sara Alice Toohey	1887
Harriette Rosemary Strafer	1890
Olga Geneva Reed (Pinney)	1890
Mary Madeline Nourse	1891
Caroline Frances Steinle	1886
Constance Amelia Baker	1892
Josephine Ella Zettel	1892
Elizabeth Neave Lingenfelter	1892
Sadie Markland	1892
Sara Elizabeth Coyne	1891
John Hamilton Dee Wareham	1893
Leonore Asbury	1894
Katharine Leslie Hickman	1895
Frederick Sturgis Laurence	1895
Frederick Daniel Henry Rothenbusch	1896
Edward George Diers	1896
Edward Timothy Hurley	1896
Rose Fechheimer	1896
Adeliza Drake Sehon	1896
Edith Regina Felten	1896
Sara Sax	1896
Charles Schmidt	1896
Mattie Foglesong	1897
Clara Christiana Lindeman	1898
Elizabeth Weldon Brain	1898
Leona Van Briggle	1899
Barbara Agnes Cook, Assistant	1892

A logical assumption is that the names of the decorators are given in the order each joined the department. The name of Caroline Steinle, who came to Rookwood in 1886, appears between 1891 and 1892. The assumption is that she was made a decorator *after* Mary Nourse and *before* Constance Baker joined the decorating staff. The eight decorators who came in 1896 probably came in the order

given. Barbara Agnes Cook, listed as assistant to the decorators, was not related to Catherine, Sara, and Emily Cook, who were sisters. A gap was left after the word May in two of the tiles, apparently for the day of the month, but this was never inserted.

On May 13, the cost estimates on the new building were revised upward to $10,232. Taylor noted that what had been the back of the old building was now to become the "front yard" of the new and that a "shed erected in 1897 over the small kilns and adjoining the old kiln room was too much in evidence as an unsightly object." He proposed that a new kiln shed be built, "and by doing much of the work ourselves" estimated its cost could be held to $350. However, by the end of the year, he reported to the board that the total cost of the new buildings, equipment, and alterations in the old building would be $15,700, nearly twice the original estimate.

During the construction that summer, some changes had to be made in the decorating room to connect it with the new addition. Therefore, for the first time since 1885, the pottery was closed for two weeks. It was necessary to shut down completely because so many of the decorators had taken time off that the decorating work was already behind; if only that department were closed, the schedule of the other departments would be thrown further out of gear.

Up to this time there had been no set vacation period and, of course, no paid vacations. An employee not at work for any reason received no pay. It was thought that closing for two weeks might force vacations into a single period, and this step marked the beginning of the annual vacation period, which was regularly set thereafter for the first two weeks in August.

At that time, the working day started at 6:30 A.M. for the pottery force and at 8:00 A.M. for the decorators and the office staff. It ended at 5:00 P.M. for all personnel except the watchman and the night crew when the kilns were being fired. A half hour was allowed at noon for rest and food, and a 5- or 10-minute rest period was given about 9:00 A.M. and again at 3:00 P.M. Saturday was a half day, 6:30 A.M. to 1:15 P.M. This remained the routine until the eight-hour-day law went into effect.

Several changes occurred in the decorating

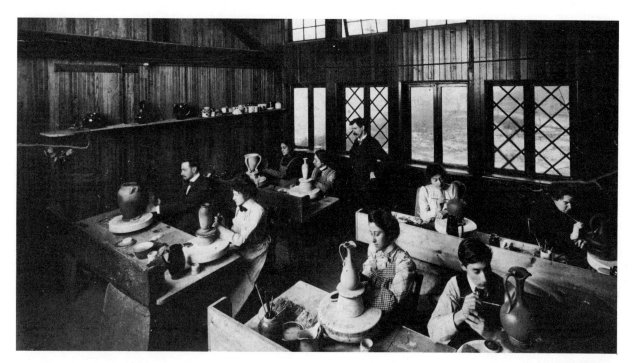

Artists in decorating room at Mt. Adams are (left to right, front row): *Sturgis Laurence, Laura Lindeman, Virginia Demarest, and Howard Altman;* (rear row) *Rose Fechheimer, Sara Sax, William McDonald, Clara Lindeman, and O. Geneva Reed Pinney. Picture was posed for use at the Paris Exposition in 1900.*

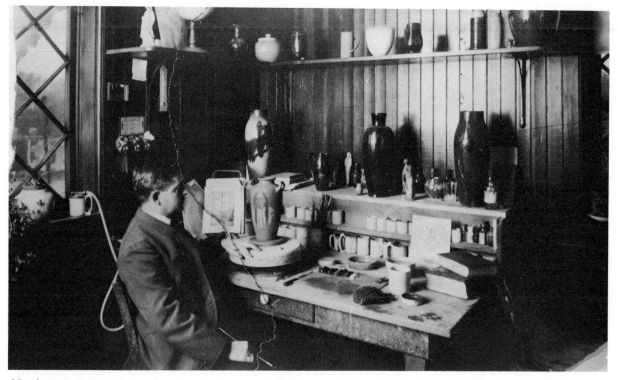

Matthew A. Daly in his studio. One of the series taken by Lawrence Studios, Chicago, for use at the Paris Exposition.

department. Artus Van Briggle, in whose education and training Rookwood had invested a substantial sum, was forced by ill health to terminate his association with the Pottery. He left on March 9, 1899 and went to Colorado Springs in the hope that the higher elevation would be beneficial. His sister, Leona, joined the decorating staff later that year. Sadie Markland, another decorator, died on December 3, 1899.

Whatever photographic work the pottery required had been handled by decorator Constance Baker during the 1890's. Now that space was available in the new building, Taylor decided to set up a separate department for this work. Fritz Van Houten Raymond, a young itinerant photographer fresh from photographing soldiers at army camps during the Spanish-American War, was hired to staff the department.

Rookwood was also busy preparing for the International Exposition to be held in Paris the following year, $7,000 having been budgeted for this purpose. Lawrence Studios of Chicago was engaged to take a series of photographs illustrating the facilities and personnel that would present Rookwood to best advantage for the international audience in Paris. Meanwhile, Fritz Raymond was kept busy photographing the wares to be shipped abroad.

A new metal mounting department (replacing the former metal work department) was started to apply metal overlays by an "electro deposit" process developed by Kataro Shirayamadani. Early results were a decided success, and it was planned to show wares in this new style at the Paris Exposition.

Bellamy Storer was named Minister to Spain by President McKinley in 1899, and transferred from Brussels to Madrid. Mrs. Storer moved her work to the Spanish capital, where she continued her artistic interests and won several awards locally for her work in metal designs. So far as is known, Asano accompanied her.

Stanley Burt was instrumental in founding the American Ceramic Society that year, and in addition to being a charter member, he served as treasurer until 1906, when he was elected president. Mrs. Storer was elected to honorary membership in the society in recognition of her interest and efforts in founding the Rookwood Pottery.

On November 14, Taylor wrote Albert Clark, the firm's secretary, who was traveling at the time:

> We are settling down into our new premises and in two weeks I hope to bid goodbye to all our contractors and our carpenters. The change is proving a great success all round especially in the Decoration Dept. and ware room. Prospects seem good for a very large Holiday business. I hope so, for of course we need all the money we can get in.

He reported in the same vein to the stockholders:

> Excellent morale in all departments has been noticeable, especially since the improvements. Such an esprit-de-corps as seems to be developing, is of very great value to the highest interests of the pottery and should be encouraged in every way.

Almost everything about the enlarged pottery on Mt. Adams contributed to this esprit de corps and encouraged the artistic expression and enthusiasm of the workers—the attractive design of the building itself and its location on the hilltop, the arrangement of the work areas, the artists' studios with their views over the city, the carefully tended and colorful gardens in the pottery yard.

A large library for study and reference contained an extensive collection of art books—selected volumes from England, France, Germany, Italy, and Japan, many with illustrations in color. The Rookwood collection of technical books and journals on ceramics and ceramic art was also one of the most complete in the country. In addition, a sizable collection of pictures of animals, flowers, birds, American Indians, and landscapes was maintained to supply models for the artists. Nude studies were kept available for anatomical reference; and copies of the works of Rembrandt, Franz Hals, Van Dyke, and other Old World masters served as sources for portraits painted on vases and plaques.

The everyday equipment was of top quality: colors, brushes, sponges, whirlers, atomizers, all were the best obtainable. Even smocks were supplied for the decorating staff.

The pottery provided other services too. Through the photographic department, members of the staff could and did obtain photographic work free of charge; the pottery supplied the film and equipment and Fritz Raymond pressed the shutter. When the blueprint machines were installed, the

employees sometimes used them as copying machines to duplicate photographs, notices, invitations, and the like.

The pay of the decorators was at the low end of the prevailing scale; it covered the necessities but left little to spend on paid amusements. This did not create a hardship, however. Without being paternalistic, Taylor encouraged and arranged a diversity of entertainment at pottery expense: teas, parties, picnics, dances, sleigh rides in winter, and tally-ho rides in summer were regular events. The pottery also sponsored and equipped a baseball team to play in the local circuit. At least once a year a major costume ball was staged. Elaborate decorations transformed a room at the pottery into a ballroom, and fanciful costumes were created. These affairs grew in magnitude through the years and culminated in an Arabian Nights Costume Party in 1913. Apparently this turned out to be a party to end all parties, for it was the last of the gala costume affairs held at Rookwood.

To fill in between pottery-sponsored events, the decorators created diversions and amusements of their own. Bicycle riding in Eden Park was a popular pastime. They also arranged outings, excursions, and week-end jaunts to nearby farms that catered to overnight guests. For several years the decorators and others at the pottery maintained a camp called "Valley of the Moon," located down the river at California, Ohio, adjacent to Coney Island. This was a favorite week-end retreat with the men. They organized clubs among themselves too. There was, for example, the Rookwood Reading Club, for which E. T. Hurley etched the bookplate, and as a postman's holiday there was even the Rookwood Pottery Club for those who wished to practice in off hours.

The decorators were active in the artistic activities of the city as well. Many of the women belonged to the Woman's Art Club, and the men participated in the activities of the Cincinnati Art Club, the MacDowell Society, the Duveneck Society, and other socioartistic groups in Cincinnati.

In Pierrot costumes are (left to right, back row): *Fred Rothenbusch, Artus Van Briggle, unidentified, Anna Valentien, Rose Fechheimer, and Mary Nourse;* (front row) *Sallie Toohey and Constance Baker.*

Reading Club bookplate, an etching by E. T. Hurley.

Numerous close friendships were formed: Charles Schmidt, Fred Rothenbush, and Ed Diers were so constantly together that the three were dubbed the "German Village." John D. Wareham and William McDonald were good friends and collaborated on a calendar design that won the $1,000 prize in a contest sponsored by Armour & Company.

The prevailing spirit of good fellowship, fun, and frolic is revealed in a collection of verses written about 1900 and found among the papers of Mary Nourse.[3] The author is unidentified. The

[3] In possession of Mrs. Clara Nourse Thompson. Ode reproduced by special permission.

Lena Hanscom making a sketch from cherry blossoms for use in decoration. Some of the artists first composed a sketch on paper. Others worked directly on clay, sometimes outlining the design in India ink, which disappeared in the firing.

excerpts that follow show a bit about the personalities of some of the Rookwood artists of seventy years ago.

ROOKWOOD ODE

A stands for Asbury, such a nice girlie
Whose mission at Rookwood's to regulate
 Hurley
When he looks in her eyes he can never be
 surly.

A is also Altman, a youth full of spirit
But he's falling in love—at least we all fear it
I could tell you her name or come very near
 it.

B is the letter that stands first for Baker
And I tell you right now she's the great picture taker
She also paints pansies—demure as a Quaker.

B is also for Bishop—a girl with long curls
The youngest of all the bright fair Rookwood
 girls
Her manner as calm as the whirler she whirls.

 * * *

D is for Daly, so solid and fair
With his fine stately walk and dark glossy
 hair
When you smell a tobacco fume, Daly is
 there.
D is also for Demarest, from Jersey she came
But to Rookwood she's welcome and soon
 may her name

Among Rookwood's fair maidens achieve its
 own fame.
F is for Felten, called "shortie" for short
She's a bright little kid and just the right sort
For some nice old bachelor to take to his
 heart.

F is for Fechheimer—avoid her for miles
For she'll spill paint all over you
With the sweetest of smiles.

 * * *

N is for Nourse—let me whisper it low
She's as jolly a maiden as Rookwood can
 show
And she mothers us all—as we gratefully
 know.

P is for Pinney—long with us she's tarried
With stately reserve herself she has carried
The girls needed a chaperone—so she got
 married.

 * * *

As might be expected, a number of Rookwood romances ended in marriage. The first was that of Anna Bookprinter and Albert Valentien, followed by the weddings of Marion Smalley and Francis Vreeland, Irene Bishop and Edward Hurley, Edith Noonan and chemist Stanley Burt, Grace Young and Fritz Raymond, Vera Tischler and potter Warren Fichter, and Elizabeth Barrett and Jens Jensen; and there may have been others. Apparently, the pottery employees, particularly the decorators, were a close, happy, spirited group who thoroughly enjoyed their work and their play!

Chapter 13

As Mr. Taylor planned to leave for Paris early in February, 1900, not to return until late in the summer, a special directors' meeting was called and Pitts Burt was appointed "Treasurer, *pro tem* to conduct the banking business of this company with the First National Bank, endorse cheques, sign cheques, borrow money for the company, and give notes for the company." A 5 per cent dividend was declared for the prior year.

A day or two before Taylor left to take ship from New York, the Fry litigation came to court on appeal. He left before the case was completed, but a letter was sent to him in Paris to let him know that the decison of the lower court had been upheld. He acknowledged the news in this note to Clark:

<div align="right">May 21, 1900</div>

<div align="right">Hotel Chatham, Paris</div>

Dear Zack:

I have just heard from home what may be no news to you by this time that the Fry case has been decided in our favor on appeal. While I could hardly expect a different result, it is a pleasure to have it "res adjudicata." As I understood Parkinson [attorney representing Rookwood] she could not take a further appeal, but I hardly think she would at any rate.

I have had a rather hard time here getting our exhibit into shape and am not through yet, though it is in much better shape. The trouble came from the light being not only bad but coming from the reverse direction expected by the Chief of our Dept.

We are making a fair amount of sales and I think our exhibit shows well against those from elsewhere. . . .

Paris is a great place but you can find out all about it in the guide books. The Exposition is beginning to be ready—many fine exhibits and special features but in the beauty of the buildings and the landscape not to be compared with Chicago.

Commend me cordially to Mrs. Clark and to your infants and believe me

<div align="right">Yours ever</div>

<div align="right">W. W. Taylor</div>

What took place in Paris is best told by Taylor in a report to the stockholders after his return:

The greatest event of the year was our exhibit at Paris. Arrangements were made with S. Bing of Paris to act as our general European agent for a term of three years. He was to receive a commission of 10% on sales at the Exposition, we to furnish the installation, salesmen and attendance, and 25% on other sales. . . .

Our exhibit was among the very few which were completed on the opening day. We had excellent position in the American Department of Varied Industries in the Invalides Building and though the light was disappointing, our installation showed us to advantage. Upon the whole the Iris type was most favorably regarded but all varieties sold.

Peculiar circumstances placed us at a disadvantage with the Class Jury but on a second examination, they gave the Exhibit the highest mark for a Gold Medal. On appeal to the superior jury, the Grand Prix

was awarded later. I was also asked to nominate two names for prizes of collaboration and gave those of Albert Valentien and Stanley Burt as representing the decorating and the ware-making departments. To the first was given a gold, and to the second a silver medal. On my protest that the rating should be equal, I was informed that all the juries assigned a slightly higher rank to the artistic section of any industry.

These and other matters prevented my return here until August 30th after a stay of about five months in Paris.

Later I was informed of my decoration as Chevalier of the Legion of Honor by President Loubet, which I mention simply as it was an additional and crowning honor to Rookwood.

We have thus received, at the greatest Exposition ever held, the utmost honors which it could confer, and it is no exaggeration to speak of Rookwood as being now classed among those potteries which hold the highest rank in the world.

Rookwood's total expense for the Paris Exposition, $8,713.85, was more than covered by sales at retail, which were $10,400. Among the buyers were many of the European museums. (See Afterchapter IV.) Although some had acquired Rookwood for their collections following the awards to the pottery at the Paris Exposition of 1889 and at the Columbian Exposition in 1893, the award of the Grand Prix in 1900 greatly stimulated professional interest, especially among the museums in the field of industrial arts. Rookwood made the most of this new recognition; every pamphlet issued after 1900 named as "patrons" all foreign museums known to have Rookwood in their collections.

Regarding the development of mat glaze work,

Photo by Böhrer
Gewerbemuseum, Nürnberg

Pink cherry blossoms, green leaves, on dark brown ground, by Rose Fechheimer. Base shows marking.

the following statement appears in the minutes for 1900: "While some experimental work was done in dull finish glaze as early as 1896, I [Taylor] had the matter taken up in a serious way by Mr. Burt, the Superintendent, considerably over a year ago with a view to its use for decorative tile." This is the first official mention of the development of the decorative tile that led to Rookwood's entry into the field of architectural faience.

The management never gave credit to Van Brig-

gle for introducing mat glaze. Taylor perhaps resented the fact that Van Briggle was forced to leave so soon after Rookwood had made considerable investment in his education, and that he had started his own pottery in Colorado Springs.

Albert Valentien at a later date reported the development of mat glaze at Rookwood:

It was first introduced . . . by Mr. Van Briggle, who later became the founder of the Van Briggle pottery at Colorado Springs, although

Small photographs on 3-by-5 file cards served to record details of every piece of Rookwood made. This system replaced the Shape Record Book about 1900.

previous to this the Grueby Tile Co. had been using similar effects in the manufacture of decorative tiling. . . . Very few pieces of this ware, however, were done by Mr. Van Briggle before severing his connection with Rookwood. In this effect, the mode of decoration differs entirely . . . in that the material is applied on the biscuit or baked body of the vase, instead of the clay. No preliminary work such as painting with slips being necessary, the material being at once the glaze and the decoration. The elements of these glazes are such as to yield in the fire not only those that can be calculated, but those unexpected variations which appear at very high temperatures.

By the end of 1900, mat glaze was an increasing part of Rookwood's production. A separate numbering system was started for mat glaze art pottery pieces to distinguish them from the regular line by adding the letter "Z" to the shape number. Thus the first mat glaze art pottery pieces were numbered 1Z, 2Z, 3Z, and so on up to about 900Z, which was reached about June, 1904. At that time the separate mat glaze-numbering system was discontinued, the use of the letter "Z" was dropped, and this ware was renumbered in the regular shape record. For example, 5Z became No. 920; 6Z, No. 953; 14Z, No. 955, and so on in irregular sequence, indicating that the transfer from a "Z" number to the regular shape record was made as the shapes happened to be produced. A pressed rook inkwell, for example, originally 354Z, was assigned No. 998 after the change, in August or September 1904; a candlestick shaped like an inverted mushroom, first numbered 331Z, became No. 1068.

About the time that the "Z" designation was adopted for the mat glaze art pottery, a "Y" classification was employed to identify the shapes and sizes of tiles, moldings, corner pieces, and other items designed for architectural use. At first, these pieces were numbered in the regular shape-numbering system used for art pottery and distinguished only by addition of the letter "Y". About 200 early architectural shapes were assigned numbers between 1000 and 2000. Later, the numbers 3000 to 5999 in the regular shape sequence were set aside to be used *only* for architectural pieces—*and there are no art pottery pieces with shape or pattern numbers from 3000 to 5999.* When art pottery shapes reached No. 2999, the next shape in the art pottery line became No. 6000.

Art pottery shapes eventually reached No. 7301, but not every number above 7200 was used. Therefore, a total of approximately 4100 regular art pottery shapes exists, exclusive of the special shapes made for presentation pieces or for commercial orders, neither of which were numbered as a part of the regular line. (In addition to the above, many shapes were of course made in two or more sizes.)

Production figures for the year 1900 are not given, but sales fell off, reflecting the general decline in business. This apparently affected Rookwood's competitors as well, for Taylor commented, "There are also signs of the exhaustion of the imitators." He was very conscious of the activities of the Weller and Owens potteries in Zanesville, which were copying Rookwood's style of decoration.

Chapter 14

1901

Early in the year, this notation was made in the Corporate Minutes:

On discussion of the so-called "dividend-in-ware" the plan adopted last year of assigning to stockholders a definite monetary value to be taken from any part of the stock was abandoned and the old plan of a distribution of "seconds" returned to.

For some time the stockholders had been given ware in place of, or to supplement, cash dividends. Just when the practice originated is not known, but apparently it was first confined to the distribution of seconds.

As previously mentioned, pieces from the kilns that developed minor faults in firing were classed as seconds. These were then marked with a large "X" roughly cut or scored in the base. Those so badly damaged as to be unsalable were destroyed. The judgment was made by the salesroom personnel, and as Edwin J. Kircher[1] wrote:

The sales personnel had access to a grinding wheel, and cut the second mark themselves. It is presumed that the decorators could also request that an item of their work be adjudged as secondary quality. The extent to which this was done, if any, is not known, but the existence of the mark in overglaze black, indicates the possibility of pre-showroom judgment by the artist.

As any collector can attest, the judgment of

secondary items over a period of years as represented by pieces of varying age appears rather whimsical. Many items so marked contain only flaws of a very minor nature. In contrast, items are known with kiln cracks of several inches or more, and are not marked seconds.

It is also known that favoritism played a part in marking seconds. If an employee of the pottery wanted a particular piece, a member of the staff in the salesroom would sometimes arbitrarily mark it as a second so that the price would be reduced on the books. Such collusion was not widespread, but it did happen on occasion; thus, some first-quality pieces are found marked as seconds.

At the end of the year, usually at Christmastime, those "seconds" in the salesroom that had not been sold were marked again on the grinding wheel with an additional cut across the "X" giving the effect of a large asterisk. These pieces, known as "give-aways," were presented free to the employees. Each piece was numbered, and corresponding numbers were drawn by lot. The drawing was a festive occasion, eagerly anticipated each year.

By 1901 Rookwood was so well recognized for the high quality of its wares that others sought to capitalize on its name. Swift & Company wrote to the pottery asking permission to use the name Rookwood for a new brand of soap. The Eaton-Hurlbut Paper Company of Pittsfield, Massachusetts, actually advertised "Rookwood Writing Paper" and also used Rookwood's brand names "Iris," "Sea Green," and "Tiger Eye." The sentiment of the management at the pottery was "unfriendly to any such use of the company's name

[1] Kircher, Edwin J., *Rookwood Pottery—An Explanation of Its Marks and Symbols.* 1962.

or brands." The Swift request was turned down, and Taylor asked Eaton-Hurlbut to discontinue the practice.

Rookwood exhibited at the Pan American Exposition held in Buffalo, New York, where they rented space in the inner court of the Manufacturers' Building. In commenting on the show, Taylor wrote:

> Sales were excellent until the tragic death of President McKinley, which seemed to paralyze the whole enterprise. The demand was largely for the later types of ware, and apart from the general advertisement, the exhibit did a great and much needed service in acquainting both dealers and the public with our recent advances.
>
> Probably ninety per cent of the visitors did not know Rookwood in any but the standard type, while the mat glazes were new to almost everyone. The jury awarded us the highest prize (Gold Medal) as well as one of the few special medals for installation (Silver Medal).

Rookwood exhibited in several arts and crafts shows throughout the United States. It was also decided, at the urging of the American Commission in charge, to exhibit at the International Exposition of Modern Decorative Art to be held in Turin, Italy, the following spring. The decision was made reluctantly, however, as the company did not anticipate the exhibit would be profitable commercially, "but as the costs were nearly all underwritten by the Commission the company assented."

Like many manufacturers, Rookwood was critical of its agents' performance. On this subject Taylor wrote to Clark:

> I am more and more impressed that our real difficulty is to get the right sort of agent. They hardly exist anywhere—excepting Andrews here or Selzer at Cleveland and one or two more. They nearly all treat Rookwood as though it were so many spoons or pocket knives. The conception of it as a work of art with individual quality in the pieces never enters their little heads. They don't know enough and there is nothing for it but to slowly educate them. Just now they merely lump us with what they call "art goods" which may include painted cuspidors or tidies—it doesn't matter so they are cheap

and the decoration (!) is bad enough. D—n.

> Our Denver friends, Parkinson & Wallace are not much better than the rest, though they think they are. By the way, if you are passing there, I wish you would notice whether they have any of the Zanesville counterfeits in stock. I don't mean jardinieres but vases.

And some time later, he noted:

> Our production has steadily improved both technically and artistically, and whenever we come into direct contact with the consumer, either in our own wareroom or at expositions, there is not the slightest sign of exhaustion in the demand.
>
> The trouble seems to be with the dealer, and our persistent effort to educate and help him seems to bear little fruit. In many cases he has no artistic appreciation of the ware; in many more, his salesmen have even less, and nearly all the ware is shown in disregard of taste. Every scheme that gave promise has been tried, and here and there improvement is manifest, but I have not exaggerated the general conditions. Were they otherwise, there is no reason why our sales should not be a half greater and an even larger production be turned readily into cash.

This dissatisfaction with the dealer spurred interest in developing the architectural end of the business, where the dealer might be eliminated and sales made directly to the buyer—the owner, architect, or builder.

Preliminary surveys among architects in Cincinnati and elsewhere indicated that there was a potential demand for decorated faience tile, but little if anything on the market to satisfy it. As a result, experiments in this direction were pushed as rapidly as possible. New bodies and glazes were made, tested, and adopted as standard, and appropriate designs in both painted and incised decorations were produced. Unlike the clay mixtures for the art pottery, tiles for architectural faience were made with a body containing grog to reduce shrinkage and add dimensional stability for exterior use. It was anticipated the architectural business would develop into "the highest importance," and if so would require further expansion.

To give himself more time for these new developments, Taylor secured the part-time services of

J. H. Gest, director of the Cincinnati Art Museum. By an understanding with the museum, Gest arranged to give the pottery "a part of every day," and devoted the morning to his activities at the museum and the afternoon to the interests of the Rookwood Pottery Company.

At the Exposition Internationale de Ceramiques et de Verrerie at St. Petersburg, Russia, in 1901, Rookwood received the Grand Prix.

The art pottery pieces made in 1901 totaled 13,088, with a value of $89,536.75. "In mat glaze work put through the decorating room, there were delivered from the kilns during the year, 3021 pieces." Presumably these were art pottery, but the figure may have included some decorated pieces for architectural use.

Indicated net profit for the fiscal year ending January 31, 1902, was $12,500, and a cash dividend of 5 per cent was declared.

1902

At the annual meeting on March 8, a resolution was passed complimenting the officers and employees of the pottery on the past year's successes. After a selection of the dividend-in-ware consisting of three pieces of "seconds," the meeting adjourned to permit the stockholders to inspect the mantel facings and panels in tile, which were mainly the work of W. P. McDonald, A. R. Valentien, and Stanley Burt, the superintendent.

Bellamy Storer was named the United States Ambassador to Austria-Hungary by President Theodore Roosevelt in 1902 and, with Mrs. Storer, moved to Vienna from Madrid. Asano, the Japanese metal expert, returned to Cincinnati and presumably resumed his metal work at the pottery for a short time, as his initials (E. H. A.) are found engraved on silver overlay pieces dated 1902. Then, with his life savings, he set out on a visit to his native Japan. He traveled as far as Singapore on his journey, and there he disappeared. He was never heard from again. The story circulated that he was murdered for his money and his body dumped into the harbor.

On March 15, Gest was elected to the position of vice-president made vacant by the resignation of Bellamy Storer. One of his first official duties was to visit the Turin Exposition in Italy. The pottery received one of the "few awards of the highest

Engraved brass nameplate used to identify Rookwood architectural installations.

class"—known in this case as the Diploma of Honor. S. Bing, Rookwood's Paris sales agent, was in charge of the exhibit.

A gold medal, the "Highest Award," was presented to Rookwood at the Charleston Exposition in 1902.

A new decorative technique was introduced about this time and officially named Rookwood Flowing Glaze; the exact date is undetermined. Apparently the new technique did not prove popular or was not sufficiently distinctive, as it was discontinued as a separate style within a short period.

The architectural department was formally organized that year, and William McDonald was placed in charge, John D. Wareham succeeding him as head of the decoration department. The first order for architectural faience was received. Optimism ran high, for the record states, "No department has ever given more promise than this."

Total production of art pottery for the year was 12,750 pieces with a value of $101,355, the highest yet attained.

1903

A 5 percent cash dividend was declared; the annual dividend-in-ware declared consisted of "seconds in metal deposit pieces."

In the spring, the first large contract for the architectural department was secured. It amounted to $5,650 for furnishing the decorative faience for the 23rd, 79th, 86th, and 91st Street stations of the New York City subway. (Either the original record is in error, or the stations designated as 79th and 91st were changed before the project was completed to be the 77th and 96th street stations that exist today.)

More space would certainly be needed if the volume of business indicated by this order was to be handled without interrupting the art pottery

production. The first step was the acquisition of eighteen lots adjacent to the pottery on the north. The president then was authorized to proceed with "new building construction, the purchase of machinery, etc., for the Department of Architectural Faience."

To finance the expansion and provide more working capital, the directors proposed the issuance of a new preferred stock to the amount of $50,000. Later, this was increased to $60,000, and by the end of the year applications had been made "by sundry persons" for more than that amount. Taylor was authorized "to apportion same among them in such proportion as, in his judgment, will be most to the best interests of the Company."

The financing arranged, he retained the firm of Elzner & Anderson to draw plans and obtain estimates for the addition of 22,171 square feet of floor space to house the architectural department.

Ground was broken for this second extension on October 20, 1903, and on the following November 24, almost twenty-three years from the day on which the first kiln was drawn, a simple ceremony was held to mark the placing of the cornerstone in the foundation walls.

In anticipation of the growth in architectural business, an "Eastern Office" was opened in the Metropolitan Building, One Madison Avenue, in New York. Sturgis Laurence, who had joined the decorating department in 1895, was placed in charge. Apparently the position of sales representative on architectural projects offered greater remuneration.

Production of art pottery for the year was 10,730 pieces having a value of $88,735. The dividend for the year was passed on account of the "extra-ordinary dullness in trade," the unusual expenses in launching the new architectural faience department, and the "new building overrunning estimates, caused largely by reconstruction of old plant to connect with the new."

1904

By 1904 Rookwood was dealing with more than 200 resources, and the list of major suppliers at the time reads like a Blue Book of American Industry. Among these firms were Roessler & Hasslacher Chemical Company (now the Electrochemicals Department of E. I. du Pont), A. Klipstein Com-

pany (now part of American Cyanamid Company), Pennsylvania Salt Manufacturing Company, Johns-Manville Co., Devoe & Reynolds, Carborundum Company, S. S. White Dental Manufacturing Co., Bristol Company, Dearborn Chemical Company, and American Metal Hose Company.

Rookwood's new Vellum finish, a transparent mat glaze attributed to Stanley Burt, was introduced at the Louisiana Purchase Exposition held in St. Louis from April 30 to December 1. The new glaze accounted for one of the two Grand Prizes the pottery received; the other was awarded for the work of the new faience department. In spite of this recognition, the exposition was not considered particularly noteworthy by the firm as "sales were disappointing and the expenses relatively large."

So that shareholders might inspect the new facilities, the annual meeting was postponed until June 4. Stockholders were authorized "to select ware at retail value without discount to the amount of $50 for each holder of 10 shares or over, and $25 for each holder of 5 shares. . . ."

At the Harvard Commencement of June 29, 1904, President Taylor received the honorary degree of Master of Arts, the English version of his citation being:

> William Watts Taylor, sympathetic and successful promotor of a highly artistic craft, manager of the Rookwood Pottery, the best American contribution to ceramic art.

In midyear the Chicago office of J. Walter Thompson Company, one of the country's leading advertising agencies, solicited the Rookwood account. The Thompson agency presented a plan for advertising and promotion involving a year's budget of approximately $7,500, which so impressed Taylor that, in recommending its adoption to the Board of Directors, he offered to lend his personal stock as collateral for a loan to finance the program, although he realized that "the results must necessarily be slow."

The plan called for consumer magazine advertising to stimulate retail sales, and through the offer of a special booklet and price list, to develop mail-order business from market areas not covered by Rookwood agents. At the time, Rookwood was sold by approximately one hundred "agents" throughout the country. By developing a mail-order business, the pottery would tap a large

market not reached by its exclusive retail outlets.

A typical advertisement from this campaign is reproduced here. Each advertisement offered a small mail-order catalog called "The Rookwood Book." It was 36 pages, 5 by 6 inches in size, attractively printed with several pages in full color. A total of 116 pieces of Rookwood were illustrated, of which 14 were shown in full color. The remaining 102 pieces were in black and white.

As this is one of the few pieces of Rookwood literature that gave detailed descriptions of the ware, and the only one on art pottery that is dated (copyright 1904), it is quoted here at some length. The following excerpts are from the introductory remarks:

> Whatever of artistic satisfaction lies in Rookwood is due first to the individuality of its artists, to their freedom of expression in the ever-changing language of an art that never repeats itself, that has in each vase some new message of beauty. Rookwood cannot be understood without an appreciation of its radical difference from commercial industries. Its whole history and development centres upon the one idea of individualism, the entire absence of duplication, and the constant progress toward new forms of artistic expression....
>
> Where artistic expression is the first consideration financial return must be secondary. While the Rookwood Pottery Company is a business organization it is deliberately operated at a minimum profit, in order that its staff of artists may have the utmost latitude in the creation of new and ever-varying objects of art....
>
> A vase made at Rookwood under the conditions existing there is as much an object of art as a painted canvas or sculpture in marble or bronze. And the artist's signature upon the vase is as genuine a guarantee of originality. An object of art is immeasurably more precious when its owner knows there is no other just like it, that the particular artistic conception expressed there will never again be found quite the same. A Rookwood artist never does two vases alike, but carefully studies, composes and works out each piece for itself. It is that creative process which makes a piece of Rookwood an object of art....

The booklet then described the various styles of ware produced in 1904, under the heading:

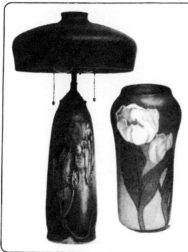

Magazine advertisement prepared by J. Walter Thompson Company in 1904, part of the program to develop mail-order sales.

THE EIGHT TYPES OF ROOKWOOD

The many-sided development of Rookwood has naturally given rise to a variety of types, each of which distinctly differs from the others....

"STANDARD"

is the name given to that widely known type of Rookwood which was first produced at the pottery. It is noted for its low tones, usually yellow, red, and brown in color, with flower decoration, characterized by a luxuriant painting in warm colors under a brilliant glaze....

"SEA GREEN"

is characterized by a limpid, opalescent, sea green effect. A favorite decoration is of fish moving under water. In floral designs under this glaze, blues, yellows, and sometimes reds are used....

"IRIS"

is a light type with deliciously tender and suggestive color effects under a brilliant white glaze ... the light body decorated in delicate greys, pinks, soft blues, greens, and yellows....

The "Mat Glazes" are distinguished by the absence of gloss. Their texture is in itself delightful, a pleasure to the eye and to the touch, whether the surface be decorated or

The Rookwood 1904 Mail Order Catalog

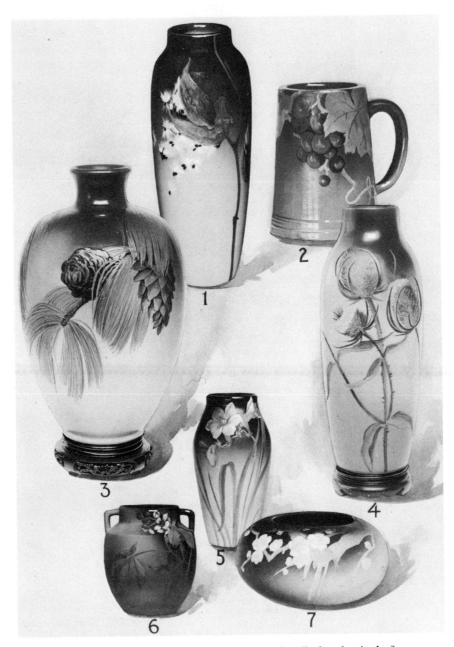

[Rookwood Standard Ware. Each item was described and priced—]

					
No. 1	Milkweed Design	8	in. high	$8.00	
" 2	Grape "	4¾	" "	5.00	
" 3	Pine Cones "	11½	" "	25.00	
" 4	Teazel "	10	" "	10.00 to 12.00	
" 5	Lily "	6½	" "	8.00	
" 6	Blackberry Blossoms	5¾	" "	7.00	
" 7	Cherry Blossoms	2¾	" "	4.00	

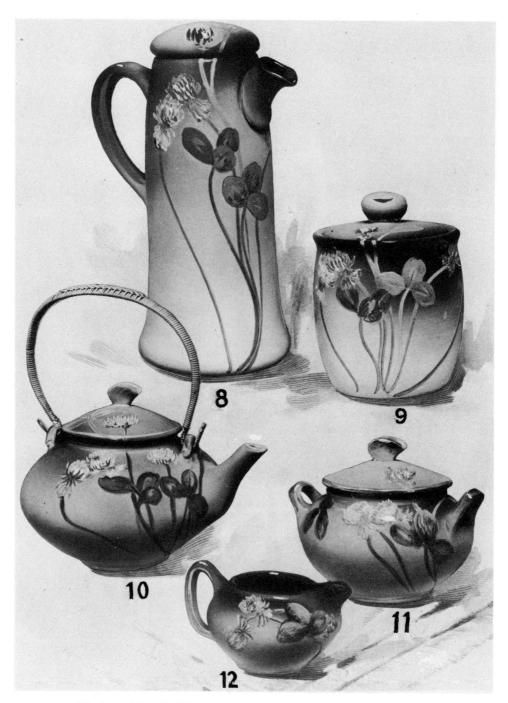

[Rookwood Standard Ware was also offered in sets with matching decorative patterns. Clover design shown was priced as follows:]

No.	8	Chocolate Pot	9 in. high	$8.00 to 10.00
″	9	Tea Caddy	5¼ ″ ″	5.00
″	10	Tea Pot	4¾ ″ ″	8.00
″	11	Sugar Bowl	3⅞ ″ ″	4.00
″	12	Creamer	2½ ″ ″	3.50

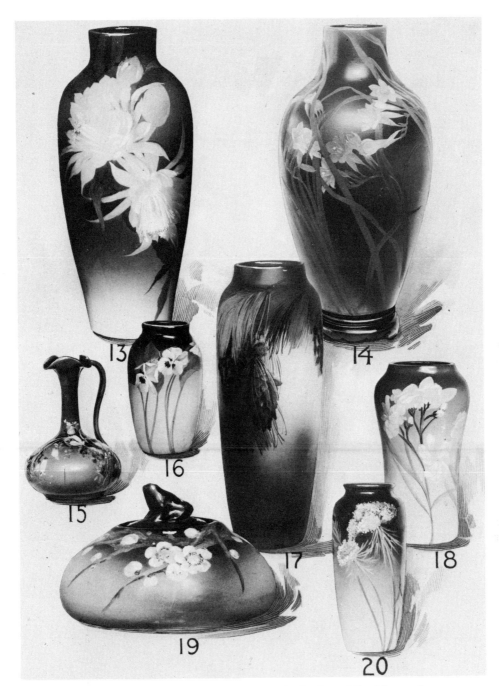

[Other Standard Wares illustrated in "The Rookwood Book" were:]

No. 13	Night Blooming Cereus	13 in. high	$20.00
" 14	Lily	14½ " "	50.00
" 15	Japanese Flower	5½ " "	3.50
" 16	Pansy	6¾ " "	6.00
" 17	Pine Cones	10½ " "	15.00
" 18	Oleander	8¾ " "	10.00
" 19	Cherry Blossoms	2½ " "	3.00
" 20	Wild Carrot	6¼ " "	5.00

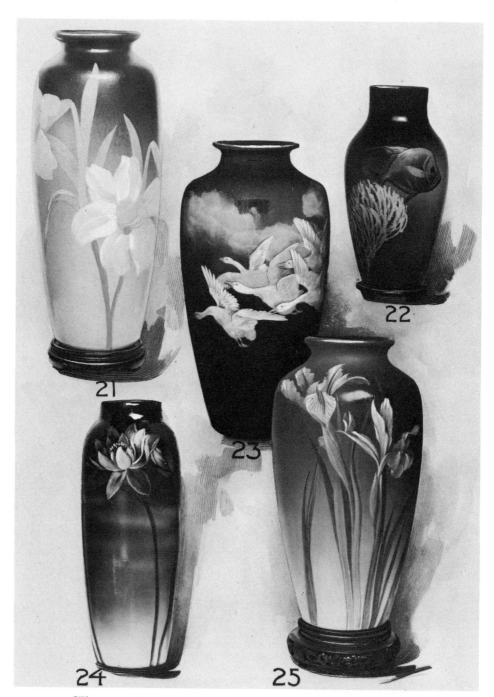

[Five examples of Rookwood Sea Green were shown and priced:]

No.	21	Easter Lily	8	in. high	$12.00
"	22	Fish	5¾	" "	10.00
"	23	Geese	10	" "	50.00
"	24	Water Lily	7	" "	8.00 to 10.00
"	25	Japanese Iris	10	" "	30.00

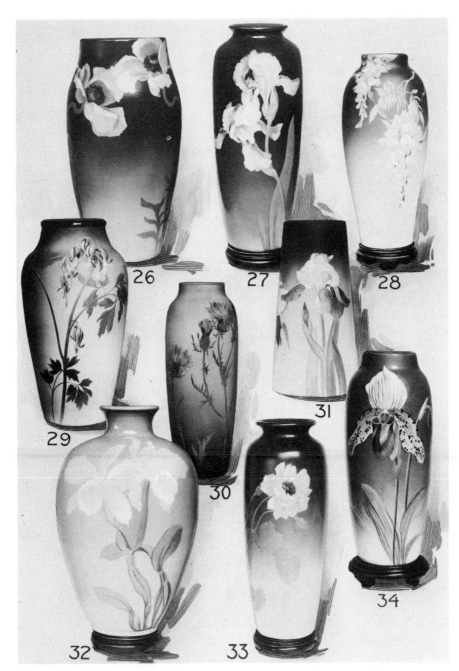

[Eighteen examples of the Iris-type ware (Nos. 26 to 43) were illustrated and priced:]

No. 26	White Poppies	10	in. high	$18.00
" 27	Iris	8	" "	12.00
" 28	Wistaria	8¾	" "	15.00
" 29	Bleeding Heart	9¾	" "	30.00
" 30	French Thistle	7	" "	8.00 to 10.00
" 31	Iris	7	" "	10.00
" 32	Orchid	14½	" "	100 to 150
" 33	Rose	9¾	" "	18.00 to 20.00
" 34	Orchid	10	" "	25.00

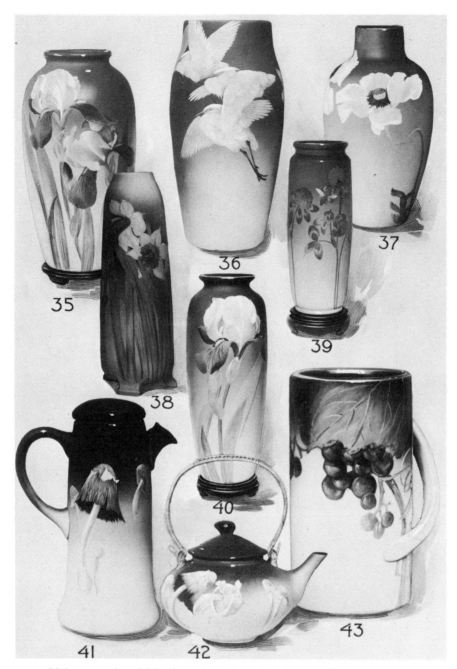

[Other examples of Iris Ware offered for mail order were:]

No. 35	Iris	9¼ in. high	$20.00
" 36	Storks	16½ " "	150 to 200
" 37	Poppies	6½ " "	8.00
" 38	Jonquil	9½ " "	20.00
" 39	Clover	5¾ " "	6.00 to 7.00
" 40	Iris	6¾ " "	10.00
" 41	Mushrooms	9 " "	15.00 to 20.00
" 42	Mushrooms	4¾ " "	12.00 to 15.00
" 43	Grapes	6 " "	8.00 to 10.00

[Five examples of "Mat Glaze Painting" were illustrated and priced:]

No.						
No. 44	Tulip	10	in. high		35.00	
" 45	Teazel	6¼	"	"	12.00 to 15.00	
" 46	Poppy	10	"	"	30.00	
" 47	Pink Dogwood	5½	"	"	25.00	
" 48	Lily	8	"	"	20.00	

[Five pieces of "Mat Glaze with Conventional Decoration in colors" were
shown and priced:]

No. 49	Iris	9	in. high	$10.00
″ 50	Poppy	11¼	″ diam.	15.00
″ 51	Grape	7¼	″ high	8.00
″ 52	Dragon Fly	7¼	″ diam.	7.00
″ 53	Cyclamen	5	″ high	6.00

[Incised Mat and Modeled Mat Styles were also offered:]

No.	54	Incised		7¾ in. high	$5.00
"	55	"		6 " "	2.50
"	56	"		5⅝ " "	2.50
"	57	"		6 " "	8.00
"	58	Modeled		12 " long	15.00

[Other Modeled and Incised Mat Types offered included:]

No. 59	Modeled	Jonquil	8½ in. high	$15.00
" 60	"	Clover Leaf	7 " "	15.00
" 61	"	Dragon	13 " "	80.00 to 100
" 62	"	Oak Leaves	10 " "	25.00
" 63	"	Iris	8½ " "	40.00
" 64	Incised		5½ " wide	2.50
" 65	Modeled		3 " "	1.00

[Modeled also ran to higher prices for more intricate designs:]

No.	66	Grapes	15	in. diam.	$75.00 to 100
"	67	Poppy	7½	" high	20.00
"	68	Grapes	5⅝	" "	15.00
"	69	Lobster	5⅝	" "	15.00 to 18.00
"	70	Ivy	9	" "	20.00

[Lamps and electroliers were also offered:]

No.			Description		in. high		Price
No. 71			Iris type Pine Cone decoration	24	in. high		$85.00
" 72			Modeled Mat Water Lily "	14	"	"	75.00
" 73	"	"	Thistle "	22½	"	"	35.00
" 74			Mat Glaze Candlestick	10½	"	"	8.00
" 75	"	"	Lamp, Dec. in color	33	"	"	100.00
" 76			Modeled Mat Candlestick, Tulip	8¾	"	"	25.00
" 77			Mat Glaze Lamp, Dec. in color	22	"	"	75.00
" 78			Modeled Mat electrolier, Tulip	14	"	"	75.00
" 79			Modeled Mat Painting, metal base	24	"	"	125.00

[Vellum, the new transparent mat glaze introduced in 1904, was illustrated in twenty-three patterns in all—Nos. 80 to 102.]

No. 80	Fish	9½ in. high	$25.00
" 81	Easter Lily	10½ " "	20.00
" 82	Conventional Fish	6½ " "	8.00 to 10.00
" 83	Jug, Grape decoration	7½ " "	15.00
" 84	Modeled Lotus	7 " "	25.00
" 85	Orchid	6 " "	8.00 to 10.00
" 86	Conventional Dragon Fly	7½ " "	12.00
" 87	Dogwood	4¼ " "	8.00

[The popular floral decoration was also widely used in the Vellum finish:]

No.	88	Narcissus	8½ in. high	$15.00
″	89	Orchid	8¾ ″ ″	15.00
″	90	Wild Carrot	7¾ ″ ″	10.00 to 12.00
″	91	White Tulip	6½ ″ ″	8.00 to 10.00
″	92	Teazel	7¼ ″ ″	8.00 to 10.00
″	93	Lily of the Valley	5¾ ″ ″	7.00 to 8.00
″	94	Jack-in-the-Pulpit	8 ″ ″	12.00
″	95	Mistletoe	4½ ″ ″	7.00

[A third page illustrated the remaining styles produced in the new Vellum finish:]

No.	96	Modeled Corn Flower	9	in. high	$18.00
"	97	" Cherry Blossom	10	" "	25.00
"	98	Marine	10⅜	" "	25.00
"	99	Modeled Fern Fronds	6½	" "	8.00 to 10.00
"	100	" Mistletoe	7½	" "	12.00
"	101	Conventional Berry	6½	" "	10.00
"	102	Orchid	7½	" "	15.00 to 18.00

not. The glaze is no longer designed merely to protect the colors beneath . . . but is now itself the dominating interest. . . .

On many pieces decoration is applied of flowers or other subjects, broadly painted or modeled. Others are treated with simple incised designs. . . .

"MAT GLAZE PAINTING"

is a mat glaze with decorations painted in rich, warm reds, yellows, greens, and blues, a process of the greatest difficulty, suggestive of flowing enamels, but with a mat texture.

"CONVENTIONAL MAT GLAZE"

This type is a mat glaze with flat, conventional decoration in colors. This new type of Rookwood appeals to a taste for simple, flat decorations rather than naturalistic treatment, and·reflects an important movement in modern art.

"INCISED MAT GLAZE"

derives its name from the incised decora-tion. This type is made . . . in a multitude of shapes; sometimes single colors, sometimes in a combination of two or more colors.

"MODELED MAT GLAZE"

This type of Rookwood has colored mat glazes, combining richness of color with soft-ness of texture and modeled decoration, in a great variety of beautiful designs. Vases of this kind are sometimes mounted as lamps or electroliers.

"VELLUM WARE"

This variety of Rookwood Mat Glaze differs from all others. . . . Devoid of lustre, without dryness, it partakes both to the touch and to the eye of the qualities of old parch-ment. The Mat Glazes hitherto known have permitted, by reason of their heaviness, of but little decoration other than modeling or very flat and broad painting. . . . The Vellum on the contrary retains for the artist all those qualities possible hitherto under brilliant glaze alone. . . .

Three rooks atop each gatepost mark the entrance to the Rookwood Pottery building on Mt. Adams, Cincinnati.

This most complete and flowery description of Rookwood styles or varieties is followed by a section entitled:

HOW TO ORDER ROOKWOOD

As no piece of Rookwood is ever duplicated, it is impossible to issue a catalogue in the ordinary sense of the term.

The pieces illustrated in this book were in the pottery studios at the time the Rookwood Book was issued, but possibly when you receive this copy there may not remain unsold a single one of these pieces. The Rookwood Book will nevertheless serve as a guide in ordering Rookwood.

If you desire any of the pieces of Rookwood illustrated, specify those you would like to see, and we will express pieces *of the same type,* as nearly as possible like the ones you have selected in form, size, and price, either to some local dealer, or to you direct, with the privilege of examining the pieces sent, selecting such as you wish to purchase, and returning the others to the pottery. This is the only way in which we are able to supply Rookwood in places where we have no local representative, and it has been uniformly satisfactory....

The Rookwood Book is sent to you as the best available method of placing before lovers of beautiful pottery a clear idea of what Rookwood is in its different types, glazes, decorations and prices....

No real work of art is valued according to its size, but by its quality. Thus, a Rookwood vase which is small in size, may be so rare in design, decoration, glaze and quality, due to the eccentricities of the fire, that it will frequently have a greater artistic value than a piece many times larger. And again, two vases of the same size may vary widely in price, according to the artist who paints the design upon the piece, or the varying conditions which affect the cost of its production.

The prices listed ranged from $1.00 to $2.00.

From the time the new promotion program went into effect (about October) until the end of the fiscal year on January 31, 1905, eighty-nine pieces, for a total of $713.93, were sold by mail order. Needless to say, these results were disappointing.

The year 1904 also saw the first employee stock participation plan introduced; Stanley Burt was permitted to buy $2,500 and J. H. Gest $1,500 worth of common stock in the company, "same to be paid for from increased salary."

Production in the decorating room increased to 11,189 pieces, up nearly 5 per cent from the year before, but the value declined more than 10 per cent. This did not include 2,322 pieces of mat glaze and incised ware that did not pass through the decorating room and was presumably for architectural use. Total sales for the twelve months' period were $89,717.16, including architectural sales of $7,101.72. These results for the year were not considered satisfactory; the dividend was passed, but Taylor's salary was increased to $5,060.

1905

During the year the new architectural department continued to be a drag on profits, and fell short of paying its own way. Taylor explained to the stockholders, "Were it charged with its full proportion of contingent expenses, the showing would be still more unfavorable. But on the other hand, the prospects were never more favorable. Orders in hand and prospective are far more continuous and more widely distributed than formerly when one or two large projects like the Subway Stations made up the bulk of the sales."

The advertising program was continued during the year, though the $17,000 expense had not so far justified itself by any significant increase in sales in the vase department. On the other hand it "...introduced the new types of ware to thousands of possible customers." Mail-order sales for the full year were only $1,504.55, a great disappointment to the management.

This year marked Rookwood's twenty-fifth anniversary, celebrated by a luncheon held for employees and ex-employees. In addition, a three-day reception was held at the pottery on the afternoons of December 5, 6, and 7 "with music and the service of tea by lady friends of the pottery." Word of the attractiveness of the Mt. Adams building apparently was circulated, as the number of visitors increased, and for the next three months, sales at the retail wareroom increased each month over the month before.

Chapter 15

At the beginning of 1906 the cash dividend for the prior year was passed (although a dividend-in-ware was declared), and additional bank loans became necessary to finance the increasing work of the architectural department. In the first four months, architectural orders amounted to $18,000, compared with $12,500 for all of 1905, and sales for the full year were expected to reach $30,000. However, since a single order could amount to several thousand dollars, and it was often many months before payment was finally received, the burden of carrying these costs created a need for additional working capital. To meet this situation another $60,000 of common stock was offered to present stockholders, increasing the total capitalization of the company to $180,000.

The first order for the New York Subway was completed. Additional orders were received for more of the twenty-three stations "of the first class" that were decorated with custom-designed tiles. Similar orders were received to supply decorated tile for the Hudson & Manhattan stations in uptown Manhattan and in Hoboken.

Rookwood's entry into the field of garden pottery was a natural outgrowth of the manufacture of architectural tile designed to withstand weather, and a catalog was issued about this time. Undated, its 14 pages illustrated one square and ten round jardinieres, a "perforated" ornamental tile for garden wall construction, and bench and table legs for outdoor use. Also offered were "duplications in one of a number of rich colors" of the wall fountain designed by Clement J. Barnhorn and William McDonald in collaboration with Howard

Molding and decorative panel for Wall Street Station, New York City Subway (photographed before installation).

Conventional garden pottery included pitcher (left), 23 inches high, priced at $25.00; bird bath with decorated bowl, 34 inches high, $75.00; and an oil jar with drip glaze, 27 inches high, $80.00.

Greeley, architect, for installation in the Prince George Hotel in New York.

The January, 1907, issue of *The Architectural Record* published an article, "Architectural Faience," by Sturgis Laurence, which generated considerable professional interest. It was illustrated with several of Rookwood's early installations: the Forty-first Precinct Police Station, the Palm Room of the Hotel Devon, and the lobby of the West Street Building, all in New York City, and the reredos of St. Paul's Church in Rochester.

Pitts Harrison Burt died on April 7, 1907, after a long, pleasant, and spiritually profitable association with Rookwood.

The members of the Commercial Clubs of Cincinnati, St. Louis, Boston, and Chicago arranged a joint trip to the Isthmus of Panama, and Taylor accompanied them for the first extended vacation he had taken since 1900 when he combined business with pleasure to attend the Paris Exposition.

During the summer of 1907, Rookwood delivered a large punch bowl to the secretary of the Harvard Class of 1868. This special presentation piece resulted in the following exchange of correspondence:

September 24, 1907

To the President and Fellows of Harvard College:

Mr. William Watts Taylor, of Cincinnati, Ohio, a temporary member of the Harvard Class of 1868, to whom an Honorary Degree of Master of Arts was given by Harvard in 1904, and who for many years has been the President of the well-known Rookwood Pottery in Cincinnati, has presented to the Class of 1868 and to Harvard University a superb Punch Bowl, which was delivered last Summer at the office of the Class Secretary at 50 State Street.

Mr. Taylor offered to make and to present this specimen of American ceramic art to the Class of 1868, when he was at the reunion of that Class four years ago.

Permission was thereafter obtained to use the College Seal as a part of the inscription to be put upon the Bowl, with the understanding that the gift should be to the Class of 1868 as long as there remained a survivor of that Class, and thereafter that it should pass to the University.

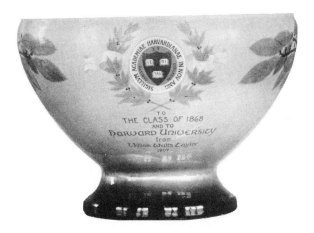

Harvard University Punch Bowl, 20 inches in diameter, has No. T-1276, indicating it was made as a trial piece. Not signed, it is believed to have been decorated by Charles Schmidt.

The attention of the President of the University was called to this by me in January, 1904, and the subject of a safe repository for the gift was then considered. The President kindly furnished a number of book plates as aids for the inscription, and suggested the Phillips Brooks House as a repository for the gift.

The Punch Bowl—which is now before you—is the result of prolonged efforts to overcome many difficulties, more than one piece being rejected before an adequate standard was attained.

As a work of art its merits are such that some wish to have it conveniently accessible in Boston for a time to discriminating persons. The firm of Doll & Richards on Park Street has consented to exhibit it, and to

arrange with The Evening Transcript's art critic to make a special mention of it in that paper.

There is a double purpose in such an exhibit in a suitable place—

1. To show one of the best specimens of American ceramic art at this date.

2. To emphasize the interest that Harvard University takes and incites in industrial work.

This Punch Bowl is a production to be used only on rare occasions.

The Class of 1868 will provide a suitable stand and a glass cover for it and will have it insured, if deemed best.

It is worthy of permanent preservation.

Sincerely yours,
ALFRED D. CHANDLER
Class Secretary of the Class of 1868

September 27, 1907
DEAR SIR:

I beg to acknowledge on behalf of the President and Fellows of Harvard College the receipt of your letter of September 24th, accompanying the beautiful Punch Bowl which Mr. William Watts Taylor of Cincinnati of the Rookwood Pottery has given to the Class of 1868 and to the University. The members of the Corporation had an opportunity to admire the Bowl at their meeting this week, and gladly accepted the custody of it, subject to the desires of the Class of 1868.

The beauty and value of the Bowl are such that the Corporation would be glad to have a suitable stand and cover as your letter suggests. It would also seem best to have a box specially prepared to transport it safely from place to place as the Class may have need of it. If the President's suggestion of Phillips Brooks House as a repository for the Bowl meets with the approval of the Class, the University will be glad to receive and take care of it there whenever it has been sufficiently exhibited.

The University is indeed under great obligation to Mr. Taylor for his loyal and beautiful contribution.

Very truly yours,
JEROME D. GREENE,
Secretary to the Corporation

Today the Harvard punch bowl is still on view in the Phillips Brooks House in Cambridge.

The first catalog for the architectural department was published August 1, 1907. It was comprised of 44 pages and included approximately 200 illustrations and a price list of stock designs in decorated tiles, mantel facings, and complete mantels.

Rookwood was awarded a gold medal at the Jamestown Tercentennial Exposition, but by this time awards were received so consistently that they were considered almost routine.

Toward the end of the year Rookwood's sales declined, following the sharp depression in general business. However, although recovery from the panic of 1907 was slow for many, Rookwood's business revived rapidly and continued a steady upward trend for the next several years. During this period several of the major architectural installations were made. The famous Rookwood Dining Room in the Sinton Hotel in Cincinnati was probably the first. This was followed by the Rathskeller Room in the Seelbach Hotel, now the Sheraton, in Louisville, Kentucky. Then came the Norse Room in the Fort Pitt Hotel in Pittsburgh, which was probably the most elaborate produced. Designed by John D. Wareham, it featured nine murals of Rookwood faience illustrating the theme of Longfellow's "Skeleton in Armor." Walls, floors, vaulted ceilings, and supporting columns were all covered with Rookwood tile, and furniture and tableware were specially designed to harmonize with the decor. From the standpoint of size alone, the Della Robbia Room and Bar in New York's Vanderbilt Hotel was probably the largest installation made.

Unfortunately the Sinton,[1] Vanderbilt, and Fort Pitt hotels have been torn down or remodeled in the name of progress, and the Rookwood architectural decoration is no longer extant; only the Seelbach remains today to show the Rookwood installation as it was a half-century ago.

The production of new vase shapes continued and reached No. 1800 during 1910. Nearly all the new shapes produced after 1900 had been designed with a smooth surface for use with mat glaze finish. Then came a new trend toward surface designs that

[1] It is reported that some of the decorative panels from the Sinton Hotel have been preserved for reinstallation in the Provident Tower constructed on the same site.

could be cast directly in the clay body—decorations modeled in low relief. The modeling tool came into greater use, and many of the decorators contributed to the new designs. These pieces were not signed, however, as they were intended to be cast and would be duplicated in design if not in glaze or coloration.

To celebrate its thirtieth anniversary that year, Rookwood introduced "Ombroso," a new style of mat glaze ware described as "unusually quiet tones of grey and brown, with occasional accents of other colors and the decorations, if any, in relief modeling or incised designs." This was promoted by a special advertising sign modeled in clay by Sallie Toohey.

In 1911, the pottery adopted a policy of allowing stockholders and employees to purchase Rookwood at a discount of one third off the retail price.

Rookwood had repeated its earlier triumphs by winning the Grand Prix at the great Alaska-Yukon-Pacific Exposition in Seattle, Washington. The firm's exhibit and the publicity that resulted were undoubtedly instrumental in helping to secure several sizable contracts for architectural faience on the west coast. There was, however, need of someone on the architectural staff who could handle the contacts and negotiations with architects on a more professional level. Edmund Schildknecht was hired for this purpose. He had been a designer for the firm of Henry Behrens, interior decorators specializing in hotel decoration, and was familiar with Rookwood through the installations at the La Salle in Chicago, the Seelbach in Louisville, and others. He joined the pottery about 1911 and remained with the architectural department until the 1930's.

In 1912, a new catalog for the architectural department was published, enlarged to 64 pages and listing approximately 600 different stock designs available in 46 colors. Theatres, railroad stations, clubs, restaurants, banks, schools, office buildings, and private homes were all included in the list of Rookwood faience installations during this period.

By 1912, total sales reached $126,249.82, of which $82,155.16 was for art pottery and $44,094.66 for the architectural products. But costs had increased materially, and it was obvious that the architectural department was still operating at a loss; the art pottery was the profitable side of the business.

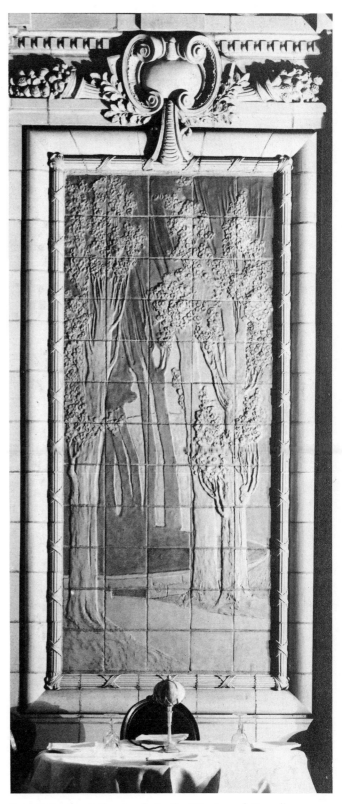

One of the decorative panels in the "Rookwood Room" of Cincinnati's Hotel Sinton.

ALL PASSENGERS WILL BE REQUIRED TO SHOW THEIR TICKETS AT THE GATES

The open tile grille above the train gates in New York's Grand Central Station was made by Rookwood.

Suddenly and unexpectedly, Mr. Taylor died of arteriosclerosis on November 12, 1913, in his sixty-sixth year. His death was a tremendous loss to Rookwood. The terms of his will, which provided for the disposition of his controlling interest in the Rookwood Pottery Company, were revealing of his character and showed the extent of his interest in the pottery's welfare. He gave all his stock in the company to a board of twelve trustees to hold in trust and to go eventually to the Cincinnati Museum Association. The twelve trustees were Stanley G. Burt, Albert H. Chatfield, Nathaniel Henchman Davis, Joseph Henry Gest, Edward Goepper, Charles J. Livingood, Elliott H. Pendleton, Harley T. Procter, Miles T. Watts, William Worthington, Lucien Wulsin, and John D. Wareham. If the number of trustees fell below five, cotrustees were to be appointed to the number of five.

The will specified that the trustees were to receive all dividends paid on the stock and, after paying expenses of the trust, could either accumulate them or use the proceeds

> towards the benefit and improvement of the said Rookwood Pottery Company, its plant, equipment, product, and employees, by purchase and gift to it of additional property, machinery, tools, ceramic ware, books, or appliances, or by constructing new buildings, or by gratuities to any of the officers or employees of said company, or by the offer of prizes to be competed for by any class or classes of such employees, or by gift directly to said company, or in any other manner whatsoever which in the judgment of the trustees will promote the welfare of the company.

The trustees were also empowered to sell shares to any employee of Rookwood if they thought it desirable to do so, with the proceeds from such sale going to the Cincinnati Museum Association. Should the pottery be dissolved, go into liquidation, or become bankrupt prior to the termination of the trust, the trust would terminate. At the end of twenty-one years after the death of the last of the original trustees, all the shares held by the trust, together with all accumulated income, was to pass to the ownership of the Cincinnati Museum Association with the further provision that the

Association should hold same in its endowment fund, "keeping the principal thereof safely invested, and using the income only for the support and maintenance of said Association."

Two other provisions of Taylor's will also pertained to Rookwood. One left $2,000 to be distrib-

uted among present employees who had been with the pottery more than five years; the other bequeathed legacies to two members of the Rookwood decorating staff: Sallie Coyne was left $500 and Caroline Steinle $250.

Courtesy Sheraton Hotels

Rathskeller Room in Louisville's Sheraton Hotel, formerly the Seelbach, shown today, much as when installed.

ROOKWOOD
POTTERY
VIEW OVERLOOKING CITY

Part IV

1914–1934

Joseph Henry Gest

Joseph Henry Gest

Joseph Henry Gest was born in Cincinnati, Ohio, April 24, 1859. He received his early education from private tutors, and later studied in Europe prior to entering Harvard College, from which he graduated with the Class of 1880.

He then joined his father's firm, Gest-Wilkenson, in the soap-manufacturing business in Cincinnati, where he stayed for three years. Finding commercial enterprise not to his liking, he turned to the greener pastures of "Winterbourne," the farm of an uncle, Erasmus Gest, located across the river from Cincinnati, just south of Newport, Kentucky. Here he engaged in the raising of fine cattle and the operation of a dairy, which was the first in the area to attempt the introduction of the glass milk bottle[1].

In September, 1886, still seeking an outlet for his artistic interests, he became associated with the Cincinnati Museum Association, which maintained the Art Museum and the Art Academy. He was assistant director, and in 1902 was named director and secretary of the Association, which positions he held until he retired in 1932 and became director emeritus. He was also secretary of the Municipal Art Society in Cincinnati from 1894 until 1914, when he was elected a trustee.

Gest's association with Rookwood began in 1901. He was elected vice-president and director in 1902.

[1] The attempt was abandoned because housewives kept the new glass containers for packing and preserving rather than returning them to the dairy.

Chapter 16

A special meeting of the Board of Directors was called for January 23, 1914, to fill the offices of president and treasurer made vacant by the death of Mr. Taylor. Joseph Henry Gest was named president, and Edward Goepper, member of the board and a trustee under Taylor's will, was elected treasurer. John D. Wareham, head of the decorating department, was named vice-president, and Stanley G. Burt was continued in the office of secretary.

Just as Mrs. Storer had felt that Rookwood was established "as a permanent art industry" when she transferred her interest to Mr. Taylor in 1889, so also did Taylor believe that he had left the best possible provision for its perpetuation. Continuation of his basic policies and philosophy seemed assured by the continuity of management. The twelve-man board of trustees included all the officers and directors of the Rookwood Pottery Company.

Business at the pottery went on much as it had before. As president, Gest continued the practice of dividing his time between the museum and the pottery. He went to his office at the Art Museum each morning at 8:30 and remained until noon. He then lunched at the Queen City Club, frequently in company with John D. Wareham or Stanley Burt, and spent the afternoon at the pottery, where he devoted his attention to broad policy matters, to the pottery's relations with the Art Academy, and to planning details of advertising and sales promotion. He left the responsibility for day-to-day operations largely in the hands of Wareham and Burt. Perhaps because he had been associated longer with the museum, or considered his position as director of the Museum Association more impor-

tant, he always named the museum first in listing his business affiliations, and gave his business address as the Art Museum in Eden Park rather than the Rookwood Pottery on Mt. Adams.

Gest also was active in civic affairs as well as art circles, and enjoyed writing articles and speaking on art subjects.

Vice-president John D. Wareham directed artistic activities. He supervised the work of the decorators and encouraged them to design new shapes. By 1914, there were approximately 2200 shapes in the art pottery line. Many of the new designs made in this period were created by Wareham, who would dash off a quick sketch from which a model would be executed by the potter.

Among the decorators, Sara Sax, Lenore Asbury, Helen McDonald, Marie Denzler, Helen Lyons, and E. T. Hurley designed new shapes that went into the line, and Kataro Shirayamadani devoted practically full time to this activity. Ernest Bruce Haswell, later a well-known Cincinnati sculptor, worked in the Rookwood architectural department, and also found time to create several designs.

Many of the new vase shapes made in this period were essentially modifications of existing patterns. A new design, either incised or in relief, was added to the surface of an earlier shape, so that it could be cast in a single operation. As these pieces were produced in quantity, a change was made in Rookwood literature some time after 1913. Before then, the claim had been, "Absolutely no printing patterns are used nor any duplicates made." This was modified to read, " . . . nor any duplicates made of signed decorated pieces."

101

Rookwood fountain on the main floor of Baer-Kaufman Department Store in Pittsburgh, installed about 1917, was designed by Clement J. Barnhorn.

Wareham also created designs for many projects of the architectural department. He would make water-color sketches showing all the design detail: the walls, ceilings, floors, columns, and any special ornamentation. His sketches would be enlarged photographically to *actual size*, to serve as full-scale blueprints from which the clay tiles were planned and fitted to exact measurements. In this way it was assured that a panoramic scene composed of many individual tiles would present a perfect picture and fit exactly into its allotted space without any cutting or adjustment on the job.

Stanley Burt assumed administrative responsibility for all production and research. To free him of the day-to-day detail of plant operation, Otto Metzner was named plant superintendent and

given a partially retroactive salary increase of $300 for the year 1914.

At Easter, 1915, Rookwood marked its thirty-fifth anniversary by the introduction of "Rookwood Soft Porcelain," a new semitranslucent body material. Ware made from it was identified by a letter "P," usually placed on its side, impressed in the base. It was widely promoted as a "new discovery," and a special display featuring the name was designed by William Hentschel. Company literature declared, "As usual, it represents years of chemical research and kiln trials, and is characterized by rich, heavy, single-color glazes flowing over forms perfectly plain or enriched with subtle low-relief modeling, or sometimes design flatly painted on the clay body."

The war in Europe in 1915 had little impact on the pottery. Elsewhere in Cincinnati, however, the effect on the city's large German population was marked. The language had been taught in most of the schools, some conducting classes in German for half the day from the first grade up. When Belgium was invaded and stories of the German atrocities reached Cincinnati, anti-German sentiment ran high. German was abolished in the city schools, and many second- and third-generation German families anglicized their names. Decorator Elizabeth Lingenfelter changed her name to Elizabeth Lincoln. Kataro Shirayamadani left Rookwood about this time to return to Japan, where he is thought to have taken a position working for the Japanese Government.

When 1917 saw the entry of the United States into World War I, work at the pottery went on with minor interruptions. There were temporary changes in the staff as a number of the young men and women volunteered for service with the armed forces or auxiliary services. Cecil Duell enlisted, as did Sturgis Laurence and others in the New York office. Still others joined the S.A.T.C. (Students' Army Training Corps) to prepare for a commission. Gest coordinated special classes for the students at the Art Academy and the decorators at the pottery for "direct application of their training and talents" to aid the war effort. They were instructed in observation and sketching of the surrounding terrain, which might be useful in map-making or reconnaisance.

In October 1917, *Art World* published an arti-

cle on Rookwood faience by Ernest Bruce Haswell, which described several new installations, including a series of large murals designed for the Chase Theatre in Washington, D.C., a fountain in the cut-flower department of Lord & Taylor in New York, and a large fountain on the main floor of the Baer-Kaufmann Department Store in Pittsburgh.

Several of the decorators supplemented their income by doing free-lance art work, and built up attractive sidelines. Sallie Toohey, for example, prepared colorful floral designs for tin candy boxes for the Heekin Can Company. Heekin also became one of Fritz Raymond's free-lance photographic accounts.

Rookwood established a "Bride's Register," in which a bride-to-be could list her preferences for Rookwood wedding gifts. It is said that almost no wedding of importance in the Cincinnati area took place during the 1920's without the bride's being listed in the register. Rookwood was extremely popular to give and to receive.

Business continued on a favorable basis into 1920, and on May 1, a dividend of 5 per cent on the common stock was paid. In an attempt to widen the market for the vase department, Rookwood introduced a number of new shapes based on Persian and Chinese pottery designs.

During the summer of 1920, the pottery produced a special order for the Commercial Club, described in the *Cincinnati Times-Star* of Oct. 23:

COMMERCIAL CLUB'S GIFT IS FIRST ROOKWOOD TABLEWARE

Dozen Plates, Marking a Departure in the Institution's Artistry to be Given to Host and Hostess at The Meadows

A dozen service plates, each a distinctive work of art, are to be a gift of the Cincinnati Commercial Club to Mr. and Mrs. Thornton Lewis, in appreciation of their entertainment of the members of the organization at The Meadows, White Sulphur Springs, last May. The plates are the creation of Rookwood Pottery, and mark a distinct departure for that institution, for they are the first tableware ever turned out by Rookwood. Gorgeous, yet tasteful coloring sets off the plates, and places them in the category of the leading creations of Cincinnati's famous pottery. There is no mistaking them as Rookwood

Garden pottery and ornaments like the samples shown were executed to special design.

work. The center of the plates is a turquoise blue. The rims are bluish mauve, with a design done in blues, greens, blacks and yellows. Three coats of arms are on each plate—the Harrison coat of arms—both Mr. and Mrs. Lewis being members of different branches of the Harrison family; the Lewis coat of arms, and the coat of arms of the Commercial Club. The plates are in two patterns, to alternate on the table, six of them having a lattice work effect on the rim, while the others are plain. On the back of each plate is inscribed the following:

TO MR. AND MRS. THORNTON LEWIS,
In Remembrance of the Visit of
the Commercial Club of Cincinnati,
at The Meadows,
May 30, 1920

Before the plates were shipped, they were displayed in a window at Loring Andrews in downtown Cincinnati.

The reference to Rookwood's "first tableware" is not wholly accurate. This may have been the first formal dinner service produced by Rookwood, but it overlooks the blue ship-design tableware Mr. Broomfield painted in the early 1880's, as well as

the miscellaneous cups and saucers, tea and coffee services, and plates and platters made over the years. Perhaps the special order called attention to Broomfield's early efforts, for it led to a revival of the blue ship dinnerware, which, during the next three years, was developed into a complete table service by the addition of new items.

The early pieces executed by Broomfield carried no Rookwood mark. Those produced in the 1920 revival of the pattern were impressed with a plain R-P monogram (without flames), and numbered to identify the size or style. Some carry a date. Typical are:

8″ salad plate	M6
Butter plate	M7
Saucer	M9
Cup	M10
Teapot	M15
Sugar bowl with lid	M19
Oval vegetable dish	M25
Cereal dish	M26

10″ oval platter	M30
Cream soup cup	M31
8¾″ luncheon plate	M33
Cream soup saucer	2710 and date 1923
Covered dish	2800 A and date 1924
Individual creamer	2800 B ″ ″ ″
Individual sugar	2800 C ″ ″ ″
Individual chocolate pot	2800 D ″ ″ ″
Individual coffee pot	2800 E ″ ″ ″
Egg cup 4½″ high	2800 F ″ ″ ″
Individual tea pot	2800 G ″ ″ ″
Egg cup 3¾″ high	2800 H ″ ″ ″

Difficulties in production, particularly in preventing the blue glaze from spotting the white surface of the ware, caused many pieces to be marked as seconds, and a high percentage of these were marked again as "give-away" items when they failed to sell at reduced prices.

In 1920 Rookwood celebrated its fortieth anniversary with a revival of its famous Tiger Eye "in

Salesroom at Mt. Adams in the early 1920's. Table and bench in center foreground have legs molded of Rookwood faience.

a new and more varied range of color," usually in shades of yellow-green. Although finished in an aventurine or crystalline glaze, the new ware lacked the deep luminescent beauty found in the original Tiger Eye.

In describing Rookwood's fortieth anniversary celebration, a reporter of the *Times-Star* rehashed much early history in his story of November 27, 1920:

It was just 40 years ago that the first little Rookwood kiln gave forth its Opus No. 1, under the guidance of the founder, Mrs. Bellamy Storer, and her little group of assistants.

Today there are 15 large kilns, 200 art workers and the fame of Rookwood has spread all over the world. The great museums of every land exhibit its creations and tens of thousands of Rookwood objets d'art decorate American homes and gardens and foreign palaces and castles.

Under the direction of Mrs. Storer, W. W. Taylor and J. H. Gest, the latter now its president, Rookwood has achieved the position of unquestioned leadership among America's art potteries. Rookwood is one of the most fascinating show places of Cincinnati. Thousands of visitors from all parts of the globe inspect the institution every year, and a visit to Rookwood is on the entertainment programme of every convention that comes to the city.

It was a piece of Rookwood of the famous Tiger Eye type that won the Grand Prix at the Paris Exposition in 1900, and this wonderful vase, which may be seen in the display at the pottery, has been valued by some at $50,000. Rookwood has brought to Cincinnati gold medals of highest awards at expositions in London, Petrograd, Turin, St. Louis, Buffalo, Jamestown, Philadelphia, Seattle and other cities. . . .

Rookwood has branched out into the production of beautiful artworks in the form of garden furnishings, fountains, panels, table services, and decorations for home interiors.

The officers' club at Fort Monroe is decorated in Rookwood; it was a piece of Rookwood pottery that Queen Elizabeth of Belgium selected as a souvenir of her visit to Cincinnati; ships on the high seas have Rookwood panels; great skyscrapers in New York, rear into the clouds, their pinnacles capped with Rookwood tile; magnificent country estates throughout the land are beautified with interior and exterior adornments from the Mt. Adams pottery; Rookwood ornaments the waiting room at the new court-house, and every President for forty years has received from admirers gifts of Rookwood. . . .

No record has been found of the New York skyscrapers "capped with Rookwood tile." Nor, surprisingly, are the names of ships with decorated panels listed in any of the records found, although a number of ship-design and seascape panels are illustrated in the architectural catalogs.

One architectural installation, well known to every Cincinnatian, that still exists much as first installed is Mills Restaurant. The Rookwood tiles were designed and produced in 1920, and the restaurant opened the following year. Sallie Toohey is credited with the design of the murals of Dutch scenes, and William McDonald designed the ornamental open grillwork. A companion restaurant of the same name in Cleveland was also decorated with Rookwood faience. Another fine example in Cincinnati is the recently renovated exterior storefront of Gidding's, now Gidding-Jenny Inc., on West 4th Street.

Financially, the fiscal year ending January 31, 1921, "showed the largest business and profits ever had by the pottery and from present indications, should continue." A 10 per cent dividend was declared on March 4, 1921. The records also note that there was "a major increase in the vase department [sales] in February and March 1921 compared with the two months of the year earlier."

Chapter 17

The visitors' register at Rookwood showed that four or five thousand people made the trip to the Mt. Adams site each year during the 1920's. Such visits were very effective in stimulating sales, and the tour of the pottery was advertised in local programs, guide books, and similar media. Every visit by a famous or internationally known figure provided publicity in the local press. Through the years the roster of famous visitors included Mark Twain, John Galsworthy, Eleanor Robeson, Mrs. Pat Campbell, E. H. Sothern, Julia Marlowe, Lillian Russell, George Arliss, Mme. Schumann-Heink, John Philip Sousa, and Robert Carter, the archeologist who discovered King Tutankhamen's tomb. Actor Joe Jefferson on frequent trips to Cincinnati spent many mornings in the studio of Kataro Shirayamadani, where he painted plaques. Anton Lang, who played the part of the Christus in the Oberammergau Passion Plays and was a potter by trade in his native Bavaria, donned a smock and turned out a number of pieces on the wheel.

Frequently a special piece was thrown in honor of a famous visitor, who then signed it. When fired, it was sent to his home. Usually on such occasions two pieces were made, as nearly identical as the hand of the thrower and decorator could turn out. This was to guard against the possibility that one might come to some accident in the kiln. For example, Queen Elizabeth of Belgium signed two pieces, one of which was sent to her, the other retained in the showroom collection at the pottery, where special pieces were kept on permanent dislpay.

Rookwood was one of the first to promote the use of colored tile for the home bathroom in

Anton Lang throwing a vase on the wheel. Directly behind him are Earl Menzel and John D. Wareham.

competition with the sterile white. It was widely used for this purpose in the more expensive Cincinnati homes built during the 1920's. One example

Mt. Adams Incline Railway provided a direct route to the Rookwood Pottery on the top of the bluff (left) *overlooking the city.*

was the Fleischmann residence, which had nine bathrooms of Rookwood tile.

A 10 per cent decline in sales in 1921 reflected the business conditions of the year, but the profits nearly equaled the record prior year, and two 5 per cent dividends were declared—in April and July, 1922—reflecting the optimism that prevailed even that early in the decade.

In May, 1922, Gest registered three trademarks of the company: the name "ROOKWOOD" as first used in November, 1880; the plain R-P monogram as first used in June, 1886; and the R-P mark with fourteen flames first used in January, 1900. The registration was granted by the United States Patent Office on May 30, covering "pottery ware made from burned clay, whether glazed or unglazed."

An honorary degree of Doctor of Humane Letters was conferred upon President Gest by the University of Cincinnati at the commencement exercises, June 17, 1922.

For the fiscal year ending January 31, 1923, Rookwood Pottery Company reported a *net* profit of $52,291.76, a new record, and the directors declared a quarterly dividend of 2 ½ per cent on the common stock, payable for the next five quarters. This action was repeated the following year, when, on April 24, 1924, the quarterly dividend of 2 ½ per cent was ordered paid through the March quarter of 1925.

It came as a temporary shock, therefore, when the books were closed for the fiscal year 1924 and showed a *net loss* of $19,907.13 for the year ending January 31, 1925.

Coincidentally, trouble arose in adjustment of the company's income tax, the Internal Revenue Department claiming the pottery owed additional taxes amounting to approximately $25,000, including interest. The difficulty stemmed from the method of valuing the art pottery inventory. Rookwood still followed the practice of shipping ware on consignment, and received payment only as it was sold by the retail stores. This worked quite satisfactorily, except that the pottery now had an inventory of unsold merchandise valued at nearly a quarter of a million dollars distributed among approximately 150 "agents" throughout the country.

On April 16, 1925, J. F. Hagedorn, assistant manager of the Cincinnati office of Ernst & Ernst, Rookwood's auditors, wrote Gest explaining the problem as follows:

> In the past, you have used as a basis the cost of sales for providing the necessary reserves which resulted in obtaining a conservative valuation at cost. This method, however, was not acceptable to the representative of the Treasury Department, and they have adopted a method whereby a percentage is obtained upon the basis of the production cost, and revised your inventory valuation since Jan. 31, 1916 to Jan. 31, 1922. . . .

Gest and Burt made several trips to Washington to defend their position, but did not succeed in having the claim reduced. The matter was argued back and forth between the pottery and the Internal Revenue Department for more than a year before it was finally taken to court. In the meantime, the company made no provision for the payment of the assessment in case of an adverse decision.

About this time, the pottery introduced a new type of decoration having the thin effect of water colors with indistinct floating outlines.

After an absence of approximately ten years, Kataro Shirayamadani returned to Rookwood from Japan and resumed his position as a decorator.

By the end of 1925, the number of shapes of art pottery had reached 2800.

The agents that handled Rookwood art pottery were usually leading retail establishments in each city. Tiffany still held the franchise in New York City; Marshall Field represented Rookwood in Chicago; L. Bamberger & Co. acquired the franchise in Newark, N.J.; Hutzler Bros. was the agent in Baltimore; Wm. Cameron & Co. handled the ware in Forth Worth and Waco, Texas. Edward Madison Co. in Montclair, N.J., and R. H. Muir in East Orange, N.J., were typical of the retailers in the affluent suburban communities, which were good markets for the sale of art pottery.

A similar selective distribution policy was tried with less success in the architectural field. Rookwood "approved" only one tile contractor in each city, but this practice was difficult to enforce, particularly since competition in the architectural field

was beginning to be more noticeable. Newer plants, equipped with tunnel kilns for continuous production, and having railroad sidings for more favorable transportation, made the business increasingly competitive. While the popularity of colored tile for bathrooms and kitchens continued to grow, the use of decorative tile for commercial building was decreasing as newer and less costly materials became available. As a result, the volume of work in the architectural department steadily declined from 1925 to 1929.

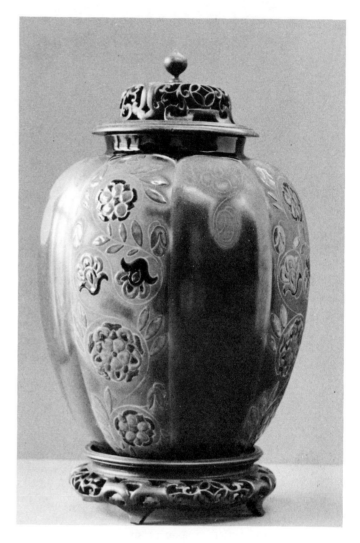

Rookwood vase, 12 inches high, presented to Charles A. Lindbergh by the women of Cincinnati, has top and stand made of teak. It was decorated by Sara Sax in an unusual combination of high and dull glazes, with blue floral motif and deep rose lining.

Vase sales continued to increase, however. For 1927 they were nearly 10 per cent ahead of 1926, and business as a whole reflected the exuberance of the times.

In 1927, following his historic flight to Paris, Charles A. Lindbergh was presented with a Chinese-style Rookwood vase by the "women of Cincinnati." Now in the custody of the Missouri Historical Society, it is on display in the Lindbergh Gallery of the Society headquarters in the Jefferson Memorial Building in St. Louis.

Another interesting presentation piece was a vase made in 1928, designed by E. T. Hurley and inscribed with the legend "TO PRESIDENT MACHADO FROM THE COMMERCIAL CLUB OF CINCINNATI." It was presented to the President of Cuba, Machado y Morales, in 1930 in recognition of the courtesy his government extended to the members of the club on their visit to Havana that year. The piece was refired to fuse the legend.

On April 20, 1928, it was noted in the record that the boilers had been condemned "on account of age and bad condition." An engineering firm advised purchasing two new boilers for general use and reconditioning the best of the old ones for additional low-pressure heating service when needed, at an estimated cost of $15,000. No action was taken because the funds were not immediately available.

Seven new artists joined the decorating staff in the period from 1925 to 1930. They were Elizabeth Barrett, Catherine Covalenco, Wesley Pullman, Wilhelmine Rehm, Delia Workum, Jens Jensen, and Janet Harris. Neither Miss Workum nor Mrs. Covalenco was listed among the decorators in the Rookwood pamphlets because no new edition of the pamphlet was issued during the time they were employed.

Miss Workum joined Rookwood in 1927. Asked for recollections of her association with the pottery, she wrote:

> I only wish I could contribute some really meaty material. I was there for such a short period, and at the time—way back then—I was one of the "younger" decorators. Mr. Hurley was the most colorful character and all of us used to enjoy his comments on practically any subject. The decorators whose

Bottom of presentation piece decorated by E. T. Hurley that was given to the President of Cuba.

work particularly impressed me then were Lorinda Epply and William Hentschel, both of whom produced work which was a real inspiration. Those of us who were "new" chafed a bit, I'm afraid, at the requirements stemming from the sales department, to produce certain wares which "sold" rather then those we most admired, but t'was ever thus! The atmosphere of the place—literal as well as figurative—the smell of the wet clay and glaze and the "damp room"—the fascination of watching a pot being thrown on the wheel, which never lost its lure no matter how often we saw it—the excitement when a kiln was "pulled" and seeing what turned out and how—all this plus the pleasure of working in a situation where there was little pressure from the management, and except for the above mentioned limitations imposed by the sales department, there was great freedom to produce what we chose. It was a happy time for me.

Miss Workum left the pottery in 1929 to be married. Her enthusiastic reminiscences are typical of those of many of the decorators—the artists thoroughly enjoyed the congenial atmosphere.

Of course, occasional problems did arise involv-

ing some of the personnel. In order to discourage employee pilferage, Edward Black, a fireman on the night shift, was stationed at the gate to inspect packages taken out by the workers. On June 16, 1929, Charles Smith, an engineer at the pottery, came out carrying a suitcase and refused to open it. An altercation followed during which Black shot Smith three times in the heart. Black was convicted of manslaughter and sentenced to serve ten to twenty years in the Ohio Penitentiary.

A decision of the U.S. Board of Tax Appeals in 1928 ruled a deficit of $19,873 in income taxes was due the government. To prevent an immediate assessment, an appeal bond of double the amount of the deficiency was required. The American Surety Company arranged to issue the bond on the condition that Rookwood put up collateral in the amount of $15,000. As the pottery was short of liquid assets, this amount was loaned by the trustees. Action was still not taken on replacing the condemned boilers because of the heavy expense involved. Although the volume of sales in the vase department continued high, costs were also higher and the margin of profit had narrowed considerably.

When the bubble burst in Wall Street in the fall of 1929, Rookwood was low on cash. The bulk of the firm's assets, aside from the land and building, was its inventory—some $250,000 worth—of unsold merchandise in the hands of agents from New York to San Francisco.

At the end of the year Harold F. Bopp was named superintendent. Stanley Burt retired from his position at the pottery but remained on the Board of Directors.

Few records have been found to make clear how Rookwood made contact with the trade on its art pottery line. Davis Collamore & Co. discontinued representing the pottery as national sales agent shortly before 1920. Rookwood was consistently advertised in the class magazines of the period. *Spur, Town & Country, Arts & Decoration, House & Garden, House Beautiful,* and *Country Life* were used to reach the homes "representative of the best in American life, both in culture and discrimination." Most of the contact with the stores appears to have been by direct mail. If and when a situation requiring personal attention developed, a representative was sent from Cincinnati. During the summers of 1929 and 1930, decorator Wesley Pullman spent some time as "sales representative" calling on the trade in New England and the Middle Atlantic States, but so far as is known the pottery employed no regular salesman.

Chapter 18

Christmas represented the pottery's best sales season, normally accounting for as much as 35 per cent of the year's total. However, holiday buying fell sharply following the market crash in 1929 and, coupled with a generally poor fourth quarter, reduced the year's total to $268,357, compared with $313,155 for the previous year.

The architectural end of the business, which had been declining steadily for several years, was practically at a standstill. The staff had been reduced to the point where only supervisory personnel remained. Early in 1930, the directors discussed discontinuing it altogether because there was "less business and less in sight than for a very long time." However, the consensus was that a time when building was particularly slow was not a fair measure of the possibilities, and no decision was made.

Replacing the condemned boilers could not be put off any longer. The problem of financing the work was solved by borrowing $17,300 from the income accrued to the trust under the Taylor will.

The board of trustees at that time consisted of Messrs. Gest, Wareham, and Burt of Rookwood, with Harry F. Woods and Charles J. Livingood as outside members. As the trust was instructed to help the pottery in every way possible, the assets of the trust were considered almost as assets of the pottery. It was therefore no problem to borrow on favorable terms from this source as long as funds were available.

In eight months preceding Oct. 1, 1930, the pottery showed a loss of $25,350. Gest reported "this was taken care of by an increase in bank loans from $25,500 on January 1, 1930, to $49,000 on September 30, 1930." The phrase "taken care of" is somewhat of a misstatement, but it should be remembered that Gest, primarily an artist and not a businessman, was not at home in finance. An aggressive sales campaign was undertaken to increase the number of agencies. The policy of limiting sales to one agent per city was discontinued. Wesley Pullman, traveling as a part-time sales representative, helped to open fifteen new accounts, including Strawbridge & Clothier in Philadelphia and B. Altman & Co. and Beaux Arts Shade Company in New York.

In view of the general Depression, it was decided not to go into any heavy expense in celebrating the fiftieth anniversary on Thanksgiving Day, 1930. John Wareham suggested inviting stockholders and a few others to the pottery "to see a kiln drawn, as was done when the original kiln was drawn in November 1880." This celebration was held as planned, the event widely reported in the local press. More than one hundred friends, decorators, and other employees joined the stockholders and trustees at the pottery on the afternoon of Thanksgiving Day to watch the opening of the kiln. The guests wandered around the building, visited the artists' studios, watched Earl Menzel, the master potter, working at the wheel, and examined again the interesting pieces displayed in the showroom collection.

Then a signal was given that the anniversary kiln was ready to be drawn. The group gathered in the big pottery workroom, where President Gest spoke briefly of the history of the company: how

Mrs. Storer had founded it as an artistic rather than a business enterprise; how Mr. Taylor had continued these policies and on his death had willed his interest in the company to a group of trustees who were now carrying on these policies. The article in the *Times-Star* continued:

> The group listened quietly while Mr. Gest spoke, and when he finished there was a moment of expectant silence, so that you could almost hear the snow falling outside. Then the workmen began to tear away the bricks that sealed the kiln entrance. They stacked them on either side of the doorway and sprinkled water on them to settle the dust. Then began the business of removing the pottery. First came two cleverly modeled animals which won a chuckle from the crowd—a Democratic donkey and a Republican elephant.
>
> Next a gorgeously decorated slate-blue vase, almost three feet tall. Other pieces followed in quick succession—ivory figurines, modernistic ashtrays, exquisite bowls, vases, pitchers, candleholders. Soon the room was overflowing with pottery and laden trays of it were taken into other rooms.

Clara Chipman Newton was the guest of honor for the occasion, and was given first choice of the pieces drawn from the kiln, each of which carried a special fiftieth anniversary mark. She selected a small round vase, attractively glazed in gray with bright touches of red and black.

The work of twenty-three decorators was included in the anniversary kiln: Louise Abel, Lenore Asbury, Elizabeth Barrett, Sallie Coyne, Edward Diers, Lorinda Epply, Janet Harris, William Hentschel, Edward Hurley, Jens Jensen, Katherine Jones, Elizabeth Lincoln, Margaret Helen McDonald, William P. McDonald, Wesley Pullman, Wilhelmine Rehm, Fred Rothenbusch, Sara Sax, Kataro Shirayamadani, Amelia Sprague, Sallie Toohey, John D. Wareman, and Harriet E. Wilcox.

When the task of unloading the kiln was completed, tea was served in the pleasant window-lined salesrooms. The blue ship tableware was used, and the room was decorated with floral arrangements in appropriate Rookwood vases.

By the third week in January, 1931, Wareham reported the anniversary pieces had been in great demand and were nearly all sold. One of these was purchased by the Chamber of Commerce of Cincinnati, and "sent by airplane to President and Mrs. Hoover as a stimulus to the use of airplane parcel post. A special newsreel movie film of this event was shown all over the country." The Commercial Club of Cincinnati also presented three of its members with pieces from this kiln.

At the annual stockholders' meeting in 1931, Gest reported that sales had declined to $196,250 and the company's net loss for the year was $47,313. Although expenses had been trimmed, bank loans had increased and additional money had been borrowed from the trustees. Gest proposed a new issue of 1200 shares of preferred stock, which was authorized by the shareholders, but there were few buyers: only 140 shares were sold for cash; 360 were accepted by the trustees in payment for their loan to the company.

By June the pottery was still operating at a loss. Although the dividends of the preferred stock were ordered paid when due, it was estimated $25,000 more would have to be borrowed by the end of the year to meet expenses. Somehow additional loans were obtained from the bank, bringing the total up to $83,500, but by October Gest reported to the board that no further increase in bank loans could be secured. It was reluctantly decided, therefore, that the pottery be shut down and the manufacturing departments closed for "as long as necessary to balance the budget." Actually, there was no other choice.

At a directors' meeting on October 27, a dividend of *one cent a share* was declared on the common stock. The purpose can only be surmised. Perhaps the directors thought that the declaration of *any dividend* would gain publicity at a time when most firms were forced to pass all payments on their common stock.

In an attempt to turn the inventory into cash, prices on Rookwood were reduced 30 per cent on November 1, and the discount to agents was increased. Agents were also given an extra 10 per cent discount for prompt payment, since money was tight and collections abnormally slow.

The Depression went inexorably on its way. Sales for the year ending January 31, 1932, fell to $128,008, but expenses totaled $171,254, resulting in a net operating loss of $43,246. The 30 per cent

price reduction also reduced the pottery's inventory value, and showed an additional loss on the books amounting to $43,700.

In explaining these disheartening results to the stockholders, Gest said:

Since last fall when a limit was reached in bank loans, members of the Board of Directors have been in continuous touch with our financial affairs, advising and helping in every way, working toward a balanced budget . . . payrolls are cut more and more, production being limited to orders and to ware that proves to be of quick sale under existing business conditions. Such limited operations as continue follow methods of increased efficiency under very careful study. . . .
Within the year we won our suit in the U.S. Circuit Court against the government in the matter of additional income taxes for the years ending January 31, 1921, 1922, 1923, 1924, 1925, and 1926, settling in full for $7,266.02 an assessment of $19,873.01, with interest a total of about $23,000.

These words are typical of his manner of expression. Saying that Rookwood *won* the tax suit against the government was his attempt to present the situation in the most favorable light.

The work force in the potting and mechanical departments had been cut to the bone. Necessary maintenance was carried on by Harold Bopp, Earl Menzel, and John Reichardt, who put in three days a week.

In April, 1932, the directors took no action on the dividend for the preferred stock. A budget forecast showed estimated sales 20 per cent below costs. One order for architectural tile for the new Cincinnati Union Station provided employment for a few workers for several weeks.

Mrs. Maria Longworth Nichols Storer died on April 30, 1932, at the age of eighty-three, at the home of her daughter, Countess Margaret de Chambrun, in Paris, where she had lived for a number of years.

By the end of the year expenses had been trimmed to $73,000, largely by stopping all work in the decorating room. Most of the long-time decorators had been laid off; a few were given occasional work if and when special orders were received.

Elizabeth Lincoln, who had started at Rookwood in 1892, took a job as a cleaning woman in the housekeeping department at Christ Hospital at a salary of $75.00 per month; Louise Abel secured temporary employment on a WPA project at the Trailside Museum in Burnet Woods; Wilhelmine Rehm and Janet Harris, unable to find employment, pooled their savings and made a trip to Europe. Katherine Jones was more fortunate—she got a job in the art department of the Gibson Greeting Card Company. For the country as a whole, the unemployment level rose to 12 per cent of the working force; men sold apples on street corners to earn enough to eat; others were forced to turn to the bread lines and soup kitchens that were set up to feed the hungry.

At the beginning of 1933 the officers' and office employees' salaries were cut, but there was not enough cash available to pay even the reduced salaries. Only partial salaries were paid; the balance was accrued. A list of "key employees" put on this basis shows:

Key Employees	Regular Salary	Reduced to	Paid in 1933
J. H. Gest	$6,000	$4,000	$1,560
J. D. Wareham	8,500	5,667	1,465
H. Bopp	4,200	2,800	1,000
E. Schildknecht	4,200	2,616	1,850

Such experiences were not confined to Rookwood; they were the order of the day in many businesses. Reductions in salary of 30 and 40 per cent were not uncommon, and deferred or accrued payroll accounts were resorted to in many companies where cash was short. Times were indeed rough all over.

The Rookwood management decided reluctantly that the pottery was not warranted in arranging for a special exhibit at the Century of Progress, as the 1933 Chicago World's Fair was called. The fact is that in 1933 Rookwood could not afford the cost of an exhibit. However, they arranged to ship a large number of pieces to Marshall Field, where they were displayed in a special ceramic exhibit for the duration of the Chicago Fair.

In the fall of 1933, three members of the board, Walter A. Draper, president of the Cincinnati Street Railway Company, Lucien Wulsin, president of the Baldwin Piano Company, and Frederick A. Geier, president of the Cincinnati Milling Machine Company, were named a committee to work out a

further plan for refinancing the pottery. However, Mr. Geier died before the committee could accomplish its mission.

Apparently new loans were sought from prominent businessmen in the city, and sufficient new money was obtained from these sources to keep the pottery operating on a minimum level. Rookwood had been a part of the art and cultural life of the city for so long that it had many friends among the leaders of the business community. Also, both Gest and Wareham were well known in Cincinnati business circles and were well acquainted with influential people. One of the benefactors was Charles F. Williams, president of the Western and Southern Life Insurance Company, who had started as a boy selling life insurance at ten cents a week.

The year ending January 31, 1934 showed a further net loss of $47,478. Sales dropped to $63,951, but expenses were approximately $111,500 in spite of the further withholding of officers' salaries.

Gest was quite disheartened that the situation, which he neither liked nor fully understood, seemed incapable of solution. Therefore, partially out of frustration and partially out of desire to relieve Rookwood of the burden of his salary, he resigned as president. He remained a director, and in recognition of his long record of association with the pottery, was named Chairman of the Board, a title created for the occasion.

Part V

1934-1954

John Dee Wareham

John D. Wareham

John Hamilton Delaney Wareham was born in Grand Ledge, Michigan, January 27, 1871, the second son of Julia (Delaney) and Hamilton Wareham.

After he graduated from Grand Ledge High School, he enrolled at the Cincinnati Art Academy, where he attracted the favorable notice of W. W. Taylor. He joined the decorating department at Rookwood in 1893, as John D. Wareham. He rarely used the name Hamilton and substituted the initial D. for Delaney, shortly changing it to "Dee," a nickname by which he was known to his friends.

Over the years, Wareham became an unofficial roving art director in the city of Cincinnati: The Queen City Club never did any redecorating without first getting his ideas; the Music Hall consulted him whenever it came time for repainting the interior; for many years he took charge of the floral arrangements and other decorations for the dinners, parties, and outings of the Commercial Club. He was also a member of the Municipal Art Society, the Duveneck Society of Painters, the MacDowell Society, the Cincinnati Art Club, a director of the Crafters Co., and a trustee of the Music Hall Association. He collaborated with the architect in the interior design of the Central Trust Bank, for which he composed a mural made entirely of pieces of colored marble.

One of his hobbies was hybridizing iris, and he developed several new varieties. Always immaculately groomed when he left home in the morning, he would frequently stroll through the gardens before going to the pottery; as a result he was known to the Rookwood employees as "the man with the muddy shoes."

Chapter 19

When John D. Wareham succeeded J. H. Gest as president in 1934, he had been with Rookwood forty-one years and served, successively, as a decorator, head of the decorating department, and vice-president. He was the one remaining link with the Taylor management, which had established the policies that built Rookwood into the foremost art pottery in America.

Wareham was both inspirer and arbiter of the art end of the business; he also knew the clays, glazes, colors, and materials as did no one else. Not only was he himself an artist of the first rank, but he was capable of bringing out the best artistic endeavors in others. In describing his contributions to the pottery, one director said, "Without John D. Wareham, the artistic and creative side of Rookwood would have been without a soul."

Wareham was also a great showman and personal salesman. He thoroughly enjoyed conducting famous visitors through the pottery and explaining what went into the making of the finest art pottery in the world. It reflected his personality that he drove about the city in a sixteen-cylinder Cadillac equipped with a special radiator cap decorated with three flying horses made by Rookwood.

That John Wareham was not primarily a businessman was a fact appreciated by the other members of the board. They convinced him that he needed a capable general manager to take charge of revamping sales and other policies that had become outmoded. Thus, when he inherited a sick business, a mere shadow of a once robust firm, his two major problems were the management of an unmanageable debt and the securing of new executive talent—without the money to pay for either. Nevertheless, the directors and Wareham set about trying to find a capable man. This was considered an essential first step in any effort to attract the new capital necessary to liquidate the debts, which by 1935 totaled almost $130,000.

There was little production at the pottery during 1935, and although the whistle was blown every morning to summon the work force, no workers arrived. This "subterfuge," as one director called it, was intended to give the impression that the pottery was working as usual. A few decorators were employed intermittently; others gave their time without pay when they had nothing else to do. Earl Menzel and one or two others in the kiln department came in to cast, glaze, and fire inexpensive shapes to retail from $2.00 to $10.00. Shirayamadani, Hentschel, and Hurley decorated a few vases, but were not regularly paid.

Joseph Henry Gest died on June 26, 1935, "a man of high ideals and noble purposes."

No records of production for this period have been found; indeed, it is doubtful that any were kept, so limited was the clerical staff. One of the directors estimated that the pottery operated an average of one week a month during the five years from 1932 through 1936, and then only at a fraction of capacity.

In the search for a new manager to assist Wareham, the directors sent inquiries to the Ceramics Department of Rutgers University, to Alfred University, another of the country's top ceramic schools, to the Boston Museum of Fine Arts, and to Boston's North Bennett Street Industrial School.

117

In 1936, acting on instructions from the trustees, the directors tried to find a buyer for the Rookwood Pottery—without Wareham's knowledge. The aid of Frederick Keppel, president of the Carnegie Corporation, was secured, and he took the matter up with the Corning Glass Works, makers of Steuben Glass—"without getting to first base." He then tried Black, Starr & Frost-Gorham, Inc. with no better results. Mr. Krehbiel, their manager in New York, summarized that company's decision: "There is a feeling that the 'product is out of date' and too costly to rehabilitate."

In October, 1936, Lucien Wulsin circulated a five-page confidential memorandum to selected members of the board:

REORGANIZATION PLAN FOR ROOK-WOOD POTTERY

In order to attract the new capital necessary for the continuance of the Rookwood Pottery, three fundamental reorganization steps must be assured of accomplishment:

(1) The agreement by Mr. Wareham: first, to relinquish all control over the direction and management of the business and financial policies of the pottery; and second, to continue his direction of the design and creation of all pottery production...

(2) The securing of a competent man to act as General Manager of the Pottery, who will formulate sales policies . . . clean up old inventory . . . and have the general business and financial direction of the affairs of the Pottery.

(3) By whatever legal means are necessary, secure a composition of the Pottery's creditors so as, approximately, to cut in half the present current liabilities of the Pottery. . . .

Other details of the plan are not important here, but Wulsin's comments on the consignment policy of distribution are revealing:

When the consignment plan of marketing Rookwood was established, the cheapest Rookwood piece sold at from $12 to $15 at retail. The corresponding price of a similar piece today, based on increases in retail price indices, would be, I believe, from $25 to $30. The volume of Rookwood sales today of pieces retailing for $25 and over is a very small part of the total sales.

Today the great volume of Rookwood Pottery sells at retail prices from $1.50 to $10 or $12. In other words, Rookwood is selling an entirely different kind of merchandise from what they did in the old days.

How critical conditions were at the pottery is revealed in the closing paragraphs of his memorandum:

I do not know if it will be possible to convince Mr. Wareham of the true condition of the Pottery, before he is brought face to face with the real situation by the action of our creditors.... My studies of the Pottery operation convince me ... the Pottery can be saved on the basis outlined above.... Otherwise the Pottery will go into bankruptcy and under forced liquidation, the assets will not realize sufficient money to pay the creditors in full.

So the search for a capable man was continued. The Fogg Museum at Harvard University was asked to recommend a qualified individual. Several persons were interviewed, and two or three applicants were told to submit ideas and recommendations for a "sales plan" to meet the existing situation. One man under consideration for the position of general manager got in touch with Rookwood agents and then reported to Wulsin:

At Tiffany's they have 50 pieces but they are mostly vases and do not sell very well. The man at Davis Collamore, which is well known here, said they used to handle Rookwood stuff but have not for twenty years because Rookwood did not keep abreast of changes.

Meanwhile, the pottery continued to operate on part time, filling a few orders for decorated ware and turning out a limited quantity of less expensive pieces. The architectural department was completely shut down, no personnel being kept on there except Edmund Schildknecht, who continued to receive "short salary" along with the rest of the staff.

In January, 1938, the Commercial Club appointed a special committee to "consider ways and means of getting behind the Rookwood Pottery problem with a view to rehabilitating, refinancing and reorganizing it." But apparently nothing came of this. No one in Cincinnati wanted to see Rook-

In some periods, the salesroom at Mt. Adams accounted for approximately 20 per cent of Rookwood's sales.

wood go either down or out, but nobody seemed to have the answer.

In June of 1938, Erastus S. Allen, Cincinnati attorney, recommended a plan for reorganizing as a non-profit corporation under Section 77B of the National Bankruptcy Act, and the formation of the Cincinnati Ceramic Guild. Nothing developed from this suggestion, either.

In early 1939, Louis E. Hellmann, president of the Rosenthal China Corporation, became interested in the possibilities of using the pottery's facilities for making china. He proposed that his company distribute Rookwood nationally and that Rosenthal China would "pre-finance" the orders and "enable Rookwood to get started at once without losing a whole season." Another plan was submitted by J. M. MacDonald of MacDonald Brothers Inc. of Boston, Massachusetts, and Mr. Draper of the Rookwood Board of Directors presented a plan to the First National Bank that represented the joint ideas of the Board. For one reason or another, none of these plans was acted upon.

The First National Bank had been cooperative and patient. Their loan of nearly $80,000 was in jeopardy, but they had to be patient in the hope of getting payment in full, or force the pottery into bankruptcy, in which case it was problematical what percentage of their loan would be recovered.

Charles P. Taft, who was a member of the Rookwood board in 1939, was of the opinion that the pottery should be closed, but the others felt all hope of saving it had not yet been exhausted. The Board of Directors was certainly persevering.

During the period from 1935 to 1940, the pottery was kept open for business even though the office and salesrooms were manned by a skeleton staff. The "Visitors' Register" continued to be filled as people rode the historic incline railway to Mt. Adams and stopped at the pottery, where they made an occasional inexpensive purchase. In the decorating department, a few artists continued to work without regular pay, knowing that if and when money came in from sales they would get a share. Earl Menzel, the master potter, was there,

casting pieces in the molds and occasionally turning a piece on the wheel for the visitors to see. Jack Ryan, for many years John Wareham's chauffeur, helped wherever he was needed, preparing clays, spraying glazes on plain pieces, loading and unloading the kilns.

The outbreak of war in Europe in 1939 brought momentary encouragement to the pottery. The following is excerpted from the *Cincinnati Enquirer* of January 6, 1940:

> On a Mt. Adams bluff, overlooking the downtown business section, is a small but nationally known industry that is beginning to feel the effects of the business pickup in recent months. It is the Rookwood Pottery Company, manufacturers of fine pottery ware and decorative products.
>
> John D. Wareham, President, said that . . . his firm is receiving requests daily from wholesalers who dealt with European firms before the war, to duplicate the inexpensive earthenware not obtainable from Europe today because of conditions arising from the war.
>
> He said his firm had no intention of trying to duplicate the inexpensive merchandise, adding that it could not do it successfully because of the higher labor and manufacturing costs in this country. . . .

But it was whistling in the dark, and the decline continued.

In November, the sixtieth anniversary was unobtrusively celebrated; a special anniversary kiln mark was printed on ware from the anniversary kiln.

The next milestone in Rookwood's history was reported in the *Cincinnati Enquirer* for April 17, 1941:

> The Rookwood Pottery Company, famous the world over for its pottery, yesterday filed a voluntary petition in bankruptcy in United States District Court.
>
> It was brought to bankruptcy stage after long efforts to save the historic organization had failed.
>
> Ninety-five creditors were listed in the bankruptcy petition filed by John D. Wareham, President. . . .
>
> Operations of the company have been greatly reduced in the last few years because of diminishing demand for the company's products and lack of working capital. . . .

Chapter 20

Two months after the bankruptcy was announced, three Cincinnati businessmen made a joint effort to save Rookwood. Walter E. Huenefeld, president of a stove and range manufacturing company, Robert A. Cline, prominent realtor, and Maurice A. Koodish, local attorney, submitted a plan proposing to pay off all preferred claims and certain other indebtedness, and guaranteeing that the institution would be rehabilitated and kept in operation. Mr. Huenefeld told the press:

> Our idea will be to keep the prestige of renowned Rookwood by maintenance of the fine and artistic standards that made products of its kilns famous the world over. The plan must receive court approval before other steps can be taken.

However, the court did not approve the Huenefeld plan; it ruled that the pottery must be put up for sale, following customary procedure in bankruptcy cases.

In July, appraisers appointed by the court valued the assets at $67,850.83. Among the individual items were:

Real Estate	$25,000.
Finished pottery	29,393.
Unfinished pottery	1,000.
Library	350.
Special art piece inventory	905.
Teak and brass stands	150.

The bankruptcy sale was set for the fall, and was ordered widely advertised to attract bidders from all parts of the country. When the sale was held on September 30, 1941, there were only two bids. The Huenefeld group submitted one, but a higher bid of $60,500 was made.

In the successful group were Walter E. Schott, Cincinnati automobile dealer, his wife Margaret, his brother Harold, Laurence H. Kyte, attor-

Jens Jensen decorates a vase while Wilhelmine Rehm looks on. Picture was taken after the department was reassembled in 1941.

121

ney, and Charles M. Williams, son of Charles F. Williams, the president of the Western and Southern Life Insurance Company and a former Rookwood director.

Plans were made to reopen the pottery, which had been shut down since April, and to start production as soon as possible. John D. Wareham was placed in charge, and he recalled members of the former staff. Among the artists forming the nucleus of the new decorating department were E. T. Hurley, Wilhelmine Rehm, Margaret Helen McDonald, Lorinda Epply, Elizabeth Barrett, Jens Jensen, and Kataro Shirayamadani.

In announcing the policy of the new organiza-

tion, Charles M. Williams, speaking for the new owners, said that Wareham would continue as president, and W. E. Mackelfresh, Jr., recently with the Owens-Illinois Glass Company, would be sales manager. By the middle of November the personnel had been largely reassembled and the pottery began production.

On November 30, 1941, a full-page advertisement in the Sunday *Cincinnati Enquirer* featured Rookwood for Christmas giving at prices from $1.50 to $50.00, and announced that the pottery salesroom would be open from 9:00 A.M. to 9:00 P.M. every day, including Sunday.

Walter Schott, who had the reputation of being

Reassembled decorating staff poses with John D. Wareham in 1943. Standing (left to right) are Loretta Holtkamp, Wilhelmine Rehm, Edward T. Hurley, Lorinda Epply, Kataro Shirayamadani (partially hidden behind Wareham), Margaret Helen McDonald, Jens Jensen, and Elizabeth Barrett Jensen.

more of a liquidator than a promoter of businesses, called in from all over the country the stock of Rookwood that the company's agents held on consignment, as well as approximately one thousand pieces that were on "loan" to the Cincinnati Art Museum. His idea was to sell all these items from the pottery salesrooms.

Then came Pearl Harbor, and the United States was plunged into World War II.

On January 6, 1942, a full-page advertisement appeared in the *Times-Star* announcing a cut-price sale of Rookwood at 25, 33 ⅓, and 50 per cent discounts from regular prices. Candlesticks priced at $4.00 were advertised at $1.50, $5.00 tobacco jars at $2.50, $15.00 covered boxes at $7.50, $12.00 jardinieres at $6.00. Artist-signed pieces formerly priced at $40.00 and $50.00 were offered at $20.00 and $25.00. The advertisement promised that mail orders would be filled promptly if accompanied by cash or money order.

It was not long before wartime shortages and priorities began to have an effect on Rookwood's output. Oxides of uranium, copper, nickel, and tin were used in making many of the glazes. When these materials were placed on the critical list, and the pottery was classified as non-essential, Rookwood was forced to curtail production. With only a part of the Mt. Adams building required for the reduced operations, Schott went after war contracts to make use of the extra space. He owned the Fay & Egan Woodworking Company, and had some of its machinery moved to Mt. Adams; thereafter, Rookwood began turning out wooden pipes for use at army air bases (steel was in critical supply). The pottery also became a subcontractor making parts for proximity fuses. All during the war period, however, pottery was still produced on a limited scale.

About the end of 1942, the Schott group transferred the ownership of the Rookwood Pottery as a gift to the Institutum Divi Thomae, a scientific, educational, and research foundation under the jurisdiction of the Roman Catholic Archdiocese of Cincinnati. As the Institutum was set up as a non-profit foundation, it was prohibited from operating a commercial business. It therefore took title to the real estate, but the commercial operation of the pottery, the equipment, formulas, and goodwill were transferred to Sperti, Inc., for a consideration of approximately $17,000. Dr. George S. Sperti, the

Margaret Helen McDonald followed in her father's footsteps to become a decorator at Rookwood.

inventor of the Sperti sunlamp, not only controlled the Sperti firm but was also a director of the Institutum.

John W. Milet was appointed to manage the pottery for Sperti, and H. L. Maithre was placed in charge of sales. Wareham continued to guide the art and production activities, but the financial affairs were managed by Sperti, Inc. As this firm was a successful enterprise, the future of Rookwood seemed more secure than it had for some time.

The members of the decorating staff were placed on the payroll of the Institutum Divi Thomae, and under the general supervision of the Right Reverend Cletus A. Miller, who gave them wide latitude in the matter of decoration. The work done in this period shows a new freedom in design trends.

Father Miller spent considerable time at the pottery, which he considered a veritable firetrap. To avoid the danger of having the records of glaze formulas lost in a fire at the Mt. Adams building, he had copies made and placed in the Institutum's safe deposit box in the Central Trust bank.

Open shelves called "catacombs" were tried as replace-ment for individual saggars in 1943, but did not work well; the old method was readopted.

Earl Menzel throws a vase. He was Master Potter be-fore being appointed a decorator.

Loretta Holtkamp, who had been at Rookwood since the early 1920's, and had worked under Sallie Toohey in the glaze room, was promoted to full decorator status. Under the influence of the church affiliation, the pottery expanded the production of religious statuary, Clotilda Zanetta being added to the staff to enlarge this line. She was an accomplished sculptress, and had worked for nearly twenty years as an assistant to Clement J. Barnhorn. At Rookwood she modeled her figures in wax from which plaster molds were made. The figures were successful and sold well, but were disappointing to Father Miller in one respect. He recalls that the glazes seemed too thick. When the statuettes were fired in the biscuit, they were excellent in every detail, but when they were decorated and

glazed, the colors would sometimes run, and the heavy glaze made such details as fingers indistinguishable.

Dr. J. F. Kowalewski, in charge of applied research for Sperti, Inc., was assigned the responsibility of directing research for Rookwood. Wareham opposed this move, as he did not believe any "outsider" should be allowed access to the pottery's trade secrets and formulas, but his objections were overruled. Research directed toward discovering substitutes for critical materials resulted in the development of new glazes and colors. A "wine madder," a "lagoon green," and an "aurora orange" were among the new colors. A new transparent glaze was described as giving a "rare, gossamer-like finish."

A Rookwood mantel was displayed in the salesroom. Note the Rookwood Spanish Galleon ship model on mantel, reported to have sold at $450 each.

On December 29, 1943, in celebration of Wareham's fiftieth anniversary with Rookwood, a luncheon was given by the Institutum Divi Thomae at the Queen City Club. Wareham was presented with a special "green tiger eye" vase to commemorate the occasion. It was signed or monogrammed by twenty-one employees then at the pottery.

An innovation in Rookwood production was tried in 1943. The six kilns then in use were lined on the inside with permanent open shelves made of saggar clay. Called "catacombs" or "permanent saggars," these shelves held about 30 per cent of the kiln's capacity, and made it possible to save considerable time in loading a kiln. Of the six kilns, the smallest would accommodate 1,800 pieces, the largest 4,500, according to figures published in

1944. Although they were never all in use at one time, they were fired with increasing regularity. The experiment with the permanent saggars did not prove completely satisfactory, however, and after a short time the pottery went back to the former method of sealing all the ware in individual saggars.

Settlement of the Rookwood bankruptcy case was completed in 1945. At a final meeting of creditors held on June 25, the report showed the trustee in bankruptcy had realized a total of $70,902. After deducting payment of $5,000 in attorney's fees, the creditors averaged a return of about 35 cents on the dollar.

In 1945, Milet, the manager, organized a new "junior decorating department" for the purpose of training additional decorators. Lois Furukawa, who had started working in the glaze department in 1942, was named a decorator and put in charge of ten or twelve young women. Those who demonstrated the requisite skills of slip decoration and painting on biscuit were promoted to full-fledged decorators. Carolyn Stegner, Jane Sacksteder, and Flora King came to the decorating staff through this route. Miss King's twin sister, Ora King, was also a member of the junior group, but left for marriage before being named a decorator. It was not until she returned to Rookwood after a year's absence that she too was given full decorator status.

In November, Rookwood marked its sixty-fifth anniversary quietly. Mayor Stewart of Cincinnati opened the ceremony at 2:00 P.M. on the Saturday following Thanksgiving, and tours of the plant were conducted both Saturday and Sunday. The famous "Tiger Eye" vase, which was shown at the fortieth anniversary in 1920, was on display, but this time instead of being given an estimated value of $50,000, it was described as "a $10,000 vase."

With the end of World War II, plans were made to expand production. The work force was increased. Research on the metallic oxides that had been unavailable was resumed, and a number of improvements on old glaze formulas are said to have been made. The R-P trademark registration was renewed by Sperti, Inc., and a revised edition of the familiar Rookwood pamphlet was prepared. The sales force was also enlarged, and sets of photographs in full color were prepared to show buyers

not familiar with the product the full range and beauty of the postwar Rookwood line.

A showroom was opened in the Merchandise Mart in Chicago, coincidentally with the Chicago Gift Show in January, 1946, and a wide variety of Rookwood was placed on display. In addition to a large assortment of vases, also offered were "many rare and older beautiful masterpieces now being revived due to popular demand and availability of materials." These included candlesticks, book ends, candy dishes, cigarette boxes, statuettes of birds and animals, and figurines of saints and madonnas.

In 1946, John D. Wareham was named chairman of an American committee to restore the International Museum of Ceramics at Faenza, Italy, which had been partially destroyed in World War II, one of the great art losses of the war. Before the war, the Faenza museum had been a world center of ceramic art. It is said to have housed 22,000 ancient, modern, and contemporary examples of ceramic art from thirty-four nations in the eastern hemisphere.

Wareham had thirty-nine specimens of Rookwood shipped to the Faenza museum, the work of eleven different decorators: Elizabeth Barrett, Wilhelmine Rehm, Jens Jensen, William Hentschel, Louise Abel, Kay Ley, William McDonald, Kataro Shirayamadani, Loretta Holtkamp, Lorinda Epply, and David Seyler.

David Seyler is not listed as a Rookwood decorator. He completed his studies at the Cincinnati Art Academy about 1937. Primarily interested in sculpture, he is believed to have used Rookwood's facilities as a convenience rather than as a paid employee. He modeled the original of a cast figure of a sailor on a horse, one of which was included in the shipment to Faenza. A paper label attached to it carries the typewritten legend: "plain porcelain, Michigan slip, 'Gob's Holiday' Model by D. S. $10.00." Impressed in the base is the R-P mark, the date XXXVIII, and the shape No. 6698. David Seyler helped organize the Kenton Hills Pottery in Erlanger, Kentucky, with William Hentschel and Rookwood superintendent Harold Bopp. It was operated for a short time about the start of World War II, but closed its doors for lack of financial support.

To celebrate Rookwood's anniversary in 1947, Edgar M. Heltman, who was handling publicity for

Kataro Shirayamadani was still decorating at Rookwood at eighty-three years of age.

Sperti, Inc., arranged for a telecast to originate at the Mt. Adams building. The program called for Kataro Shirayamadani to demonstrate the sculpturing of a bas-relief vase before the television camera. As he was climbing the stairway to the second floor for his appearance, the old man lost his balance and fell down fifteen steps, cutting his head so badly that he required hospital care. In a hastily arranged substitution, Clotilda Zanetta took his place before the camera and the show went on.

Shirayamadani recovered and went back to Rookwood, but when the pottery shut down for inventory the following summer, he became ill. He died July 19, 1948, at the age of eighty-three.

Quite unexpectedly, a new installation of Rookwood architectural tile was made in 1947. It happened in this way, according to newspaper accounts of the time: The Holy Family Church School was under construction on Price Hill in Cincinnati, and Monsignor John Kuhn mentioned to Joseph Neyer, retired building contractor, the need for material to finish the interior of the school cafeteria. Forty years before, Neyer had worked in the architectural department at Rookwood, one of his jobs

being to destroy those tiles that were damaged or warped in firing. One lot that was officially rejected and ordered destroyed did not seem that bad to Neyer, and instead of breaking up the tiles he buried them on the side of Mt. Adams. Reminded of the incident, he returned to the spot on the hillside and found them still there, intact after forty years. With the permission of Rookwood's owners, they were retrieved and installed in the cafeteria of the Holy Family School.

The concerted effort to revive Rookwood's former sales position and prestige continued into 1948, but it was becoming obvious that the market had changed. The public was no longer interested in buying new art pottery of the quality of Rookwood and at the price that had to be charged for it. In spite of the considerable investment of time and money aimed at rejuvenating the business, it was decided that the effort would have to be curtailed. The Chicago salesroom was given up. Most of the decorators were laid off, and the production of signed decorated pieces was decreased and gradually gave way to the manufacture of items that could be finished in flat colors and sold in a lower price range.

In 1950 when Rookwood held its seventieth anniversary, this brief announcement appeared in the *Cincinnati Enquirer* for November 21:

The 70th anniversary of the founding of Rookwood Pottery will be observed Friday at 2 P.M. at the Pottery, Rookwood Place, Mt. Adams. One of the features will be an exhibition of the new Rookwood clocks, which will be presented by John A. Binford, Vice President. John Dee Wareham, Director of the Pottery, will be host to the public at a special

drawing of the anniversary kiln containing art pieces with a 70th anniversary Rookwood mark impressed in the bottom of each piece.

To liquidate the inventory that had accumulated at the pottery, it was offered to wholesale buyers at reduced prices. Pogues, a Cincinnati department store that had not previously handled Rookwood, purchased a large quantity and advertised a special sale at 35 to 75 per cent off regular prices. Artist-signed pieces made to sell at $10.00 to $80.00 were offered at $3.95 to $35.00. A vase decorated by Shirayamadani was marked down from $20.00 to $7.50; one by Margaret Helen McDonald, from $35.00 to $12.50; another by Lois Furukawa, from $20.00 to $6.00.

An illustrated price list dated May 15, 1951, offered the ware then available in three categories: monochrome—pieces in one color; duochrome—usually vases with one color outside and a lining of a second color; and polychrome—pieces finished in several flat colors. Examples of suggested retail prices were: Rookwood pheasant in monochrome at $15.00 and in polychrome at $30.00; a three-piece tea set in monochrome at $25.00 and in duochrome at $32.00; and a cast rabbit figurine, originally designed by Louise Abel, was priced at $2.00 in a choice of four colors—Wine Madder, Ivory Mat, Ming Yellow, and Celadon.

On Sunday night, April 25, 1954, John D. Wareham died of a heart ailment at the age of seventy-three at his home on Morrison Avenue. He was active at Rookwood until the end, going to the pottery on Mt. Adams almost every day. With his death, another phase of Rookwood may be said to have ended.

Part VI

1954–1967

The Last Years

Chapter 21

During the Sperti regime, the corporate structure of the pottery was reorganized on several occasions. These changes, however, did not affect operating policies and procedures. At one time William H. Albers of the grocery chain bearing his name was president of Rookwood; for a period, the pottery was operated as a division of Sperti Products, Inc.; and, lastly, it was restructured as a separate corporation under the name Rookwood Pottery Company, Inc., and William A. Shea, for whom Shea Stadium was named, was president and chairman.

After Wareham's death Edgar M. Heltman, who handled public relations for Sperti, Inc., was appointed the director of Rookwood. Production at this time was restricted to simple shapes and to filling commercial and special orders. One of the most unusual of the latter was received in 1954. The Procter & Gamble Company, in searching for an item of universal interest to put in the cornerstone of its new building in Cincinnati, secured the counsel of Dr. Nelson Glueck, noted archeologist. Because the death of languages has been among the greatest of mankind's losses through the ages, Dr. Glueck suggested an inscription translated into all modern and classical languages and engraved on a clay tablet for permanence. Accordingly, such a tile was ordered from Rookwood. On it the first line of Genesis, translated into forty-three languages—from Afrikaans and Annamese to Urdu and Welsh—was incised by Earl Menzel. This tablet was deposited in the Proctor & Gamble cornerstone on May 26, 1955.

Another Rookwood story from this period may

Earl Menzel incising the first line of Genesis in forty-three languages on tablet for the Procter & Gamble cornerstone.

be apocryphal, but is worth repeating. Rookwood was exhibiting in a trade show in Cincinnati, its booth being adjacent to a display of the General Electric Company. Suddenly a Geiger counter in the General Electric exhibit began to tick—the instrument was being activated by the uranium used in the glaze on some of the Rookwood pieces.

Heltman envisioned the Rookwood building as "a place where the artistic heritage of the city will

be preserved and new life in the arts will be fostered." He told newsmen, when interviewed in 1955, "If you write anything about us, I wish you would emphasize the fact that we still have the kilns going, and would like to see more visitors around the place. Someone, I don't know who, has started the rumor that we're not operating any more."

Part of the Mt. Adams premises had been occupied by Sperti's research laboratories. When these were moved elsewhere, Heltman promoted use of the building for art and photographic studios as part of a plan to re-establish the Mt. Adams site as an art center. An art exhibit was arranged, and an art school was set up to be operated in conjunction with the pottery. Albert Miller, guest instructor at the Cincinnati Art Academy, was named to direct these activities under the name of Rookwood Studios. Courses in ceramics, ceramic sculpture, and oil and water-color painting were offered. It was also contemplated that Rookwood Studios would present art films and lectures for the general public as part of an attempt to focus attention on the pottery.

Earl Menzel continued to work in the casting shop turning out shapes to be glazed and fired by John Reichardt in the kiln room. In October, 1955, a pair of elephant book ends was sent to President Dwight D. Eisenhower, inscribed by Menzel on the base with a facsimile of Eisenhower's signature copied from a public document. These are now in the collection of elephant models belonging to Milton Eisenhower.

Perhaps once in two months, one of the smaller kilns was fired, but production was all but ended and demand had virtually disappeared. When an offer was made for the building, Sperti, Inc., decided to sell with the understanding that the purchaser keep the pottery in operation. On January 5, 1956, papers were signed transferring the property and assets of the Rookwood Pottery Company, Inc., to William F. MacConnell and James M. Smith, two Cincinnati businessmen who had leased space in the building. It was their intention to keep the Rookwood Pottery operating in one section of the building, and to remodel the balance into offices. They formed Rookwood Realty, Inc., for this purpose.

Earl Menzel was placed in charge of the pot-

Elephant bookends presented to Dwight David Eisenhower in 1955.

tery, and was also officially appointed a decorator in addition to his title of master potter. During his long career with Rookwood, he had never been interested in joining the decorating department because the pay was better as a potter.

Menzel, Reichardt, and a few part-time helpers were kept employed filling orders that came in. But Rookwood no longer produced the fine art pottery that had made it famous, and MacConnell found it could not even compete successfully for available commercial business because of its out-of-date methods and obsolete equipment. He decided to investigate having Rookwood-designed pieces shipped elsewhere for production. As an experiment he sent an expensive artist-decorated Rookwood vase, one that thirty years before would have sold for $80.00, to a pottery in Italy and asked for a quotation on producing similar pieces. In due time, the original was returned together with an almost exact duplicate, even to the Rookwood trademark, shape number, and artist's monogram. The price quoted for quantity production was something like $10.87 delivered to New York. "That," MacConnell said, "decided for me there was no longer an opportunity to make Rookwood in this country. We simply could not compete."

When MacConnell and Smith purchased Rookwood from the Sperti interests, the sale apparently did not include the Rookwood collection of famous

pieces that had been on display at the pottery showroom for many years: the "$10,000" Tiger Eye vase, duplicates of the presentation pieces, at least one of the pieces made at Rookwood by Anton Lang, and others. Today, this Rockwood collection is in the custody of the Institutum Divi Thomae in Cincinnati.

One of the pottery's commercial accounts had been the Herschede Hall Clock Company, which made a high-quality line of hall and mantel clocks. Rookwood had supplied ceramic clock faces to this company for many years. Since Herschede distributed their clocks largely through the better jewelry and department stores, it was believed that Rookwood might provide a suitable companion item and that the ware might be revived to its former position of prestige.

So the Herschede Company arranged to buy the Rookwood Pottery business at the end of 1959. Ownership of the pottery building on Mt. Adams was retained by MacConnell and Smith. The kilns in the original building were dismantled, and this and the first extension were remodeled into individual offices and suites. The large beehive kilns in the architectural department are still standing. At one point, plans were made to lease that section to Danny Kaye and certain associates for use as a radio broadcasting station, with the kilns to serve as soundproof studios.

Menzel and Reichardt retired at the end of 1959, and the pottery was left in charge of William T. Glass, who had graduated from Notre Dame in 1955 with a Fine Arts degree, and came to Rookwood in July, 1959. In an attempt to put new life into the ware, the use of colored clay bodies was revived. Glass designed new shapes, which were numbered and entered in the records. Most of these were modern ash trays, although a few new bowls and vase shapes were made.

At the end of June, 1960, the manufacturing operations of the Herschede Hall Clock Company and the Rookwood Pottery Company were moved to Starkville, Mississippi, attracted by the incentive of a new plant and more favorable operating costs. In announcing the move, Robert Herschede, vice-president of the clock company and president of the Rookwood subsidiary, said: "The prestige of the name and its past development of methods and glazing will be carried on. What we are interested in is in regaining the front of the prestige market for pottery and ceramics."

When the move was planned, Glass was instructed to select the materials to be taken to Mississippi. Many shape patterns had been discarded during the Sperti and MacConnell ownership, but Glass estimates that over 3,000 shape molds and biscuit patterns for thrown pieces remained early in 1960. More than 60 per cent of these were considered to have no future and therefore were destroyed. The remainder were sent to Starkville. Other surplus equipment and miscellaneous memorabilia left by the workers at Mt. Adams during the past seventy years were auctioned off.

Glass continued in charge of the pottery operation when it started again in a section of the new one-story plant at Starkville, where a modern electric kiln was installed. The plan was to produce high-quality ware, including individually decorated pieces, and two attempts were made in this direction. The first was an effort to enlist the services of former Rookwood decorator Wilhelmine Rehm to form a new decorating department. She refused the offer, however, feeling that the environment at Starkville was not comparable to that which she had known at Mt. Adams.

The second attempt was made with the cooperation of Ralph Hudson, director of the art department at Mississippi State College for Women in neighboring Columbus, Mississippi. In the fall of 1961, he authorized a class in ceramic decoration. Elizabeth Dice, a young instructor, was placed in charge. The expectation at the time was that the class might provide a talent pool of future artists, much as the Cincinnati Art Academy had in former years.

Glass designed several simple flat shapes that could be decorated without the use of whirlers. These green or unfired clay shapes were sent by truck from the plant in Starkville to the college in Columbus, where the students decorated them with mineral colors and colored slips. The decorated pieces were then transported back to Starkville for glazing and firing, a round trip of approximately fifty miles. Transporting the wet clay shapes proved difficult, and the results were not considered commercially satisfactory. After three kiln loads were completed, the attempt was abandoned.

The *R-P,* trademark registration was again

renewed in 1962, and the *R* in a circle indicating a registered trademark was impressed in the ware for the first time. The name and address— ROOKWOOD POTTERY COMPANY, STARK-VILLE, Miss.—were also impressed on some of the ware to publicize the new location. A considerably modified edition of the long line of Rookwood pamphlets was printed, but it omitted a list of decorators' names and monograms. In 1964 and 1965, a small distinctive label printed in black on gold and containing the *R-P* mark and the name ROOKWOOD POTTERY was also affixed to some pieces.

About sixty different cast and pressed shapes were offered in a choice of nine glaze colors. Approximately half of these shapes were made from molds brought from Cincinnati; the others

were originated by Glass before he left the employ of the pottery in 1962. The last number in the shape record was a mug, shape No. 7301, although for some reason many numbers between 7205 and 7300 were not used.

Unfortunately, this limited line did not appeal to buyers. Production was gradually curtailed until, by 1966, the pottery was operated only on an occasional basis. In the summer of 1967, the controlling interest in the Herschede Hall Clock Company was sold. With this transfer, the operation of the Rookwood Pottery was suspended.

Will another attempt be made to revive Rookwood's prestige and acceptance of former years? It seems unlikely. In the meantime, the wares of former years bear silent testimony to the fact that Rookwood was once America's finest art pottery.

Afterchapters

Afterchapter I

ROOKWOOD MARKS

Identification of Rookwood art pottery started with the pieces prepared for the first kiln in 1880. During the first three years, a variety of marks was used. By 1882, however, a logical system of marking the ware began to evolve, and soon this became standardized. It continued in use until 1967.

The marking system was based on numbers, letters, and symbols that served both as identification of the ware and as an index to the factory records in which were listed the details of every shape produced. Marks may be grouped into six categories: factory marks, clay or body marks, numbers and letters indicating shape and size, miscellaneous marks or symbols having special meanings, architectural tile and garden pottery marks, and decorators' initials or monograms. A key to the system is necessary if a collector wishes to establish as much information as possible about any particular piece.

Factory Marks

Prior to 1882, various marks were employed to identify the factory. These are found incised or painted on the bottom of each piece.

The first mark used was the name ROOKWOOD, painted in gold, together with the initials of the decorator, Maria Longworth Nichols. The ware was not dated.

In 1881 the most common mark was the name of the pottery incised in the base and usually accompanied by the date.

A variation consisted of the initials R.P.C.O.M.L.N., painted or incised, standing for Rookwood Pottery Cincinnati, Ohio, Maria Longworth Nichols.

In 1881 and 1882 the Rookwood trademark designed by H. F. Farny was occasionally *printed* on the base under the glaze.

An anchor was sometimes used, either impressed or in relief, at times accompanied by a date. Dr. Barber in *Marks of American Potters* says this is one of the rarest of Rookwood marks.

An oval mark with the name and address of the pottery was also used for a short time.

In 1881 and 1882 the name impressed in a raised ribbon was used on the Garfield Memorial Pitcher and on a beer tankard made for the Cincinnati Cooperage Co.

A variation is found stamped or impressed in other pieces made about this time.

The word ROOKWOOD and the date became the regular mark in 1882. The date was changed each year until 1886.

A small kiln mark was sometimes impressed on the ware during 1883.

The *R-P* monogram mark was first used on June 23, 1886. It became the standard mark, replacing the word ROOKWOOD on ware made after that date.

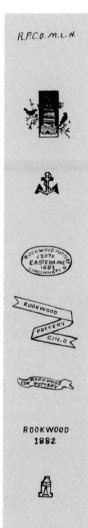

135

To represent the year 1887, one flame point was placed above the *R-P* mark. Another flame point was added for each year until there were fourteen flame points for the year 1900.

The *R-P* mark with fourteen flame points was continued into the new century with the addition of a Roman numeral to denote the year, as in the example shown for 1907.

After 1962, the *R* in a circle was sometimes added to denote that the trademark was registered, as illustrated in the mark for 1965.

Pieces fired in the kilns for the fiftieth, sixtieth, and seventieth anniversaries had a special kiln mark *printed* on the ware.

For the seventy-fifth anniversary, a diamond-shaped insigne was printed on the ware.

The name and location were occasionally added to ware made after 1942 when the pottery was seeking to regain its former prestige. Other variations are known.

ROOKWOOD POTTERY
STARKVILLE MISS

After the pottery moved to Mississippi, the name and new address were sometimes impressed on the ware in an effort to publicize the new location.

Clay or Body Marks

A letter representing the clay or body composition of the piece was frequently impressed on the base of ware made between 1883 and 1900. The letter designated the color or shade of the clay body used:

G O R S W Y

G stood for ginger, R for red, S for sage green, W for white, and Y for yellow. An O for olive is also listed in Barber's *Marks of American Potters*, but no reference to an olive-colored body has been found in the existing records of the pottery.

Rookwood also made a pink body composition, but probably it was in use only a short time and, so far as is known, was not identified, although the letter P would have been appropriate at the time.

P ᴘ

In 1914, the letter P was chosen to identify the "Soft Porcelain" body introduced that year, and it continued to be used for several years. Usually it is found on its side in relation to the other marks on the base.

Shape Numbers and Size Letters

Each shape or pattern in the regular art pottery line was identified by a number, which usually appears under the name or the *R-P* monogram and date.

14 7183

When a pattern or shape was made in two or more sizes, the size was indicated by a letter usually following the shape number. Six size categories were provided for, identified by the letters A through F. A indicated the largest size; the others indicated diminishing sizes down to F, the smallest.

856 A 510 C
725 C

When a new shape was introduced with the intention of later making it in other sizes, it was commonly assigned the letter C or D; this allowed for larger sizes (*A* and *B*) or smaller (*E* and *F*) to be added. For example, shape No. 553 was first thrown in 1889 and designated as size C. A smaller size, designated *E*, was made in 1892, but sizes labeled *A, B, D,* or *F* were never made.

821 BB

Exceptions occurred when a size was made larger than the *A* or smaller than the *F* already in use. These were indicated by a double X. If a new size were added in between existing sizes, it was

indicated by a double letter, as *BB* or *CC*, but such exceptions were infrequent.

No relationship existed between the size categories of one shape and those of another.

Miscellaneous Marks and Symbols

A number of other marks were used at different periods to convey special meanings.

K 3
K 1

An after-dinner coffee cup and saucer and a matching teacup and saucer of delicate proportions were marked K_3 and K_1 respectively. Believed used about 1922.

M - 3
M 6
M 34
2800 H

The letter *M* was used on some of the blue ship-pattern tableware. The number following the letter indicates the particular piece, *M 34* being a 16-inch oval platter. Other pieces in the set were numbered 2800 followed by a letter indicating the piece. *2800 H* was a small egg cup.

S 1368
S

The letter *S* was used to identify a special piece, usually not part of the regular line. When the letter precedes a number (as shown), it indicates the piece was made directly from a sketch or drawing bearing that number. When the *S* is found alone, it denotes a piece thrown for demonstration, often when a prominent visitor was conducted through the pottery.

S C

The letters *S* and *C* were also used circa 1946 to 1950 to mark sugar and cream sets.

T 540

The letter *T* followed by a number indicates a trial piece. Any new shape on which some difficulty in production or firing was anticipated was first made as a trial piece.

V

The letter *V* was impressed in the base to denote the use of vellum finish, a transparent mat glaze introduced in 1904.

z
354 z

The letter *Z* was used following a number as the standard designation for shapes made for mat glaze finish from 1900 to 1904, at which time the *Z* category was discontinued and the shapes renumbered in the regular shape line.

R 465 GORHAM MFG. CO.

999/1000 FINE

The name of the Gorham Mfg. Co. is found engraved on the silver overlay that this company applied circa 1892 to 1895. The *R* stands for Rookwood and 465 is the Gorham order number assigned to the piece. The indication of the silver quality is also found on some pieces.

A large *X* roughly cut or scored in the base indicates a piece that was found to be imperfect. It was so marked in the salesroom to denote second quality, and the piece was offered for sale at a reduced price.

When these "seconds" did not sell after a reasonable time, they were cut or scored again with an additional line to identify them as "give-away" merchandise, and given to the employees.

In 1904, Dr. Barber stated, "Esoteric or process marks are occasionally *impressed* on pieces of Rookwood ware, often accompanied by varying record numbers. As these characters only occur on experimental pieces, they are seldom found on examples which leave the factory, and their significance is never divulged." The marks he illustrated are shown here; the meanings of three of them are now known: A number inside a diamond shape was a record of a trial or experiment with a new glaze formula. The number between single or double X's denoted a trial or experiment with a new decorative technique, usually involving the use of a different material or glaze to create a new artistic effect. The letter *Z* was a regular mark between 1900 and 1904 as explained above, and is quite common.

X /

*

▲

X 15 X

◆

(53)

♥

⟨15⟩

z

⌣

Architectural and Garden Pottery Marks

A similar numbering system was used to record the hundreds of designs, sizes, and shapes produced for architectural faience. As Rookwood garden pottery was also produced and fired in the architectural department, it was included in this record system.

℞

Y

3041 Y

3041 AY
3041 EY

1314 Y1
1314 Y2

A large version, about three inches high, of the plain *R-P* mark was sometimes impressed on the back of architectural tiles or the ends of large moldings.

The letter *Y* following a number indicated any piece made in the architectural department.

Each tile design or garden pottery shape was assigned a pattern or shape number followed by the letter *Y*.

When two or more sizes of the same design were produced, each size was indicated by a letter placed between the pattern number and the letter *Y*, as shown.

When more than one tile was required to complete a single design, as in a large panel, a single pattern number followed by the figures 1, 2, 3, etc., was used to identify each tile comprising the design. Some stock panel designs had thirty-six or more individual tiles.

Decorators' Marks or Signatures

From the first, the artists or decorators signed their work, usually by incising or painting their initials on the base of the ware. Occasionally, a few of the early decorators used a full signature, either incised on the base or painted in underglaze color on the decorated surface.

During the period from 1885 to 1900, an extra letter was sometimes added by the artist in conjunction with his initials, as in these examples:

$A\,R\,V/_S$ $\quad\quad \dfrac{S\,M}{L}$

Many different letters have been found, but their meaning has not been determined. One theory is that the letter represented the decorator's suggestion for the color of glaze to be used in finishing the piece; another, that it served as a record of the pieces each artist decorated in a given period, letters being used rather than numbers to avoid confusion with the numbers used for shapes or for glaze experiments.

In a later period, several decorators impressed their marks in the base with the aid of a die made of baked clay, similar to the dies used to impress the Rookwood trademark.

It should also be mentioned that the mark of a decorator is sometimes found on a cast or pressed piece. The mark appeared when a signed original design was used in making the mold, and the artist's mark was thus transferred to the mold and duplicated on subsequent pieces. This probably occurred infrequently.

One hundred ten decorators are known to have been at the pottery between 1880 and 1959. A number of them used several styles or forms of marking on their work over the years, and these are given (where known) in the order in which they are believed to have been used.

Mark	Decorator
E.A.	Abel, Edward
Ⓐ	Abel, Louise
HA.	Altman, Howard
L.A.	Asbury, Lenore
ℱA ℱA	Auckland, Fannie
C.A.B.	Baker, Constance A.
🅱	Barrett, Elizabeth
J.B.	Bishop, Irene
C.F.B.	Bonsall, Caroline F.
ℳB AℳB	Bookprinter, Anna Marie
ℰⱳℬ	Brain, Elizabeth W.
AB	Brennan, Alfred

WHB	Breuer, W. H.	
C	Conant, Arthur	
PC	Conant, Patti	
·D·C·	Cook, Daniel	
C C	Covalenco, Catherine	
Sε	Coyne, Sallie E.	
E.B.I.C.	Cranch, E. Bertha I.	
εPC εpG	Cranch, Edward P.	
¢	Crofton, Cora	
M.A.D. MADaly	Daly, Matthew A.	
VBD—	Demarest, Virginia B.	
◁G▷	Denzler, Mary Grace	
C J·D·	Dibowski, Charles John	
ED.	Diers, Edward	
C·A·D·	Duell, Cecil A.	
LE	Epply, Lorinda	
RF R	Fechheimer, Rose	
ERF.	Felten, Edith R.	
E·D·F	Foertmeyer, Emma D.	

MF	Foglesong, Mattie
LF LF	Fry, Laura A.
LF	Furukawa, Lois
AG	Goetting, Arthur
G.H.	Hall, Grace
L.E.H.	Hanscom, Lena E.
JH	Harris, Janet
M	Hentschel, William E.
KH	Hickman, Katharine
NJH N.J.H.	Hirschfeld, N. J.
4	Holtkamp, Loretta
B—	Horsfall, R. Bruce
HH H.H	Horton, Hattie
A.H.	Humphreys, Albert
E.T.H.	Hurley, Edward T.
JJ JJ	Jensen, Jens
KJ	Jones, Katherine
FK.	King, Flora
OK	King, Ora

WK.	Klemm, William
K	Koehler, Mrs. F. D.
SL	Laurence, Sturgis
ECL	Lawrence, Eliza C.
LEY	Ley, Kay
L.N.L. LNL	Lincoln, Elizabeth N. (Also Lingenfelter, Eliz. N.)
C.C.L.	Lindeman, Clara C.
LEL	Lindeman, Laura E.
TOM	Lunt, Tom
HML.	Lyons, Helen M.
S.M.	Markland, Sadie
K.C.M.	Matchette, Kate C.
EFM	McDermott, Elizabeth F.
MHM	McDonald, Margaret Helen
W.McD. WMD WPMcD	McDonald, William P.
CJM	McLaughlin, Charles J.
REM	Menzel, Ruben Earl
MM	Mitchell, Marianne
C.N	Newton, Clara Chipman

MLN	Nichols, Maria Longworth
E.N.	Noonan, Edith
Mn	Nourse, Mary
MLP MP MR	Perkins, Mary L.
PB	Peters-Baurer, Pauline
AP	Pons, Albert
WP	Pullman, J. Wesley
MR.	Rauchfuss, Marie
O. G. R.	Reed, Olga Geneva (Also Pinney, O. G. Reed)
WR WR	Rehm, Wilhelmine
MR M.R-	Rettig, Martin
R.	Rothenbusch, Frederick
JS	Sacksteder, Jane
S.S. S S	Sax, Sara
CS	Schmidt, Charles
A.D.S.	Sehon, Adeliza D.
NF KS	Shirayamadani, Kataro
M·H·S	Smalley, Marian H.
SB SB	Sprague, Amelia B.

✓	Stegner, Carolyn
ℭℷ	Steinle, Caroline
M L S	Storer, Maria Longworth
H·R·S	Strafer, Harriette Rosemary
#	Stuntz, H. Pabodie
$	Swing, Jeannette
兩 兩·	Taylor, Mary A.
V7	Tischler, Vera
C.S.T.	Todd, Charles S.
匀 季 孑	Toohey, Sallie
A.R.V.	Valentien, Albert R.
a.m.v.	Valentien, Anna Marie

A.V.B.	Van Briggle, Artus
LVB.	Van Briggle, Leona
KH.	Van Horne, Katherine
F.V.	Vreeland, Francis
▥ JDW. ᵈᵐ	Wareham, John D.
H.W.	Wenderoth, Harriet
H.E.W.	Wilcox, Harriet E.
ᴱL W	Wildman, Edith L.
▨ vᴠ	Workum, Delia
¥ ¥	Young, Grace
C Z.	Zanetta, Clotilda
乎 乎 乎	Zettel, Josephine E.

Afterchapter II

Rookwood Artists and Decorators

Of the artists employed at the Rookwood Pottery during the nearly three quarters of a century that the decorating department was in operation, a number gained national and international recognition, not only for their contributions to ceramic art, but for their accomplishments in other fields. Many were well known for their work in other media: oil or water-color painting of landscapes, portraits, murals, or nature studies; sculpture or etching; design work; weaving; batik; jewelry; leather work.

With few exceptions, all Rookwood decorators received their early instruction at the Cincinnati Art Academy or continued their studies there after joining the pottery. Several also taught at the Academy, before, during, or after their connection with Rookwood. Others continued their studies elsewhere in this country or in Europe, and went on to pursue their art interests in related fields.

The period when each decorator was employed at the pottery must be considered approximate rather than absolute. Existing records, particularly concerning many of the earlier decorators, are extremely fragmentary; and for the later ones, even the memory of twenty or thirty years ago can be inaccurate. Several of the artists are known to have left the pottery and then returned and resumed their work at a later date. Others may have come back for a visit and decorated a piece or two while there. On a hand-decorated piece, an artist's mark together with the date may be considered proof that the artist was there that year. But remember that an artist's mark is occasionally found reproduced on a cast piece that may have been duplicated years after the artist created the original.

For those interested in further information, an attempt has been made to gather additional pertinent data about each decorator. An asterisk (*) indicates those whom the author was able to locate. Dates of birth and death, where known, are given in parentheses. The abbreviation CAA is used for Cincinnati Art Academy.

ABEL, EDWARD

Believed to have come to Rookwood in 1890 and left about 1892. No relation to Louise Abel.

ABEL, LOUISE (1894-)*

Born Widdern, Wurttemberg, Germany. Came to U.S. 1909. Studied Art Students League, Louis C. Tiffany Foundation, Barnes Foundation, Pratt Institute, CAA. At Rookwood about 1920 to 1932. On leave 1928-29 to study at Kunstgewerbe Schule, Stuttgart. Created many animal figurines produced at Rookwood for paperweights and ornaments. Taught sculpture CAA and art in Cincinnati public schools. Returned to Germany 1959.

ALTMAN, HOWARD

At Rookwood from late 1899 to 1904.

ASBURY, LENORE

At Rookwood 1894 to 1931, occasional work later.

AUCKLAND, FANNY

Daughter of William Auckland, first thrower at Rookwood. Probably there from 1881 to about 1884. Reported to be only twelve years old at time she decorated vase selected by Seymour

Heyden. Work characterized by incised decoration.

BAKER, CONSTANCE AMELIA

At Rookwood 1892 to 1904. Also in charge of photographic work at Rookwood before the regular photo department was set up in 1900.

BARRETT, ELIZABETH*

Born Maysville, Kentucky. CAA, and ceramics University of Cincinnati. At Rookwood 1924-1931. Returned 1943-1948. Occasional work in the interim. Married Jens Jensen Oct. 30, 1931.

BISHOP, IRENE (1880-1925)

Born Colorado Springs. Art Students League and CAA. At Rookwood 1900 to 1907. Married Edward T. Hurley Aug. 16, 1907. Later painted miniatures, exhibited New York and Philadelphia. Died Cincinnati. Charter member Woman's Art Club.

BONSALL, CAROLINE F.

At Rookwood about 1902 to 1905.

BOOKPRINTER, ANNA MARIE (1862-1947)

Born Cincinnati, daughter of Karl and Magdalene Buchdrucker, but name was anglicized to Bookprinter. Studied McMicken and CAA. At Rookwood from 1884 to 1905. Married Albert R. Valentien June 1, 1887. After marriage signed work A.M.V. On leave of absence with husband in Europe, studied at academies Colorossi and Rodin in Paris. Tried unsuccessfully to interest Rookwood in sculptured art forms. Moved to California with husband and continued art work on West Coast. Died San Diego.

BRAIN, ELIZABETH WELDON

At Rookwood 1898 to about 1901 or 1902.

BRENNAN, ALFRED LAURENS (1853-1921)

At Rookwood from 1881 to 1883 or 1884. Recorded as the designer of a few early shapes. Later worked as an illustrator and produced over 10,000 pen-and-ink drawings, which appeared in various publications. Also poet and writer of reviews. Died in Brooklyn.

BREUER, W. H.

At Rookwood about 1881 to 1884. Shape Record book credits Shape No. 140 and Shape No. 353 to Mr. Breuer.

CONANT, ARTHUR P.

At Rookwood from about 1915 to the late 1920's. Rejoined Rookwood as sales representative during the depression. Husband of Patti M. Conant.

CONANT, PATTI M.

At Rookwood from about 1915 to late 1920's. Wife of Arthur P. Conant.

COOK, DANIEL (1872-1950's?)

Born Cincinnati CAA, Royal Academy Munich, Ecole des Beaux Arts. At Rookwood 1893 to 1894. Later staff artist on New York *World* and New York *Sunday Telegraph*. Art instructor at University of Cincinnati 1919 to retirement. Went to Mexico 1947 to teach English.

COVALENCO, CATHERINE PISSOREFF (1896-1932)

Born Kiev, Russia. At Rookwood about two years between 1925 and 1928. Died Cincinnati.

COYNE, SARA ELIZABETH

Joined Rookwood in 1891 but was not a decorator until 1892. At Rookwood until 1931.

CRANCH, E. BERTHA I.

A relative of Edward P. Cranch, probably his daughter. At Rookwood for a short period about 1887.

CRANCH, EDWARD POPE (1809-1892)

Prominent Cincinnati attorney. Occasional decorator from 1880 to 1890. Said always to have used ginger-colored clay and etched his unusual designs, filling in the lines with black. Died in Cincinnati.

CROFTON, CORA

At Rookwood for short period sometime between 1886 and 1892.

DALY, MATTHEW ANDREW (1860-1937)

Born Cincinnati. Studied McMicken, CAA. Worked at Matt Morgan Art Pottery for short time before joining Rookwood in 1882. One of top decorators. Left Rookwood in 1903 to head art department at U.S. Playing Card Company. In 1928, following death of first wife, married Olga Geneva Reed Pinney. Charter member of Cincinnati Art Club.

DEMAREST, VIRGINIA B.

At Rookwood from 1900 to 1903.

DENZLER, MARY GRACE
At Rookwood about 1913 to sometime after 1915.

DIBOWSKI, CHARLES JOHN
At Rookwood a short time in 1892 and 1893.

DIERS, EDWARD GEORGE (1871-1947)
Born Cincinnati. At Rookwood from 1896 to retirement in 1931. Died Cincinnati.

DUELL, CECIL A. (1889-1946)
Born in Missouri. CAA. Joined Rookwood about 1907, stayed until leaving for service in World War I. His wife, Cathryn A. Duell, also worked at Rookwood and designed some shapes but was not a decorator. Mr. Duell was a sculptor, and operated a metal-casting business in the Woodlawn section of Cincinnati.

EPPLY, LORINDA (1874-1951)
Studied ceramics at Columbia University. At Rookwood 1904 to 1948. Taught weaving at CAA in 1943. Died Cincinnati.

FECHHEIMER, ROSE (1874-1961)
Born Cincinnati. At Rookwood from 1896 to 1906. Died Santa Monica, California.

FELTEN, EDITH REGINA
At Rookwood from 1896 to 1904.

FOERTMEYER, EMMA D.
At Rookwood about 1887 to 1892.

FOGLESONG, MATTIE
At Rookwood 1897 to 1902.

FRY, LAURA A. (1857-1943)
Born White County, Indiana, one of ten children in famous family of Cincinnati wood carvers. Studied CAA and England and France. At Rookwood from 1881 to 1887, with occasional work thereafter. 1892 joined Lonhuda Pottery. 1896 to 1922 taught art at Purdue University. Died Cincinnati.

FURUKAWA, LOIS (1912-)*
Born Los Angeles. Started in glaze department at Rookwood 1942; in charge of junior decorating department in 1945; promoted to decorator in 1946. Left Rookwood 1948.

GOETTING, ARTHUR (1874-)*
Born Mauston, Wisconsin. At Rookwood three months in the summer of 1896. Illustrated works

of E. A. Poe. In 1920 changed name to Arthur Curtis; became well known as hybridizer of "Curtis Giant Poppies"; made "Master Gardener" by Federated Garden Clubs of America, 1954.

HALL, GRACE M.
At Rookwood about 1902 to 1905. Is believed to have returned later, and been there about 1910 to 1912.

HANSCOM, LENA E.
At Rookwood about 1902 to 1907.

HARRIS, JANET (1907-)*
Born Richmond, Indiana. Graduate Oberlin College, studied New York School of Applied Design. At Rookwood 1929 to 1932. Then opened Rookwood Department at Lycett's in Baltimore.

HENTSCHEL, WILLIAM E. (1892-1962)
At Rookwood about 1907 to 1939. Started Kenton Hills Pottery in Erlanger, Kentucky. Painter and muralist. Taught at CAA 1921 to 1956.

HICKMAN, KATHARINE LESLIE
At Rookwood 1895 until marriage in 1900.

HIRSCHFELD, N. J.
Worked at Matt Morgan Art Pottery before coming to Rookwood. At Rookwood about 1882 to 1883.

HOLTKAMP, LORETTA*
Joined Rookwood about 1920 and worked for many years in the glaze room under Sallie Toohey. Promoted to decorator about 1943. Left after 1953.

HORSFALL, R. BRUCE (?-1948)
At Rookwood about 1893 to 1895. Later famous painter and illustrator of bird life.

HORTON, HATTIE
At Rookwood about 1882 to 1884.

HUMPHREYS, ALBERT (1864-1926)
Born Cincinnati. Studied McMicken. At Rookwood about 1882 to 1884. Later studied in Paris. Sculptor of small animal groups. Philadelphia Sketch Club. Died New York.

HURLEY, EDWARD TIMOTHY (1869-1950)
Born Cincinnati. Graduate St. Xavier College.

At Rookwood 1896 to 1948. Nationally known etcher, published many books of etchings of Cincinnati. Taught at St. Xavier. Married Irene Bishop, August 16, 1907. Cincinnati Art Club, Duveneck Society. Died Cincinnati.

JENSEN, JENS JACOB HERRING KROG*
Born Fynen, Denmark. Graduate Ryslinge & Askov, Jutland. Came to U.S. 1927. At Rookwood 1928 to 1948. Married Elizabeth Barrett, October 30, 1931. Started small pottery Ripley, Ohio. Continued to paint.

JONES, KATHERINE*
Born London, Kentucky. CAA. At Rookwood about 1924 to 1931. Left to accept position with Gibson Art Company.

KING, FLORA R. (1918-)*
Born Peoples, Kentucky. Joined Rookwood 1945 as junior decorator; promoted to decorator; left shortly thereafter to be married. Twin sister of Ora King.

KING, ORA (1918-)*
Born Peoples, Kentucky. Joined Rookwood 1945 as junior decorator; left in 1946 to be married. Returned as decorator in 1947 and left 1948. Twin sister of Flora King.

KLEMM, WILLIAM
At Rookwood a short period between 1900 and 1902.

KOEHLER, MRS. F. D.
Believed at Rookwood for short period between 1886 and 1890.

LAURENCE, FREDERICK STURGIS
Rookwood decorator from 1895 to 1904, when he was placed in charge of "Eastern Office" in New York City. About 1900 gave illustrated lectures on Rookwood. Wrote article in *Architectural Record* 1907.

LAWRENCE, ELIZA C. (?-1903)
At Rookwood 1900 until her death in 1903.

LEY, KAY
At Rookwood about 1945 to 1948.

LINCOLN, ELIZABETH NEAVE (1880-1957)
Became decorator in 1892 under the name Elizabeth N. Lingenfelter, which she later anglicized to Lincoln. Left Rookwood 1931. Became assist-

ant housekeeper Christ Hospital; later employed at Bethesda Hospital. Considered one of best decorators of mat glaze work.

LINDEMAN, CLARA CHRISTIANA
At Rookwood 1898 until after 1907. Sister of Laura E. Lindeman.

LINDEMAN, LAURA E.
At Rookwood 1899 until after 1905. Sister of Clara C. Lindeman.

LINGENFELTER, ELIZABETH NEAVE
See Lincoln, Elizabeth Neave

LUNT, TOM
Believed to have been at Rookwood between 1886 and 1890. Did Rookwood's photographic work before Constance Baker.

LYONS, HELEN M.
At Rookwood from about 1913 until sometime after 1915.

MARKLAND, SADIE (?-1899)
Joined Rookwood 1892 and died in 1899 while still employed there.

MATCHETTE, KATE C.
At Rookwood from about 1892 for a short period.

MCDERMOTT, ELIZABETH F.
At Rookwood from about 1912 to sometime after 1915.

MCDONALD, MARGARET HELEN (1893-1964)
Born Cincinnati, oldest daughter of William McDonald. CAA. At Rookwood 1913 to 1948.

MCDONALD, WILLIAM PURCELL (1865-1931)
Born Cincinnati. Graduate School of Design, University of Cincinnati, CAA. Joined Rookwood 1882 and spent entire working life at Rookwood. One of top decorators. In charge of decorating department in 1899 in absence of Valentien; in charge of architectural department in 1904. Duveneck Society, Cincinnati Art Club, MacDowell Society. Died Cincinnati.

MCLAUGHLIN, CHARLES JASPER (1888-1964)
Born Covington, Kentucky. CAA, Ecole des Beaux Arts, studied architecture France, Belgium, Italy, and Greece. At Rookwood 1913 to 1920. Later taught architectural design at Texas A. & M. College. Died Charlottesville, Virginia.

MENZEL, RUBEN EARL (1882-)*
Born Cincinnati. Joined Rookwood in the clay department 1896, where his father was foreman and master potter. Later succeeded his father as master potter. Began decorating and signing his work about 1950. Retired 1959.

MITCHELL, MARIANNE
At Rookwood 1901 to 1905.

NEWTON, CLARA CHIPMAN (1848-1936)
Born Delphos, Ohio. Schoolmate of Maria Longworth at Miss Appleton's. Studied McMicken. 1881 joined Rookwood as secretary. Also decorator. Resigned 1884. Known for interior decorating. Founder and first secretary of Cincinnati Women's Club; Pottery Club, D.A.R., Porcelain League.

NICHOLS, MARIA LONGWORTH (1849-1932)
Founder and first decorator at Rookwood Pottery. See biographical sketch introducing Chapter 1. Died at home of her daughter in Paris, France.

NOONAN, EDITH (1881-)*
Born Cincinnati. Joined Rookwood 1904. Married Stanley Gano Burt, March 1, 1910 and left the pottery at that time.

NOURSE, MARY MADELINE (1870-1959)
Niece of internationally known artist, Elizabeth Nourse. CAA. Taught CAA 1889. At Rookwood 1891 to October 1905.

PERKINS, MARY LOUELLA
At Rookwood about 1886 to about 1898.

PETERS-BAURER, PAULINE
At Rookwood about 1893 or 1894. Woman's Art Club.

PINNEY, O. GENEVA REED
See Reed, Olga Geneva

PONS, ALBERT
At Rookwood from about 1904 until about 1911.

PULLMAN, JOHN WESLEY (1886-1931)
Born Philadelphia. Studied Pennsylvania Museum and School of Industrial Art. At Rookwood from 1926 until his death in 1931.

RAUCHFUSS, MARIE (1879-?)
Born Cincinnati. CAA. Is believed to have worked at Weller Pottery in Zanesville before coming to Rookwood in 1899. Left about 1903, moving to Louisville. Woman's Art Club.

REED, OLGA GENEVA (1873-?)
Came to Rookwood 1890; married in 1890's, changing her name to Pinney, but continued to sign work O.G.R. Probably left pottery about 1903. After death of Mr. Pinney, she married Matt Daly in 1928.

REHM, WILHELMINE (1899-1967)*
Born Cincinnati. Graduate Smith College. CAA, University of Cincinnati. Rookwood 1927 to 1932, 1935, and 1943 to 1948. Taught art in Cincinnati public schools. Considered returning to Rookwood at Starkville in 1961, but decided against it.

RETTIG, MARTIN (1869-1956)
Born Cincinnati. At Rookwood for a short period beginning in 1883. Left to join elder brother John in painting elaborate scenery for spectacular shows put on by Order of Cincinnatus in the 1880's. Studied under Duveneck and became authority on this artist. Member and president of Cincinnati Art Club. Died Cincinnati.

ROTHENBUSCH, FREDERICK DANIEL HENRY
Nephew of Albert R. Valentien. At Rookwood 1896 to 1931.

SACKSTEDER, JANE (1924-)*
Born Cincinnati. University of Cincinnati and Mt. St. Joseph College. Junior decorator at Rookwood 1945, promoted to decorator 1946. Left in 1948.

SAX, SARA
At Rookwood 1896 to 1931.

SCHMIDT, CHARLES (1875-1959)
Born in Germany. Apparently changed his given name to Carl shortly after joining Rookwood in 1896. Left pottery 1927 to join R. F. Johnston Paint Co. Later worked for Cincinnati *Times-Star*.

SEHON, ADELIZA DRAKE (?-1902)
At Rookwood from 1896 until her death in 1902.

SHIRAYAMADANI, KATARO (1865-1948)

Born in Kanazawa, Japan. Name means White Mountain Valley. At Rookwood from 1887 until his death in 1948 except for ten years in Japan from 1915 to 1925. Credited with developing electro-deposit method of metal overlay; also designed many shapes.

SMALLEY, MARIAN FRANCES HASTINGS (1866-1957)

Born New Orleans. At Rookwood 1899 to 1902. Married Francis William Vreeland April 18, 1903. CAA and University of Denver. Worked for National Arts Club, New York. Moved to California. Died Hollywood, California.

SPRAGUE, AMELIA BROWNE

At Rookwood 1887 to 1903. Apparently returned later, as pieces of hers were in the fiftieth-anniversary kiln in 1930.

STEGNER, CAROLYN (1923-)*

Born Cincinnati. University of Cincinnati. At Rookwood as junior decorator in 1945. Promoted to decorator, left 1947.

STEINLE, CAROLINE FRANCES (1871-1944)

Born Cincinnati. (Brother Andrew at Rookwood from early 1880's as utility boy, later paymaster.) Came to Rookwood 1886; became decorator 1892. Later put in charge of color room. Left Rookwood about 1925 to enter convent. Died Newport, Kentucky.

STORER, MARIA LONGWORTH NICHOLS

See Nichols, Maria Longworth

STRAFER, HARRIETTE ROSEMARY (1873-1935)

Born Covington, Kentucky. CAA. At Rookwood 1890 to 1899. Left to pursue art studies in New York. Woman's Art Club. Died Covington, Kentucky.

STUNTZ, H. PABODIE

Came to Rookwood for a short time about 1892.

SWING, JEANNETTE (1868-?)

Born Cincinnati. At Rookwood 1900 to 1904.

TAYLOR, MARY A. (1859-1929)

Cousin of W. W. Taylor. At Rookwood 1883 to 1885. Left to marry George DeForest Dominick. Died Cincinnati.

TISCHLER, VERA (1900-)*

Born Cincinnati. At Rookwood 1920 to 1925. Married G. Warren Fichter, potter at Rookwood.

TODD, CHARLES STEWART (1885-1950)

Born Owensboro, Kentucky, CAA. Joined Rookwood about 1911 and stayed until early 1920's. Cincinnati Art Club, MacDowell Society. Died Owensboro.

TOOHEY, SARA ALICE

At Rookwood 1887 to 1931. From about 1908 until 1917 in charge of glazing for architectural department. Also created many designs such as Dutch tiles in Mills Restaurant. Later in charge of glaze room for vase department.

VALENTIEN, ALBERT ROBERT (1862-1925)

Born Cincinnati. CAA. At Rookwood 1881 to 1905 in charge of decorating department. Studied abroad 1899 to 1900, also painting wildflowers in Germany. Moved to California, commissioned by Ellen Browning Scripps to paint wild flowers of California—about 1,500 individual water-color pictures. Died San Diego, California.

VALENTIEN, ANNA MARIE

See Bookprinter, Anna Marie

VAN BRIGGLE, ARTUS (1869-1904)

Born Felicity, Ohio. Worked under Karl Langenbeck at Avon Pottery before joining Rookwood in 1887. One of most promising decorators; was sent for three years' study to Julian Art Academy and Beaux Arts in Paris. Forced by ill health to leave Rookwood 1899. Went to Colorado Springs. Started Van Briggle Art Pottery in 1901. Married 1903. Died Colorado Springs, Colorado.

VAN BRIGGLE, LEONA

Born Felicity, Ohio. Younger sister of Artus Van Briggle. At Rookwood 1899 to 1904.

VAN HORNE, KATHERINE

At Rookwood from about 1907 to 1917.

VREELAND, FRANCIS WILLIAM (1879-1954)

Born Seward, Nebraska. At Rookwood 1900 to 1902. Married Marian Smalley April 18, 1903. Studied Art Students League, New York; Julian Art Academy, Paris. Mural painter of note. Known by nickname Toby. Died Hollywood, California.

WAREHAM, JOHN HAMILTON DELANEY (1871-1954)
Born Grand Ledge, Michigan. At Rookwood 1893 to 1954. See biographical sketch introducing Chapter 19. Died Cincinnati.

WENDEROTH, HARRIET
At Rookwood 1881 to about 1885.

WILCOX, HARRIET ELIZABETH
At Rookwood 1886 to 1907. Returned later and remained until after the fiftieth anniversary in 1930.

WILDMAN, EDITH L.
At Rookwood from about 1911 to about 1913.

WORKUM, DELIA (1904-)*
Born Cincinnati. CAA, University of Cincinnati, and Columbia Teachers College. At Rookwood 1927 to 1929.

YOUNG, GRACE (1869-1947)
Born Covington, Kentucky. CAA. Taught at CAA. Joined Rookwood 1886. A gifted painter; was among first to introduce portraits on vases. Left Rookwood 1904 to return to teaching at CAA. About 1916, married to Fritz Van Houten Raymond, Rookwood photographer, following death of his first wife. Died Montclair, New Jersey.

ZANETTA, CLOTILDA MARIE (1890-?)
Born Concepcion, Chile. Came to U.S. 1921. CAA. For ten years, assistant to Clement J. Barnhorn. Joined Rookwood about 1943 and stayed until about 1948. Designed many religious figures. Later taught art at Our Lady of Cincinnati College. Returned to Chile in 1956.

ZETTEL, JOSEPHINE ELLA (1874-1954)
Born Cincinnati. At Rookwood from 1892 to 1904. Later worked in florist shop and gift shop. Died Cincinnati.

Afterchapter III

The Shape Record Book

For serious collectors and students of Rookwood history who desire more information about the early ware, the Shape Record Book has much of interest. The following summary of the first 200 pieces made gives the origin or inspiration for many of the shapes, the records of sales (entered only until mid-1884), and other pertinent data:

1. Aladdin Vase, 1880, decorated by MLN in high relief with fishes, crabs, etc. Height 2 ½ feet. Sold six at $25 each.
2. Rose jar. Mr. Brennan's design. No successful specimen.
3. Circular disc Mr. Brennan's design. Not successful, reshipped to pottery from sample lot sent to Boston 1883.
4. Jug. Miss Fry's design. Height 12″.
5. Bowl. Miss Fry's design. Specimen sage green finished with silver spider web. 1883. Sold at salesroom to Mrs. W. N. Harris, Cleveland.
6. Vase, disc top. Mr. Brennan's design. No successful specimen made.
7. Japanese metal vase. Gold leaves, $10; Persian blue, dry smear, two copper crabs applied, $10. Six sold in 1883 and 1884.
8. Umbrella stand. Thrown by William Auckland, June 1883. Design suggested by WWT, first specimen decorated by MLN and sent east with sample lot in 1883. 3 sold.
9. Vase for umbrella stand. Thrown by WA. Decorated by ARV. Sent east with sample lot 1883. 2 sold.
10. Tankard, mold bought from Dallas & Co. 1881. 3 sizes, only saleable size largest 11½″. Sell well as biscuit pieces. 2 decorated overglaze gold background CCN sold 1882, 1 decorated fleur de lis in blue under the glaze LAF 1883.
11. Bowl. Pressed. 1881. 2 sold 1883.
12. Large thrown jug in 4 sizes: A, B, C, and D. 53 sold.
13. Dutch Jug or Longfellow Pitcher. 1880. Based on original Wedgwood pitcher made in England. Pressed. Smaller size thrown, decorated by LAF sent east with samples 1883. 46 sold.
14. Vase thrown June 1883. First specimen decorated by MLN. 2 sold.
15. Pitcher. 1881. Thrown by WA. Ht. 5″. Carved red clay, did not prove saleable.
16. Round candy box. Thrown Oct. 1883. 3 sizes. 8 sold.
17. Pitcher. 1881. Not saleable as carved pieces. 14 sold.
18. Miss Fry's pitcher, thrown by WA. First specimen decorated with flowers incised and finished with cobalt, sent east with sample lot 1883. 32 sold.
19. Vase thrown 1881. Regular decoration grasses, butterflies, etc, moderately saleable. 18 sold.

20. Vase. 1882. Modeled after antique vase. Ht. 9″. Finish blue glaze. Positively unsaleable.

21. Square candy box. Pressed. Oct. 1883. 3 sizes. 99 sold.

22. Jewel box. 1882. After Japanese design. Pressed. Decorated with grasses, butterflies. Not very saleable. 8 sold.

23. Hexagon vase. 1881. Pressed. 2 sizes. Not saleable.

24. Persian pitcher. Miss Fry's design, thrown by WA. First specimen decorated by LAF sent east in 1883. 6 sold.

25. Japanese incense burner, model furnished by H.R.G. of Duhme & Co. Finish blue or green glaze. Green glaze proved more artistic and saleable. Demand from dealers small, sales to private parties reasonable.

26. Persian Pitchers (made with one handle and with two handles) 1881, Height 12″. Thrown. 22 sold.

27. Vase. 1883. Made on wheel. 1 sold.

28. Lamp vase. Pressed. Modeled after antique vase. Ht. 7″. Blue glaze finish. Demand from dealers and private sales small. 25 sold.

29. Hebe Vase. 1881. Thrown. Ht. 17″. Demand for biscuit painting good. 1 in blue glaze sold to Ovington.

30. Vase after design furnished by Mr. Brennan. July 1883. Two sizes. 4 sold.

31. Vase. Red clay, Oct. 1883. Decorated by Miss Fry. First specimen sold to Mr. Galbreath, sent to Paris.

32. Three piece berry set including handled basket. June 1882, Pressed. 27 sets and 4 single baskets sold.

33. Small basket berry set. Designed after small French china basket. Pressed. 15 sold.

34. Berry set—third piece (pitcher). Pressed June 1882. Demand small. 7 sold.

35. Fruit plate after design modeled by LAF. June 1881. Pressed. Demand small. 9 sold.

36. Pitcher. Thrown by WA June 1882. Decoration regular style very saleable in summer and fall of 1882. Also

37. Vase. Thrown. Claret pitcher shape. 1881. Design stamped and filled with color. This style work was tried in Rookwood Pottery by Fannie Auckland Sept. 1881. Success in market limited. 4 sold.

38. Club vase. Thrown. 1881. Ht. 9″. Decoration carving, smear finish. Not saleable.

39. Pitcher designed by W. Auckland. Decorated by Miss Fry. Sept. 1883. Ht. 13″. First specimen ginger neck, pale blue body, rough smear, white flowers & slight finish of gold.

40. Claret Pitcher. Thrown 1881. One of oldest and most successful shapes. Decorated in 3 styles, regular, smear by MLN, and hammered bronze by LAF. All styles saleable. 28 sold. (This number was cancelled and reassigned to Japanese vase in 1884.)

41. Spanish water jar. 1882. Thrown by WA. Made in yellow clay, smear finish. Dealer demand moderate, private sales excellent. 25 sold.

42. Japansee crock after model furnished by MLN 1884. 3 sold.

43. Japanese tea pot after model furnished by Kate Wood. Includes 3 pieces as tea set. 14 sets sold.

44. Easter egg. Model furnished by Mrs. L. B. Harrison, 1881. Made in 3 sizes. 147 sold.

45. Footed basket. Made in 3 sizes. After design furnished by Mrs. Jewitt, Calif. 1882. Demand good. 69 sold.

46. Vase made on wheel. 1882. 1 sold. (This number was cancelled and reassigned to a thrown vase designed by WWT, 1885.)

47. Covered jar made on wheel by WA. Decorated ARV. Metal finish at base. 1 sold.

48. Footed egg dish. Design furnished by Mrs. Sherlock 1883.

49. Pilgrim vase. 1881. Pressed. Ht. 11″. Demand fair, shape not sufficiently novel to make it very marketable. Decorated two styles, flowers and landscape. 25 sold.

50. Pitcher. Made on wheel 1882. Ht.

Afterchapter III

The Shape Record Book

For serious collectors and students of Rookwood history who desire more information about the early ware, the Shape Record Book has much of interest. The following summary of the first 200 pieces made gives the origin or inspiration for many of the shapes, the records of sales (entered only until mid-1884), and other pertinent data:

1. Aladdin Vase, 1880, decorated by MLN in high relief with fishes, crabs, etc. Height 2 ½ feet. Sold six at $25 each.
2. Rose jar. Mr. Brennan's design. No successful specimen.
3. Circular disc Mr. Brennan's design. Not successful, reshipped to pottery from sample lot sent to Boston 1883.
4. Jug. Miss Fry's design. Height 12″.
5. Bowl. Miss Fry's design. Specimen sage green finished with silver spider web. 1883. Sold at salesroom to Mrs. W. N. Harris, Cleveland.
6. Vase, disc top. Mr. Brennan's design. No successful specimen made.
7. Japanese metal vase. Gold leaves, $10; Persian blue, dry smear, two copper crabs applied, $10. Six sold in 1883 and 1884.
8. Umbrella stand. Thrown by William Auckland, June 1883. Design suggested by WWT, first specimen decorated by MLN and sent east with sample lot in 1883. 3 sold.
9. Vase for umbrella stand. Thrown by WA. Decorated by ARV. Sent east with sample lot 1883. 2 sold.
10. Tankard, mold bought from Dallas & Co. 1881. 3 sizes, only saleable size largest 11½″. Sell well as biscuit pieces. 2 decorated overglaze gold background CCN sold 1882, 1 decorated fleur de lis in blue under the glaze LAF 1883.
11. Bowl. Pressed. 1881. 2 sold 1883.
12. Large thrown jug in 4 sizes: A, B, C, and D. 53 sold.
13. Dutch Jug or Longfellow Pitcher. 1880. Based on original Wedgwood pitcher made in England. Pressed. Smaller size thrown, decorated by LAF sent east with samples 1883. 46 sold.
14. Vase thrown June 1883. First specimen decorated by MLN. 2 sold.
15. Pitcher. 1881. Thrown by WA. Ht. 5″. Carved red clay, did not prove saleable.
16. Round candy box. Thrown Oct. 1883. 3 sizes. 8 sold.
17. Pitcher. 1881. Not saleable as carved pieces. 14 sold.
18. Miss Fry's pitcher, thrown by WA. First specimen decorated with flowers incised and finished with cobalt, sent east with sample lot 1883. 32 sold.
19. Vase thrown 1881. Regular decoration grasses, butterflies, etc, moderately saleable. 18 sold.

20. Vase. 1882. Modeled after antique vase. Ht. 9″. Finish blue glaze. Positively unsaleable.

21. Square candy box. Pressed. Oct. 1883. 3 sizes. 99 sold.

22. Jewel box. 1882. After Japanese design. Pressed. Decorated with grasses, butterflies. Not very saleable. 8 sold.

23. Hexagon vase. 1881. Pressed. 2 sizes. Not saleable.

24. Persian pitcher. Miss Fry's design, thrown by WA. First specimen decorated by LAF sent east in 1883. 6 sold.

25. Japanese incense burner, model furnished by H.R.G. of Duhme & Co. Finish blue or green glaze. Green glaze proved more artistic and saleable. Demand from dealers small, sales to private parties reasonable.

26. Persian Pitchers (made with one handle and with two handles) 1881, Height 12″. Thrown. 22 sold.

27. Vase. 1883. Made on wheel. 1 sold.

28. Lamp vase. Pressed. Modeled after antique vase. Ht. 7″. Blue glaze finish. Demand from dealers and private sales small. 25 sold.

29. Hebe Vase. 1881. Thrown. Ht. 17″. Demand for biscuit painting good. 1 in blue glaze sold to Ovington.

30. Vase after design furnished by Mr. Brennan. July 1883. Two sizes. 4 sold.

31. Vase. Red clay, Oct. 1883. Decorated by Miss Fry. First specimen sold to Mr. Galbreath, sent to Paris.

32. Three piece berry set including handled basket. June 1882, Pressed. 27 sets and 4 single baskets sold.

33. Small basket berry set. Designed after small French china basket. Pressed. 15 sold.

34. Berry set—third piece (pitcher). Pressed June 1882. Demand small. 7 sold.

35. Fruit plate after design modeled by LAF. June 1881. Pressed. Demand small. 9 sold.

36. Pitcher. Thrown by WA June 1882. Decoration regular style very saleable in summer and fall of 1882. Also

37. Vase. Thrown. Claret pitcher shape. 1881. Design stamped and filled with color. This style work was tried in Rookwood Pottery by Fannie Auckland Sept. 1881. Success in market limited. 4 sold.

38. Club vase. Thrown. 1881. Ht. 9″. Decoration carving, smear finish. Not saleable.

39. Pitcher designed by W. Auckland. Decorated by Miss Fry. Sept. 1883. Ht. 13″. First specimen ginger neck, pale blue body, rough smear, white flowers & slight finish of gold.

40. Claret Pitcher. Thrown 1881. One of oldest and most successful shapes. Decorated in 3 styles, regular, smear by MLN, and hammered bronze by LAF. All styles saleable. 28 sold. (This number was cancelled and reassigned to Japanese vase in 1884.)

41. Spanish water jar. 1882. Thrown by WA. Made in yellow clay, smear finish. Dealer demand moderate, private sales excellent. 25 sold.

42. Japansee crock after model furnished by MLN 1884. 3 sold.

43. Japanese tea pot after model furnished by Kate Wood. Includes 3 pieces as tea set. 14 sets sold.

44. Easter egg. Model furnished by Mrs. L. B. Harrison, 1881. Made in 3 sizes. 147 sold.

45. Footed basket. Made in 3 sizes. After design furnished by Mrs. Jewitt, Calif. 1882. Demand good. 69 sold.

46. Vase made on wheel. 1882. 1 sold. (This number was cancelled and reassigned to a thrown vase designed by WWT, 1885.)

47. Covered jar made on wheel by WA. Decorated ARV. Metal finish at base. 1 sold.

48. Footed egg dish. Design furnished by Mrs. Sherlock 1883.

49. Pilgrim vase. 1881. Pressed. Ht. 11″. Demand fair, shape not sufficiently novel to make it very marketable. Decorated two styles, flowers and landscape. 25 sold.

50. Pitcher. Made on wheel 1882. Ht.

smear finish, green glaze, carved. 85 sold.

11″. Demand small.

51. Turkish coffee pot. 1882. Pressed. Decorated two styles. Demand good, particularly popular at salesroom. 26 sold.

52 Gourds, with and without foot. 1882. 3 styles decoration: carved, regular, and smear. Very saleable in 2nd and 3rd styles of decoration. Oct 1883 introduced a net in which to hang gourd. 68 sold.

53. "Fish" entree dish. Japanese model, blue and white. $6 per dozen. Oct. 1883. 35 sold.

54. Pitcher made on wheel 1882. 3 sizes. Good demand. 155 sold.

55. Easter egg opening in center. 3 sizes. 82 sold.

56. Pitcher. 1882. 3 sizes. Made on wheel. Moderately saleable. 21 sold.

57. Waste paper basket. 1883. Made after model furnished by Davis Collamore. 3 sizes. 18 sold.

58. Egg cup (A) and saucer (B) from Wedgwood model furnished by Mrs. J. H. Perkins. 1884. 107 sets sold.

59. Japanese flower dish. 1884. 3 sizes. 6 sold.

60. Flat jug made on wheel. 1881. Limoges. Nearly 1400 sold.

61. Round jug made on wheel. 1881. Decorated Limoges or carved. Over 4,000 sold.

62. Thrown jug designed by WA 1883. Two mounted with silver bands 1884. 10 sold.

63. Cream jug after design furnished by Miss Fry 1884. 14 sold.

64. Alhambra Pitcher. Design furnished by Miss Fry. 2 sold.

65. Pitcher. 1882. Limoges. Sent east with sample lot. 25 sold.

66. Vase made on wheel 1882. Decorated MLN. 5 sold. (This number was cancelled and reassigned to thrown vase by WA.)

67. Cylinder lamp vase. 10¼″ high. 17 sold. 25 made in lower and wider size for R. Hollings.

68. Pitcher made on wheel 1881. 3 sizes. 37 sold. (Number cancelled and reassigned to large thrown Japanese Lantern umbrella stand, suggestion MLN 1884.)

69. Tea pot 1884. Japanese design furnished by MLN. 10 sold.

70. Salad bowl. 1883. Miss Fry's design. Made on wheel. Sample sent east 1883, hammered surface, sage green and yellow clay, flowers. 11 sold.

71. Round vase. Design taken from English ware. Made on wheel. Sample decorated by Miss Fry and sent east 1883. 2 sold.

72. Plate design furnished by WWT 1884 finished in colored glazes.

73. Umbrella Stand. Thrown by WA 1884. 2 sold.

74. Cream pitcher from design furnished by MLN. 1884.

75. Pitcher, cream clay. 1882. Made on wheel. Ht. 10″. Decorated light blue or pink spray of leaves or flowers. 9 sold.

76. Pitcher, cream clay. 1882. Made on wheel. 7 sold. (Number cancelled and reassigned to a small jar thrown by WA 1884.)

77. Pitcher, cream color, 1882. 2 sold. (Number cancelled and reassigned to covered jar thrown by WA. 1884.)

78. Cream pitcher. 1882. Sales at salesroom good. (Number cancelled and reassigned to Moresque plaque "Othello," 1884, designed and molded by J. C. Meyenberg.)

79. Cream pitcher 1882. Made on wheel. 20 sold.

80. Chocolate pot with spout at side, from Japanese vase MLN. 11 sold.

81. Chocolate pot first made in white ware with gilt and colored bands. 1880. Thrown.

82. Bowl. Thrown 1884. Design furnished MLN.

83. Footed pot. Design furnished MLN. 1884.

84. Pot. Design furnished MLN. 1884.

85. Pilgrim Flask. 1881. Model stein wine bottle. Very saleable. Pressed. 81 sold.

86. Group of 3 vases. Design furnished MLN. 1884.

87. 3 Piece Porridge set. Pressed 1882. Pitcher, bowl and saucer. Finish 2 styles, blue glaze and Limoges. 47

sets sold. 266 saucers sold.

88. Tea pot. From French fire proof ware.

89. Hot water pitcher. Thrown. Design furnished by Miss Stettinius 1880. 2 sizes. 3 sold.

90. Pocket vase. 1882. Limoges. Sales good. 17 sold.

91. Chocolate pot. Designed by WA. 1884.

92. Small jar. From model furnished by MLN.

93. Match holder. From suggestion of Ovington, Brooklyn.

94. Vase or lamp base. 1882. Made on wheel. 3 sizes. Demand moderate. 37 sold.

95. Lamp base or vase. Made on wheel. 3 styles of decoration: Limoges, smear, or carved. 65 sold.

96. Tea caddies. Carved or Limoges. Made on wheel. Not very saleable. 24 sold.

97. Covered vase from English model. 1881. Three sizes. Large for vase or lamp base, medium and small for tea caddy. Very saleable. 297 sold.

98. Pocket vase. 1881. Pressed. Modeled from French vase. Limoges decoration. 60 sold. (Number cancelled and transferred to after-dinner cup and saucer, one of the early shapes but not given a number until Oct. 1884.)

99. Jardiniere. Ht. 12". 1 sold.

100. Chocolate pot. Kingfisher decoration. 25 sold.

101 Claret jug. Made on wheel 1883. Decorated 3 styles, smear, Limoges, and carved. First & second styles saleable. 61 sold.

102. French crushed vase from model of Nancy ware. Made on wheel 1881. 2 sizes. Limoges & smear decoration. Sales good. 32 sold.

103. Vase made on wheel 1882. 41 sold. (Number cancelled and reassigned to Hearthstone Tea pot. First made early in pottery history, but first numbered Oct. 1884.)

104. Vase. 1881. Not saleable. Very few decorated.

105. Beer Mug. Mohlenhoff.

106. Flower pot. Pressed.

107. Vase. 1881. From Nancy ware model furnished by R. H. Galbreath. Pressed. All pieces to Nov. 19, 1883 decorated by Mrs. Nichols.

108. Spanish water jar. 1882. Made on wheel. After Hungarian model in Exposition 1882. Very saleable. 14 sold.

109. Scalloped bowl and saucer. 1880. Not decorated, not saleable.

110. Corrugated pitcher. 1881. From Nancy ware model. Decorated by Mrs. Nichols. 4 sold.

111. Tete a tete set. Square tray with oriental design tea pot, sugar, creamer and two cups and saucers. 1881. Not saleable.

112. Globe lamp vase. 1882. Made on wheel. 24 sold.

113. Vase made on wheel. 2 sizes. 1 sold.

114. Bouillon bowl and saucer. LAF design. 1884.

115. French crushed pitcher from Nancy ware model furnished by R. H. Galbreath. 1881. All to Nov. 1883 decorated by Mrs. Nichols. 13 sold.

116. Horn pitcher. 1882. Pressed. Sales fair. 41 sold.

117. Vase made on wheel. 1882. 2 sizes. 6 sold.

118. Lamp vase. 1882. Made on wheel. Carved by Miss Wenderoth. Dipped in blue or green glaze. Not very saleable. 15 sold.

119. Chocolate Pot. Pressed 1881. 4 styles of decoration: Kingfisher, Decorated, Panel design, Basket design. 47 sold.

120. Porridge bowl. (Mrs. Warner.) 1884.

121. Salad bowl. 1882. Pressed. Decorated Limoges. Saleable. 43 sold.

122. Rip Van Winkle jug. 1881. Made on wheel from design suggested by Mrs. Charles Kebler. Decorated CCN. Sales fair. 52 sold.

123. Pitcher. Pressed. 1882. Limoges decoration. 20 sold.

124. Flat vase. 1882. Pressed. Saleable as biscuit ware, not to trade. (Number cancelled and transferred to Pressed Cabbage Leaf plate, colored glazes.)

125. Large flat vase. 1882. Vase referred to by Oscar Wilde in Cincinnati lec-

ture. Saleable to ladies for decoration, not to trade. 5 sold.

126. Vase. 1882. Made on wheel. 2 sizes. Very saleable. Large size sold 60, small size sold 128.

127. Lotus leaf bowl. Design from lotus leaf sent to Mrs. Nichols by Reuben Warder. 2 styles, decorated and green glaze. 6 sold.

128. Vase. Ht. 16¼″. 1881. Made on wheel. (Number cancelled and transferred to thrown vase designed by WWT 1885.)

129. Globe vase. 1881. Pressed. Limoges decoration. 4 sold.

130. Vase with net. Sales moderate. 5 sold.

131. Lamp vase. 1881. Made on wheel. Sold 1. (Number cancelled and transferred to jiggered jardiniere after model by J. C. Meyenberg 1884)

132. Pitcher. First thrown from model furnished by J. L. Stettinius. molds made for jiggering 1884.

133. Pitcher. 1881. After Hannah Barlow design. Sales for decoration to ladies good, to trade poor.

134. Hanging soap dish. Pressed.

135. Stationary wash bowl. Pressed.

136. Candy, sugar, or powder box. After drawing by ARV from Japanese collection of Prof. E. S. Morse, Salem, Mass.

137. Dutch or Longfellow jug modeled in clover leaf pattern by J. C. Meyenberg, 1884.

138. Mustard or custard cup. Jiggered from model furnished by MLN.

139. Vase. Modified from A. Brennan's design. 3 sizes. Thrown.

140. Umbrella stand. Panels designed by Mr. Breuer. 11 sold.

141. Vase. Single piece finally sold from old stock for $5, 1884. (Number transferred to vase thrown 1885. Design by WWT.)

142. Tea Jar. Pressed 1881. 4 sizes. Several styles decoration. Carved by Miss Wenderoth, decorated by Miss Fry. 23 sold.

143. Tea jar. 1881. 3 pieces decorated. 1 piece still at salesroom Nov. 1883. (Number cancelled and transferred to thrown vase from drawing of

WWT Oct. 1884.)

144. Vase 1881. In pottery museum collection as one of first pieces decorated in Rookwood Pottery. (Large birds.)

145. Chinese lantern. Model furnished by Mr. Galbreath. Decorated by Mrs. Nichols. 1 sold.

146. Water cooler. Pressed 1881. Decorated by Mr. Cranch. (Bears.)

147. Jug. Made on wheel. Not saleable. (Number cancelled and reassigned to plates modeled after patterns from Choisy-le-Roi. 6 styles. First made 1883. First numbered 1884.)

148. Jardiniere. Pressed. 1881. Not saleable. 1 sold.

149. Footed bowl. After Japanese bronze. 1884.

150. Pitcher. 1882. Limoges decoration. 6 sold.

151. Pitcher. 1882. Only 3 or 4 pieces made. 1 sold.

152. Pitcher. Not saleable.

153. Claret vase. 1882. Carved bands. Not saleable.

154. Barrel pitcher. 1881. Plain red clay. Demand fair at pottery.

155. Vase. 1882. Ht. 15″. (Number cancelled and transferred to thrown vase by W. Auckland.)

156. Tea Kettle. 1882. Pressed. 2 styles: Limoges and smear. 3 sold.

157. Vase. 1882. Not saleable. (Number cancelled and transferred to thrown vase by W. Auckland.)

158. Pitcher, pressed 1883. Sent east with sample lot 1883. Demand fair. Limoges decoration. 15 sold.

159. Triangular pitcher. 1881. Pressed. Used only for over-glaze and biscuit painting.

160. Vase. Made on wheel. 1881. (Number cancelled and transferred to thrown vase by W. Auckland.)

161. Vase. 1882. Not saleable. Ht. 13″. 7 sold.

162. Vase. Yellow clay. Made on wheel 1882. 3 sizes. Vases decorated by Mrs. Nichols have been saleable. 7 sold.

163. Punch bowl. 1882. Pressed. Difficult to fire. Demand light. Ht. 8½″, D. 16½″. 4 sold.

164. Vase. Ht. 13″. Pressed. Mold the property of Miss McLaughlin. Shape popular for ladies' decoration. Demand from dealers light.
165. Pitcher. Made on wheel 1882. 1 sold.
166. Square salads. 4 sizes. 66 sold.
167. Vase. 1881. Pressed. Form generally used for gold nets.
168. Vase. 1 piece made 1881. Gray clay body. Stamped by Fannie Auckland. Filled with cobalt.
169. Funnel. Pressed. Model furnished by MLN. 1884.
170. Vase. Dallas model 1879.
171. Butterfly plate on 3 small feet. After model furnished by Mrs. Green of College Hill. One or two dozen made in 1883. First numbered and made in quantity Nov. 1884.
172. Vase designed by WWT 1884.
173. Vase pressed. [Mold] Bought from F. Dallas 1880. First numbered 1884.
174. Chocolate pot, dragon decoration.
175. Puck Pitcher.
176. Decorated beer mug.
177. Umbrella stand. First made 1881 or 1882. Numbered in 1884.
178. Umbrella stand. Made after suggestion of G. W. Weston, Boston.
179. Footed vase. Original model thrown by WA. 1884.
180. Jardiniere. First molds made from piece thrown by WA 1882.
181. Jardiniere. Suggestion of WWT. 1884.
182. Pitcher. 1882. Carved. Finished in green glaze. 2 sizes. 41 sold.

183. Pitcher. White clay. Ht. 11½″. 12 sold.
184. Vase made on wheel. 1881. 22 sold.
185. Water bucket. Yellow ware, one of original shapes at pottery in 1880. First decorated buckets made 1883. Sent with tube (No. 186) to Mrs. W. L. Anderson.
186. Foot tub. Yellow clay. 1880.
187. Cuspidore. 2 sizes. Model furnished by Collamore. 215 sold.
188. Pressed plaque. Decorated in monochrome. Not saleable.
189. Red clay plaque. Decorated by H. Farny. Could not be fired hard enough to set the colors in manner desired by artist. (Number cancelled and reassigned to jardiniere after an old piece of Imari blue and white porcelain owned by J. L. Stettinius.)
190. Pressed plaque, windmill. Not very saleable. (Number transferred to Renaissance Tea Set.)
191. Plaque decorated by MLN 1881.
192. Bottle. 1882. After Japanese bottle of MLN. Not saleable.
193. Vase. Thrown 1881.
194. Vase. 1881. 2 made. Not saleable.
195. Vase 1882 after Japanese bronze model. Not very saleable.
196. Drug jar. Jiggered. 2 sizes.
197. Vase. Thrown.
198. Handled bowl. Made with and without feet. 1,312 sold.
199. Covered basket. 2 sold. 1883.
200. Pitcher made in 3 sizes. 33 sold.

Afterchapter IV

Rookwood in Museum Collections

Following the presentation of the highest awards to Rookwood Pottery at the Paris International Expositions of 1889 and 1900, and at the World's Columbian Exposition in Chicago in 1893, twenty-four foreign museums acquired examples of this new American art. Their names, along with those of two American museums that had prominent Rookwood collections, were listed as patrons of the pottery in all the regular Rookwood promotion pamphlets issued after that time.

More than sixty-five years later, and after the destruction of two World Wars, it is interesting to find that many of these collections are still intact. Except for the few examples of Tiger Eye, all the pieces are artist signed and most have floral designs. Prices paid at the time of acquisition, where known, are given in parentheses. The collections are summarized as follows:

Musée National de Céramique, Sèvres, France. Two pieces: one a vase with St. George and the dragon, decorated by William McDonald, acquired 1889; the other a vase decorated by Artus Van Briggle, acquired 1901.

Museum of Decorative Arts, Budapest, Hungary. Two specimens: one of Tiger Eye given the museum by Davis Collamore; the other the gift of L. Dellamare Didot, both presented in 1889. The latter, badly broken during World War II, has been repaired.
(*See* photo in Chapter 8.)

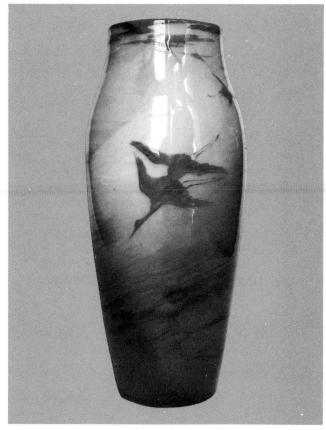

Kunstgewerbemuseum, Berlin
Storks against a yellow sunset sky, by Harriet E. Wilcox.

Museum of Decorative Art, Copenhagen, Denmark. One vase acquired in 1893, decorated by Albert R. Valentien.

Royal Industrial Art Museum, Berlin, Germany. Six pieces: Two purchased in 1896

155

were a ewer-shaped pitcher by Shirayama-dani, embellished with silver overlay by Gorham Mfg. Co. ($179), and a vase with fish decoration by Albert R. Valentien ($88.00). The four acquired in 1900 included two vases ($25.00 and $18.50) and a mug ($90.00) decorated by Harriet E. Wilcox, and a vase decorated by Sara Sax ($27.50).

Museum of Art and Industry, Hamburg, Germany. Five pieces: a portrait mug by Bruce Horsfall acquired in 1893; four vases acquired in 1900—two decorated by Albert R. Valentien, ($150 and $125), one by Amelia B. Sprague ($15.00), and one by John D. Wareham showing frogs in relief ($75.00).

Victoria and Albert Museum, London, England. Eight pieces purchased in 1900 include the work of Harriet E. Wilcox ($48.75), Josephine Zettel ($34.00), Constance A. Baker ($25.00), O. Geneva Reed ($60.00), Albert R. Valentien (decorated with Chinese dragons, $85.00), Kataro Shirayamadani ($20.00), Frederick Rothenbusch ($25.00), and one piece whose decorator is not identified ($25.00).

State Hermitage Museum, Leningrad, U.S.S.R. The collection originally purchased in 1900 by the Central School-Stieglitz Museum in St. Petersburg entered the custody of the Hermitage in 1929. There are seven pieces: two early experimental mat glaze, painted with landscape scenes by Sallie Toohey ($10.00 and $15.00); two by Albert Valentien ($60.00 and $45.00); one by John D. Wareham ($30.00); one by Kataro Shirayamadani; and one Tiger Eye vase, unsigned ($125).

Museum of Industrial Arts, Oslo, Norway. Two pieces, purchased in 1900, are vases decorated by Albert R. Valentien ($100 and $70.00).

Museum of Decorative Arts, Bergen, Norway. One vase purchased in 1900, decorated by Mary Nourse ($37.50).

Moravian Industrial Museum (Moravska Galerie) Brno, Czechoslovakia. An "electro-deposit" copper overlay piece, designed and signed by John D. Wareham, acquired in 1900.

Industrial Art Museum (Narodni Galerie) Prague, Czechoslovakia. Three pieces. Two purchased in 1900 were decorated by Kataro Shirayamadani and Harriet E. Wilcox; one acquired in 1913 was decorated in 1900 by Marian H. Smalley.

Royal Industrial Art Museum of Wiirttemberg, Stuttgart, Germany. Originally acquired four pieces, two of which are now missing. Of the two remaining, one is an American Indian portrait vase purchased in 1900; the other a floral vase, artist not identified, purchased 1894.

Bavarian Industrial Museum, Nuremberg, Germany. Four pieces purchased in 1901

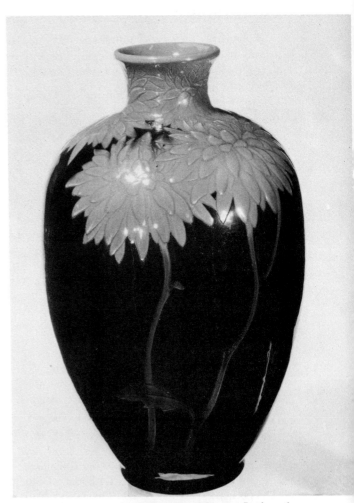

State Hermitage Museum, Leningrad
Decoration in low relief with orange-red chrysanthemums, brown stems on darker brown ground, by Albert R. Valentien.

represent the work of Rose Fechheimer ($20.00), O. Geneva Reed ($25.00), Anna M. Valentien ($60.00), and Kataro Shirayamadani ($80.00).

Museum of Decorative Arts, Mulhouse, France. Three pieces listed in the museum's catalog of 1903 disappeared during World War II. One, packed for safekeeping, was relocated in 1966. It is a vase acquired in 1900, decorated by Mary Nourse.

Other foreign museum collections of Rookwood

pottery have either disappeared or not been located. The Luxembourg Museum in Paris did not reopen its doors following the occupation during World War II. Its collections are reported to have been sent to the Musée National d'Art Moderne, from which they were dispersed to other museums throughout France, but efforts to trace the Rookwood once in the Luxembourg collections have been unsuccessful. The City Museum of Dortmund, Germany, was destroyed during World War II. Although it has been re-established in the nearby town of Schloss-Cappenburg, only a catalog giving the shape Nos. 706B, 30D, and 804A remains as evidence of the Rookwood once in its collection.

The museums in Karlsruhe, Fribourg, and Leipzig in Germany, Teplitz in Czechoslovakia, and Breslau (now Wroclau) in Poland report there is no longer any Rookwood pottery in their collections. The museum at Wroclau suggests that its pieces were probably lost during World War II.

The Imperial Commercial Museum in Tokyo, the Industrial Museum in Naples, and the Industrial Art Museum in Pilsen, Czechoslovakia,

Photo by Böhrer
Gewerbemuseum, Nürnberg

Iris-type vase has ivory-colored blossoms, gray-green stems and leaves, on a gray-beige ground. Decorated by O. Geneva Reed, as indicated on the base.

completed the list of Rookwood's patrons, but these museums are believed no longer in existence, and no record of their collections has been found.

Efforts to trace the examples of Rookwood taken to Japan by Kataro Shirayamadani in 1893 as "gifts to his Emperor" have not been successful. Normally, such gifts are placed in the custody of the Japanese Imperial Household Agency, and then dispersed to art museums throughout the country.

Mention should also be made of the Rookwood sent to the Museo Internazionale della Ceramiche in Faenza in 1946, and described in detail elsewhere in the text.

Photo by Dalibor Suchy
Moravska Galerie, Brno
"Electro-deposit" copper overlay, designed by John D. Wareham. Sea horses against deep blue shading to blue-black ground. Acquired in 1900 by Moravian Industrial Art Museum from L'Art Nouveau, Paris.

State Hermitage Museum, Leningrad
Iris-type pitcher in low relief with pink orchid on pale cream ground by Albert R. Valentien.

The two American museums named by Rookwood as among its patrons were the Cincinnati Art Museum and the Pennsylvania Museum and School of Industrial Art in Philadelphia. Since the time they were first listed, a number of other American museums have accessioned Rookwood pottery for their collections. Although in many cases not on permanent display because of space limitations, such pieces will usually be made available for study by the serious collector and student if an appointment is made in advance.

Cincinnati Art Museum, Cincinnati, Ohio
This, the largest collection available to the public, comprises a total of about 250 pieces, including many of historic interest. A large part of the collection has recently been placed on permanent display.

Smithsonian Institution, Washington, D.C. Comprising about 135 pieces, the collection is the second largest available to the general public. It includes the Rookwood from the collection of the late Dr. Marcus Benjamin, a prominent collector of American art pottery, circa 1900. Quite a few specimens of Rookwood are on permanent display.

Morse Gallery, Rollins College, Winter Park, Florida. A diversified collection of approximately 130 pieces recently acquired and not presently on display owing to space limitations.

City Art Museum of St. Louis, St. Louis, Missouri. Interesting examples of early Rookwood are among the thirty-three from the personal collection of Laura A. Fry which she presented to the museum in 1911. Not on permanent display.

Robert Hull Fleming Museum, University of Vermont, Burlington, Vermont. Eight inter-

Musée des Arts Décoratifs de Mulhouse

Lost during World War II, this vase with yellow tulips on a dark brown ground was found again in 1966. Photo of the base shows the paper label affixed to pieces sold at the Paris International Exposition in 1900.

esting and unusual pieces of early Rookwood, including a 17½″ platter decorated by Maria Longworth Nichols, undated and believed to be from the first kiln. The collection was presented to the museum in 1963 by Mrs. Joseph Longworth Nichols, daughter-in-law of the founder of the Rookwood Pottery.

Philadelphia Museum of Art, Philadelphia, Pennsylvania. Merged with the Pennsylvania Museum and School of Industrial Art, after which the early pieces of Rookwood assembled by Dr. E. A. Barber were sold at various public auctions between 1941 and 1954. Now numbers five pieces in its collection; not on permanent display.

Museum of Fine Arts, Boston, Massachusetts. A collection of fourteen pieces of Rookwood was presented to this museum in July, 1882, by Maria Longworth Nichols. However, most if not all of the collection was sold at auction in December, 1922. The museum now has only one piece, acquired at a later date and not on display.

Other American museums reporting one or more examples of Rookwood pottery in their collections include the following:

The Art Institute of Chicago, Chicago. In 1895, acquired by purchase two pieces from E. A. Barber, Philadelphia, and also accessioned a collection of ten pieces that had been presented by the Rookwood Pottery to the Field Columbian Museum. Perhaps this collection was "on loan" from the pottery, for in 1907 all twelve pieces were returned to Cincinnati in exchange for fifteen new examples of Rookwood. These pieces have since been dispersed, and today the Institute's catalog lists only one

item remaining, a Tiger-Eye piece, not presently on display.

Brooklyn Museum, Brooklyn, New York. Seven pieces, some on display.

Butler County Historical Society & Museum, Hamilton, Ohio. Six pieces, on display.

J. B. Speed Art Museum, Louisville, Kentucky. Fourteen pieces, not on display.

John Herron Art Institute, Indianapolis. Three pieces, not on display.

Lightner Exposition, St. Augustine, Florida. Two pieces, on display.

Lyman Allyn Museum, New London, Connecticut. Six pieces, not on display.

Milwaukee Public Museum, Milwaukee, Wisconsin. Thirty-three pieces, not permanently on display.

Museum of Art, Rhode Island School of Design, Providence. One example, not presently on display.

Museum of Modern Art, New York City. Several pieces, not on permanent display.

Rochester Museum of Arts & Sciences, Rochester, New York. One example, not on display.

The Metropolitan Museum of Art, New York City. Two pieces, not presently on display.

The Newark Museum, Newark, New Jersey. Fourteen pieces, not presently on display.

Western Reserve Historical Society, Cleveland, Ohio. About forty pieces, most of which are on display.

Worcester Art Museum, Worcester, Massachusetts. Two pieces, not presently on display.

ROOKWOOD
IRIS

Afterchapter V

Architectural Faience and Garden Pottery

Readers desiring more information about the Rookwood production of architectural tile and garden pottery may find the following of interest.

After the architectural department was organized in 1903, each project assigned to it was given an order number—A1, A2, A3, and so on. Existing records are fragmentary, but among the initial projects were:

A2. Seal of the Treasury of the United States. Detail for a mantel made for the office of the Secretary of the Treasury, Washington, D.C.

A6. Memorial Tablet erected in St. James' Church, West Hartford, Connecticut.

A9. Mantel Facing—Orange. McD. 31 tiles, 6¼ x 6¼. Foliage blue green; stems brown, fruit yellow & brown.

A10. Large mantel, 7 ft. wide, 7 ft. 8 in. high. In grey green with darker green leaves, yellow fruit and brown stems. Suitable for a large room with heavy woodwork.

A14. Reredos for St. Paul's Church, Rochester, New York. Heins & LaFarge, Architects.

A18. Mantel Facing—Night bl. cereus. A.R.V. 28 tiles 7 ⅛ x 12. Ground dull green, flowers white and yellow, stems green and brown.

A20. Number plaque made for the Twenty-third Street Station, New York Subway.

As larger projects developed, a separate order number was assigned to cover each part of the job.

The New York City subway stations each had a separate order number. In a major installation like that in the Norse Room of the Fort Pitt Hotel, as many as twenty-five separate order numbers were required to cover the various sections of the job.

By 1907, the architectural business had grown to the point where Rookwood published its first catalog covering architectural tile. This was 5 by 8 inches in size, and had forty-four pages. The introduction stated:

> We supply only Mat Glaze Faience Tile, not bright finished or gloss surface. Rookwood colors and textures are individual and can be obtained only in tile manufactured by the Rookwood Pottery Company.
>
> The illustrations show some of the Stock Designs in single or repeat Decorated Tiles, Panels, Mantel Facings and Complete Mantels.
>
> Rookwood decorated tiles are used singly, as borders, or as panels in connection with plain Rookwood tiles to produce effects of color in harmony with carefully planned interior or exterior decoration. The mat glaze texture adapts itself to surrounding materials. The range of color is almost unlimited. Cost can be regulated by concentration of the decorative surfaces at the most essential points...
>
> Rookwood gives particular attention to special designs prepared by its own artists, or by architects and decorators, where this is warranted by the importance of the subject.

Plain tiles were priced and offered singly. Those up to 6 by 6 inches in size were $1.00 or $1.25

each, depending on the color; tiles 6 by 12 inches or 12 by 12 inches were $2.00 or $2.25 each, again depending on color of the glaze.

Thirty glaze colors were available: Twenty-one in the lower-priced Class A were eight shades of green, two yellows, two browns, russet, sienna, ivory, and six shades of blue. The Class B, or more expensive, glaze colors were two shades of red, a pink, an orange-brown, purple, white, light and dark gray, and a "yellow to brown."

One hundred forty-five modeled or outline designs of decorative tiles were offered in a choice of any of the colors listed, and outline designs could be ordered in a combination of any two or more colors.

Prices for these ornamental tiles ranged from fifty cents each for a small (2- by 3-inch) size in a single color, to $15.00 each for a 12- by 18-inch outline marine scene in several colors.

Approximately one hundred twenty-five designs of stock moldings, caps, and corner pieces were also offered for use in inclosing tile panels, capping wainscots, bordering chimney breasts, fire openings, and so on.

Revised catalogs, enlarged in size to 11 by 14 inches and with an increased number of pages, were issued in 1909 and 1912. The 1909 catalog explained:

> The manufacture of Rookwood Mat Glazes cannot be hurried and the indefinite number

Typical decorative architectural tile. Size letters in first two rows were transposed, circa 1900.

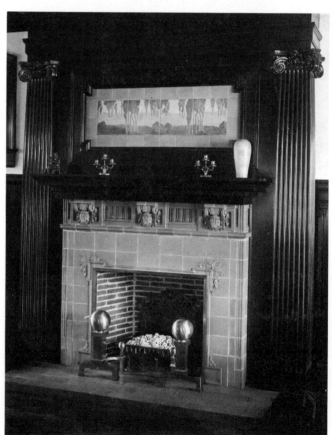

Typical fireplace mantel facing and panel. Over 100 mantel designs were available from stock.

of combinations of size, design and color make it impossible to keep a stock on hand. Practically every order must be made after it is received. The shortest time for manufacture is three weeks, while more elaborate projects range from five weeks upward. If any disaster occurs in any stage of the process the material has sometimes to be refired, but more frequently made over from the start. These time requirements for the necessary processes and these risks of further delay from accidents are inseparable from a product which must go through fires at very high temperatures. They should be allowed for, because fine workmanship and individuality cannot be had without them. . . .

No cancellations of orders can be accepted after they have gone into process. This rule is invariable.

In 1912, an effort was made to control the distribution of the architectural catalogs because they were costly to produce. Each one was numbered and stamped:

CATALOG NO. __3312__
Loaned by the Rookwood Pottery Co.
and subject to recall.

After 1912, the pottery discontinued publishing bound catalogs and used loose-leaf pages assembled in sets according to the particular interest of each prospect. For example, individual sheets were available illustrating nursery tiles, ornamental tile inserts, decorative tile medallions, ship design tile inserts, tile masks for fountain heads, medallions in relief designs, scenes and statues in relief of religious subjects, and other categories.

A similar change was made in the catalogs of garden pottery and garden ornaments—early bound copies gave way to the loose-leaf format. A price list dated August 1, 1925 contained sixty-seven items, including large vases up to forty-two inches high, urns of the same size, sectional window boxes in a variety of ornamented designs, sundial pedestals, bird baths, and fountain figures, all of which were produced in the architectural department.

Much speculation exists as to the profitability of the architectural department operation during

An indication of the size of some of Rookwood's garden pottery.

its existence. That it "carried the pottery for many years" seems to be a widely held misconception. Actually the annual gross volume never attained that of the art pottery division. The contribution to net profit was negligible even in the best years, as a result of the much narrower profit margins on the architectural products. Compared to the vase department, where production costs were between 32 and 44 per cent of the selling price, the costs in the faience department were between 77 and 91 per cent of the sales price—leaving much too narrow a margin for safety, but one necessitated by the competition. Remember that Rookwood was a hand-tailored, art-and-design-oriented operation, not geared to mass production methods. The pot-

Garden ornaments included many statues and fountain figures.

tery could not compete with the low-cost producers of machine-made tiles fired in continuous tunnel kilns. Also, the terra-cotta tile manufacturers who had supplied the building industry long before Rookwood faience came into being had a major cost advantage—their product required only one firing, whereas Rookwood faience needed two, one for the biscuit, and a second for the glaze. In the Union Trust Company building completed in Detroit in 1929, Rookwood faience tile was used for the foyer and lower banking room, but the Pewabic Pottery Company of Detroit supplied the bulk of the glazed tile for the exterior, and the Atlantic Terra Cotta Company furnished the materials for interior decorative relief and exterior trim.

Rookwood probably enjoyed its highest level of sales in the architectural department between 1907 and 1913, after which sales gradually declined until 1920. From that year on, the decline in business was more abrupt, and such orders as were obtained were generally small in size.

It is not possible to compile a complete list of the large projects in which Rookwood architectural faience was installed. Those known ranged from New York to San Francisco, and from Minneapolis south to Dallas. Some of the larger or more prominent ones were:

Office Buildings

Metropolitan Life Insurance Company Building, San Francisco

Jackson-Brooks Building, Chicago (faience walls)

Monroe Building, Chicago (faience elevator hall and vestibule)

North American Building, Chicago (restaurant walls)

Frances Building, Sioux City, Iowa (entire interior finish; walls, floors, stairs, and ceilings)

Union Trust Building, Detroit (foyer and lower banking room)

Mayo Clinic Building, Rochester, Minnesota (grand stairway, wall, fountains, and vases)

Lord & Taylor, New York City (large fountain and several smaller drinking fountains)

West Street Building, New York City (paneling of main corridor)

Forty-first Precinct Police Station, New York City (exterior frieze and panels)

Willys-Overland Administration Building, Toledo (several wall fountains)

Baldwin Piano Company Building, Cincinnati (floors, and facing for tower clock)

Dixie Terminal Building, Cincinnati (panels at either side of entrance)

Gidding-Jenny, Inc. (formerly Gidding's), Cincinnati (exterior decorative storefront)

Cincinnati Union Terminal, Cincinnati (tearoom and bar)

Carew Tower, Cincinnati (both ends of arcade)

Western and Southern Life Insurance Company Building, Cincinnati (main lobby)

Baer-Kaufmann Department Store, Pitts-

Center façade and onion domes show exterior installation of Rookwood architectural faience.

burgh (large fountain on main floor with figures sculptured by Clement J. Barnhorn)

Schools, Libraries, and Clubs
U.S. Military Academy, West Point, New York (colored wainscot)

Emma Willard Seminary, Troy, New York (walls, floors, interior trim)

Miami University, Oxford, Ohio (model of university seal)

Madisonville School, Madisonville, Ohio (kindergarten room)

Avondale School, Cincinnati (corridors)

Hughes High School, Cincinnati (drinking fountains and plaques[1])

Holy Family School, Price Hill, Cincinnati (cafeteria)

Connecticut State Library, Hartford

Illinois Athletic Club, Chicago (swimming pool)

Women's Club, Cincinnati (several fireplace mantels)

Shrine Temple, Milwaukee

Churches
Christian Science Church, Stamford, Connecticut (trim and exterior decoration)

St. Paul's Church, Rochester, New York (reredos)

Christian Science Church, Buffalo, New York

St. Francis de Sales Church, Cincinnati (floors)

[1] One of the best examples of Rookwood installations in Cincinnati schools.

First Church of Christ Scientist, Cincinnati
(floors and wall fountain)
St. James' Church, West Hartford, Connecticut (plaque commemorating death of Reverend Joseph William Hyde, Rector)
Trinity Church, Columbus, Ohio (reredos)

Banks and Savings Associations
First National Bank, Denver (vestibule)
Union Trust and National Bank of Commerce, Detroit
Lafayette South Side Bank, St. Louis, Missouri (floor, wainscot, screens, counter facing, etc. "Even portraits of former presidents of the bank were executed in Rookwood faience.")

Toledo Savings Association, Toledo
Washington Bank, Cincinnati

Hotels and Restaurants
Hotel LaSalle, Chicago (Palm Room and German Room)
Claypool Hotel, Indianapolis (faience wainscot, fountain, and billiard room)
Seelbach Hotel, Louisville, Kentucky (now Sheraton Hotel) (Rathskeller)
Sorrento Hotel, Seattle, Washington (mantel facing)
Phoenix Hotel, Lexington, Kentucky (walls, floors, lighting fixtures in grillroom)
Oregon Hotel, Portland, Oregon (special mantel, two mottoes and crest incorporated

The Norse Room in Pittsburgh's Fort Pitt Hotel was probably Rookwood's most elaborate installation. Wall panels, floor, arched ceilings, and trim were all faience designed by John D. Wareham.

in landscape)
Radisson Hotel, Minneapolis (billiard room)
Vanderbilt Hotel, New York City (Della Robbia Room)
Hotel Devon, New York City (wainscot in dining room)
Prince George Hotel, New York City (original of wall fountain of "Boy and Dolphin" sculptured by Clement Barnhorn)

Washington Hotel, Seattle, Washington (elaborate faience mantel 14½' by 12½', of special design framed in Rookwood totem poles. Sold for $1250.)
Southland Hotel, Dallas, Texas (main lobby)
Fort Pitt Hotel, Pittsburgh (Norse Room, one of the most elaborate of Rookwood installations)
Hotel Sinton, Cincinnati (main dining room)

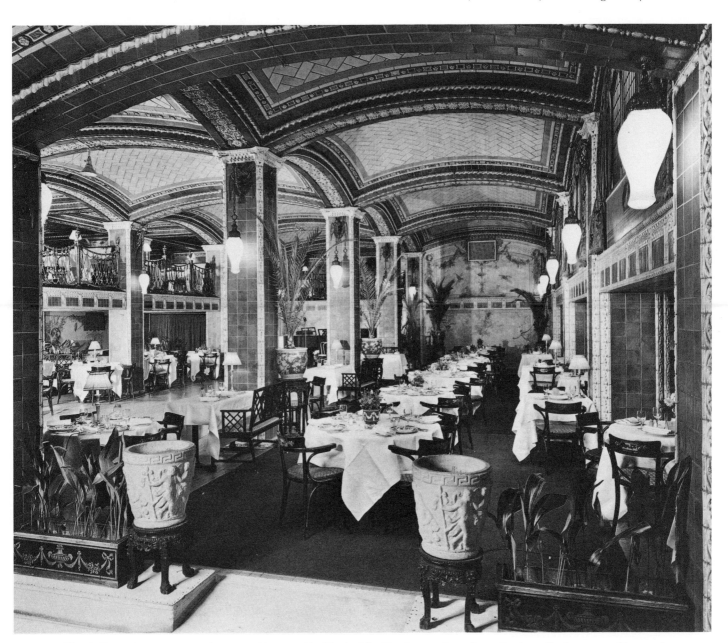

The Della Robbia Room and Bar at New York's Vanderbilt Hotel may have been Rookwood's largest architectural installation.

Mills Restaurant, Cincinnati (decorative wall paneling)
Mills Restaurant, Cleveland
Cafe Savarin, Equitable Building, New York City (mural panels, walls, and floors)
Baltimore Lunch, Detroit

Theatres
Alhambra Theatre, Indianapolis
Majestic Theatre, Columbus, Ohio.
Seattle Theatre, Seattle, Washington
Chase Theatre, Washington, D.C.
Poli's Theatre, Washington, D.C.

Railroad Installations
Grand Central Terminal Building, New York City (pierced tile grills over doorways)
New York City Subway: Wall Street, Fulton Street, 23rd Street, and 86th Street Stations. Probably the stations at 77th Street and at 96th Street, and perhaps others, also have Rookwood faience.
Hudson & Manhattan Railroad, New York City (tunnel stations on Manhattan uptown branch and Hoboken, New Jersey)
Delaware, Lackawanna & Western Railroad (location not known) stations
Long Island Railroad, Flatbush Avenue Terminal, Brooklyn (main concourse and waiting room)
Baltimore Union Station, Baltimore (walls, doorways, cornice, tile behind lamps, and wall fountains)
Memphis Union Station, Memphis, Tennessee (main waiting room and dining rooms)

Afterchapter VI

ROOKWOOD'S COMPETITION

In view of the widespread interest in pottery decoration in the decade following the Philadelphia Centennial, it is not surprising that a number of attempts were made to establish art potteries. In Cincinnati, in addition to Rookwood, there were the efforts of T. J. Wheatley, already mentioned; the Cincinnati Art Pottery, with which Wheatley was also identified; the Matt Morgan Art Pottery; and the Avon Pottery. Most of these were short-lived, and are of little interest today except that they served as training ground for Rookwood decorators Valentien, Hirschfeld, Daly, and Artus Van Briggle. Even Miss McLaughlin may be said to have started a pottery, for she had a kiln built in the yard adjoining her home where she made art pottery under the name of "Losanti" ware, from Losantiville, an early name for the city of Cincinnati.

However, it was not long before "the success of Rookwood naturally evoked a number of imitators, W. A. Long, of Steubenville, being the first in the field with what was called Lonhuda ware."[1] Long, a pharmacist familiarly called "Doc" by his friends, had been experimenting with glaze formulas for a dozen years. In 1892, he and two associates, W. H. Hunter and Alfred Day, formed the Lonhuda Pottery, taking the name from the first letters of the names of the founders.

Laura A. Fry, who had developed the airbrush method of spraying backgrounds during her years at Rookwood, joined the Lonhuda organization,

much to the consternation of Rookwood's management; they knew she could reveal many of their hard-earned secrets. How much Miss Fry taught the workers at Lonhuda in addition to the atomizer technique is not known, but the ware closely resembled Rookwood's underglaze slip decoration.

Long turned out to be a somewhat peripatetic potter; he introduced Lonhuda methods to a number of other potteries. His first move was to the pottery of S. A. Weller in Zanesville.

The S. A. Weller Company

Samuel A. Weller had operated a pottery in Zanesville since 1882, making "flower pots decorated with ordinary house paint." In 1890, he expanded this operation to include jardinieres, umbrella stands ,and cuspidors, which were distributed and sold nationally.

At the World's Columbian Exposition in 1893, Weller was so favorably impressed with the Rookwood and other exhibits of art pottery that he decided the field would support another manufacturer. Accordingly, he entered into negotiations with W. A. Long to acquire the Lonhuda Pottery in Steubenville, and with it the necessary know-how of the methods and glazes involved. Norris F. Schneider, in his booklet *Zanesville Art Pottery*,[2] cites the following item from the *Zanesville Signal* for January 31, 1895:

The Lonhuda Company of Steubenville, manufacturers of fire under-the-glaze pottery, will

[1] Jervis, W. P., *A Pottery Primer*. New York: O'Gorman Pub. Co., 1911.

[2] Schneider, Norris F., *Zanesville Art Pottery*. Published by the author. 1963.

remove here and the business will be conducted under the control of S. A. Weller in part of the mammoth new addition to his pottery in the Ninth Ward. . . .

The ware is similar to that of the famous Rookwood Pottery of Cincinnati, and the fact that it can be made of Zanesville clays marks an important epoch in the history of Zanesville industries.[3]

Weller entered the art pottery field by continuing Lonhuda production under the new name of Louwelsa, coine dfrom the name of his daughter Louise, the first three letters of Weller, and his own initials. Like Lonhuda, Louwelsa closely resembled Rookwood Standard wares, with underglaze decorations of flowers, fruits, portraits of American Indians, and animals done on spray-blended grounds of darker colors. Weller assembled a staff of artists to execute the decoration.

The name Louwelsa was usually impressed on the bottom of the ware, and the mark or monogram of the artist was sometimes added. Dr. Barber, in his *Marks of American Potters*, listed the names and marks of twenty-three decorators who were at Weller before 1903, when he gathered the material for his book. The decorating department continued to expand until as many as fifty decorators may have been employed at one time during the peak of production in the 1920's. The Louwelsa line proved popular and was continued for eighteen or twenty years, but as this pottery was not dated, it is impossible to determine when a particular piece was made.

Weller also expanded art pottery production by the addition of new styles of ware. By 1904, the list included:

Aurelian—similar to Louwelsa but with backgrounds applied with a brush, rather than spray-painted.

Eocean—similar to Louwelsa but with a lighter body color and lighter and more delicate backgrounds shaded with the atomizer.

Dickensware—usually incised designs filled in with

color, or scenes from the work of Charles Dickens done in this technique.[4]

Sicardo—characterized by metallic luster designs on irridescent dark green, brown, and purple backgrounds applied to many art forms. A distinctly different and original technique.

Turada—a white lacelike decoration on a very dark or black ground.

L'Art Nouveau—a semi-mat finish, usually decorated in relief design.

Although the name Weller was impressed on the bottom of these lines of pottery in block capital letters, the name of the style was also added in various forms. A die is believed to have been used for Dickensware and Turada. Sicardo is usually found marked by hand on the surface of the design. The names Eocean and Aurelian are marked in an incised script on the bottom, probably placed there by the decorator. The variations in the method of marking the ware may have contributed to errors in identification, as incorrectly marked styles occurred with some frequency.

As time went on, numerous other lines were introduced, but the names of these later ones did not appear on the ware; only the word Weller was used.

By 1910, Weller claimed to be "the largest pottery in the world, covering 300,000 feet of floor space." It is quite probable that the total production, both in number of pieces and in dollar volume, exceeded Rookwood's annual output at that time. So far as is known, no effort was made to restrict or limit the sales to one outlet per city, as Rookwood did; Weller pottery was distributed through any logical outlet that would handle the ware.

By 1918, Weller was bringing out two new lines each year, continually offering something new to the trade. As these lines were listed only in the sales literature of the period and not identified on the ware itself, the names today have small interest. Typical were Roma, Zona, Blue Ware, Blue Drapery, Fairfield, Floral, and Forest. Sometimes the names were descriptive of the motif or design theme of the particular ware; at other times apparently they were unrelated to the design. Any

[3] Weller did use a clay found in the immediate vicinity of Zanesville, but also "imported" clays from Georgia, Tennessee, West Virginia, and Pennsylvania.

[4] Reportedly named in honor of the English novelist because of Dickens' character, Sam Weller.

employee might suggest names, and Weller would select one he liked. In all, more than 125 different styles or lines are reported to have been made between 1895 and 1945.

S. A. Weller operated as an individual proprietorship until June 16, 1922, when the business was incorporated as a stock company so that the ownership might more easily be distributed to members of the family. On his death in 1925, at the age of seventy-four, Samuel Weller was succeeded as president by his nephew, Henry Weller.

At that time, three plants were in operation. Plant No. 1 produced art pottery and garden ware; Plant No. 2 made only utility wares, brown and white mixing bowls, and kitchen equipment; Plant No. 3 made some of both types of ware. When fire destroyed Plant No. 3 in 1926, a much larger modern plant was built on the same site. The offices were moved to the new plant, which had sufficient capacity to enable management to close Plant No. 2 and, later, Plant No. 1 as well. Volume in the late 1920's is reputed to have reached $850,000 to $900,000, considerably greater than Rookwood's.

The business depression of the 1930's, and the untimely death of Henry Weller in an automobile accident in 1932, contributed to a slowing down of the company's sales. Operations were cut back and production was concentrated on utilitarian items such as kitchenware and beer mugs, for which the repeal of Prohibition created a new demand. Hand decoration was virtually discontinued, and the decorating department as such was closed. Those art pottery lines still made were limited to designs that could be economically produced and sold at low prices. It was during this period that a script style of lettering was introduced for the Weller imprint on the bottom of the ware. The new imprint was used on most of the production thereafter, but the name in block letters was continued on some of the cast pieces and on jiggered ware until the pottery ceased operation.

Although the firm kept introducing new lines each year following the Depression, it never regained its former volume or sales success. World War II saw some revival in demand, but the company never fully recovered. The controlling interest was finally sold to the Essex Wire Corporation of Detroit, which discontinued pottery production in 1948. The S. A. Weller Company was officially dissolved on August, 18, 1949.

The J. B. Owens Company

W. A. Long, who was instrumental in getting Weller into the art pottery field in 1895, stayed only a short time with the Weller firm. Before a year had passed, he transferred his interests to another organization in Zanesville, the J. B. Owens Pottery Company.

J. B. Owens started making flowerpots "in a modest way" in 1885, in Roseville, Ohio. By 1891, he was successful enough to build a new factory in Zanesville, and he moved his operation to that city. Owens made majolica flowerpots, jardinieres, fern dishes, umbrella stands, and "fancy novelties." When Long took his knowledge of underglaze decoration to Owens, the firm started making art pottery and employed a staff of artists to decorate the wares.

The earliest line, called Utopian, closely resembled Rookwood Standard ware and Weller's Louwelsa. It too was decorated with portrait heads of American Indians, horses, dogs, cats, as well as floral designs in underglaze slip-painting on both light and dark grounds. Other lines added during the next several years included:

Henri Deux—described as incised designs filled with colored clay after the manner of the famous Faience d'Orion ware of France.

Alpine—a freehand overglaze decoration in a mat finish, the ware having "soft mellow tints in blue, green, and brown colors."

Corona—said to resemble varieties of bronzeware in form and decoration and produced with mineral colors.

Corona Animals—an unglazed earthenware body "in which the forms and decorations simulate various animals in their natural colors."

Venetian—a ware of irregular surface that yields a highly irridescent effect to the metallic glaze employed.

Gun Metal—an unglazed, metallic-coated ware resembling a dull gun metal in appearance.

Mission—decorated with scenes depicting old Spanish missions of the American Southwest and

finished in a mat glaze. Each piece is said to have been accompanied by a stand or receptacle of "weathered oak" in keeping with the then-popular "Mission" style of decoration.

Rustic—made in rustic shapes to simulate tree stumps, sawbucks, and the like, for use primarily as planters.

Opalesce—a wavy line background of light colors with an overglaze design in gold, silver, or copper. Said to resemble the famous "Italian Vermicel ware of the sixteenth century."

Utopian Opalesce—a similar background to Opalesce but with decorations underglaze and characteristics of the Utopian line, i.e., flowers and portraits of animal heads.

Aborigine—designs taken from early Indian pottery at the Smithsonian Institution.

Art Vellum—underglaze decor in warm tints of autumnal foliage under a "soft vellum finish of great delicacy."

The name Owens *and* the name of the line were usually marked on the bottom of the ware. In 1904, Owens issued a forty-page catalog in which some 800 items were illustrated. It may have been intended to compete with "The Rookwood Book," which the Cincinnati pottery published that year to develop mail-order sales.

At its height, the Owens firm employed a decorating staff rivaling that of Rookwood in size. Barber, in his *Marks of American Potters*, lists the names and initials or monograms of thirty-two on the staff before 1904.

Owens art pottery was of a high grade. It is believed that for a year or two volume of production may have approached or even exceeded that of Rookwood, but apparently the company lacked the distribution and sales to support it. Possibly the firm was overextended, for it ran into financial difficulties and did not survive the panic of 1907.

Owens remained in the ceramic field, however, engaging in the manufacture of architectural tile until his plant was destroyed by fire in 1928. By then, the architectural tile business had grown more competitive. Although he rebuilt, the new plant was completed just at the start of the Depression and he lost control of the business. He retired to Florida, where he died in 1934.

W. A. Long stayed at Owens only a short time after 1896. He then moved to Denver, Colorado, where he organized the Denver China and Pottery Co., continuing to make goods under the name of Lonhuda ware. In 1905 he moved again, this time to organize the Clifton Art Pottery in Newark, New Jersey.

The Roseville Pottery Company

The Roseville Pottery Company started in business in 1892 by acquiring the original J. B. Owens plant in Roseville, Ohio. Six years later, Roseville Pottery bought the Zanesville plant of the Clark Stoneware Company. In 1900, George F. Young, secretary and general manager of Roseville, attracted by the success of Weller and Owens, decided to enter the art pottery field. He did so by introducing a line named Rozane, a combination of the names Roseville and Zanesville. The pottery was hand decorated by underglaze slip-painting, and closely resembled Rookwood's Standard ware, Lonhuda, Weller's Louwelsa, and Owen's Utopia.

To match the Zanesville competition, Roseville introduced new lines with increasing frequency, and within five years had placed the following on the market:

Rozane Royal—a new name given the original Rozane line to distinguish it from other new lines, which were:

Rozane Fugi—having incised decorations and believed designed to compete with Weller's "Dickensware."

Rozane Woodland—said to be inspired by the Celadon of the Chinese. The designs were frequently incised and colored in the foliage hues of autumn leaves.

Rozane Mongol—a rich red color glaze resembling the Chinese *Sang de boeuf* in color; a major contribution to the art pottery of this country.

Rozane Egypto—produced in varying shades of green that simulated the colors found in the ware of early Egyptian potteries; frequently decorated with modeling in low relief.

Rozane Mara—a variety of ware made in prevailing tones of red, from light pink to deep magenta, and having an opalescent quality intended to compete with Weller's "Sicardo" line.

The names of the individual lines were not

marked on the ware, but were used primarily for descriptive and promotional purposes. In his *Marks of American Potters*, Dr. Barber shows the Roseville mark as a circle enclosing the name ROZANE WARE and a rose. But the incised name ROZANE and the letters *R P CO* (for Roseville Pottery Company)[5] were used more often. The incised ROZANE mark is believed to have been in use until as late as 1905 or 1906. The *R P CO*, sometimes used earlier in conjunction with the ROZANE mark, was used alone until about 1910 or 1912.

During this period Roseville operated four plants. Commercial and household utility wares were produced in two plants in Roseville and one in Zanesville; art pottery lines were made in the fourth plant, in Zanesville. By 1905, Roseville sales are reported to have reached $500,000 and its work force 350, but most of the volume was in commercial wares rather than art pottery. Under the aggressive leadership of George Young, however, Roseville continued to match its competition from Weller by introducing new styles.

The two plants in Roseville producing utilitarian wares were closed about 1910, and Young pushed the development of art pottery. About this time the mark was changed from the *R P CO* to an *R* with a small *v*, in this fashion: ...

Among the lines introduced in this period were Donatello, Carnelian, Mostique, and Rosecraft. Again, the names were used for promotion only and not marked on the ware.

[5] No confusion need exist between the R P CO of Roseville and the early R.P.C.O. mark Rookwood used in 1881. The Roseville ware so marked was twenty years later and clearly reflected the improvements in technique and the wider range of colors available.

In 1917, when a fire destroyed the plant making cooking wares, the manufacture of these products was moved to the art pottery plant, where a tunnel kiln was installed to handle the work. The following year, Russell T. Young succeeded his father as general manager. About this time, the trademark "Roseville U.S.A." was adopted and was marked on the ware in raised letters.

New lines were introduced with increasing frequency—after 1918, two new ones were brought out each year. Among those introduced in the 1920's were Dogwood, Florentine, Cremona, and Tuscany. A decorating staff was always employed; at its peak, it is reported to have numbered about forty artists. Total sales, including the commercial lines, are said to have reached a million dollars a year.

Although sales dropped off during the Depression, Roseville still continued to bring out new lines. During the 1930's Pinecone, Ferrella, Blackberry, Laurel, Morning Glory, and Sunflower were popular and continued to sell. All together, approximately ninety lines of art pottery were made by Roseville between 1900 and 1950.

Sales revived during World War II, and in 1945 are reported to have reached $1,250,000; after the war, they declined again. Although new lines—Apple Blossom, Gardenia, Zephyr, Lily, and others—were brought out in the 1940's, the market had changed and the general public was no longer interested in art pottery.

Roseville had continued some commercial production, but this was probably less than 10 per cent of its volume. About 1952 the company began the manufacture of oven-to-table dinnerware, but it did not prove successful. Finally, on November 1, 1954, the Roseville Pottery closed its doors and the plant was sold to the Mosaic Tile Company.

With the death of Roseville, the last of the Zanesville potteries that Mr. Taylor had characterized as "those counterfeiters and imitators" came to an end.

Afterchapter VII

Collecting Rookwood

Rookwood has been collected ever since the first kiln was drawn in 1880. Employees of the pottery and their friends at once began gathering examples of the little company's work, and the Women's Art Museum Association started acquiring pieces that are today preserved in the extensive collection of the Cincinnati Art Museum.

Since that time, considerably more than a million pieces of Rookwood art pottery have been produced. Nobody knows the precise number, and the figure excludes the thousands of pieces of Rookwood garden pottery and garden ornaments, and the hundreds of thousands of architectural tiles, many of which were attractively decorated in colorful patterns or molded in relief designs.

Today, Rookwood is one of America's most collectible items. The enormous number and variety of pieces produced by the pottery afford an opportunity for selectivity sufficient to satisfy the tastes of the most discriminating collector.

To a collector of Rookwood, one of its most important assets is the excellent system of marks. Each piece of art pottery is marked, numbered, and dated, and many are signed by the artist as well. Thus, a collector is assured of the authenticity of any specimen he buys. He can also learn something of the background of each, and in the case of an artist-signed piece, he can be certain that it is unique. Fine decorated pieces of Rookwood are a good investment, just as any well-selected piece of art is. And the thrill of acquiring a work of art comparable to examples purchased by leading museums of Europe or found in a number of American museums today is, of course, an added measure of satisfaction.

Another pleasing aspect of collecting Rookwood is the wide choice of categories. A collection can include all types of ware, but the opportunities to specialize are numerous. For example, Rookwood can be collected by date—a piece to represent each year; or by decorators—an example of the work of every artist; or by specializing in the work of a single artist. Some collectors seek only one type of ware, such as metal overlay pieces, plaques, portrait pieces, or landscapes.

Still another opportunity to specialize is afforded by the many categories of wares available—indeed, it can be said that if an article could be produced in clay, Rookwood made it. In addition to vases, the line included candlesticks, mugs, ashtrays, book ends, paperweights, chocolate pots and teapots, cigarette and candy boxes, pitchers, compotes, cups and saucers, clocks, lamps, dinnerware, statuettes, and religious figures. In fact, the opportunities for selection of a specialty are so numerous and varied that one can be found to fit virtually any taste, interest, or pocketbook.

In today's market, prices for Rookwood extend over a wide range—from $2.00 to $600. Artist-signed pieces in general command higher prices than those not signed, exceptions being the Tiger Eye and Goldstone pieces that were often undecorated and unsigned. Wares produced in more limited quantities, such as the metal overlay pieces, also bring higher prices. Inexpensive items, those that originally sold for less than $10.00, have increased relatively more than higher-priced pieces. Simple

cast pieces originally sold at $1.50 to $5.00 are rarely found for that today. It is interesting to note that signed pieces originally made to sell from $8.00 to $15.00 have more than doubled in price, but those that sold from $80.00 to $150.00 are often found in the same range today.

The three factors that should have the most influence on prices today are date, quantity produced, and quality.

Date is an indication, but only an indication, of comparative scarcity. Generally speaking, the earlier the date the more desirable the piece to a collector because it is assumed fewer were made. That is not always true, however. In the case of the little jugs (Nos. 60 and 61), several thousand were produced for packaging toilet water or cologne. Any pieces with the early factory marks are comparatively rare.

The second factor, quantity, is subject to some evaluation. No artist-signed pieces were ever duplicated—even matching pairs varied slightly in execution—so each is unique. But those pieces that are plain, incised, or decorated in relief, and *cast* from the same mold, were duplicated and turned out in considerable quantity. After 1900, when mat glaze pieces were introduced in volume, this trend toward quantity production was stepped up as the demand for inexpensive pieces increased. Many of these are available today.

Comparatively few pieces of garden pottery appear to have survived the ravages of time, weather, and vandalism. Decorative tiles and other shapes made in the architectural department are also comparatively scarce. It is an extremely difficult task to salvage them without damage; they were installed for permanence, and it is practically an archeological feat to remove them intact—far too costly for the modern demolition processes that have sealed the fate of such installations as the Rookwood Room, the Norse Room, and the Della Robbia Room, for example. Although many homes throughout the country, and particularly in Cincinnati and its suburbs, boast at least one Rookwood fireplace, these would be equally difficult of removal if they became available. Most of the examples of architectural tile found on the market today are those that were in stock at the pottery in 1941, and were sold at ten cents a tile in order to liquidate the inventory.

The third factor, quality, is determined largely by the design of the shape and the skill of the decorator. Many shapes with surface decorations cast in the mold are in excellent taste; others are quite horrendous. About 1893, when Rookwood endeavored to price its wares in relation to their cost, the works of the most skillful decorators (who received higher salaries) commanded top prices. Wares decorated by Valentien, Daly, and McDonald were in this category. If examples of a decorator's work are among those pieces held in museum collections, other pieces decorated by the same artist are also likely to be high-quality work. Of course, the quality of the decoration improved as the decorators gained experience in underglaze techniques and as new colors became available. Excellent quality work was done by the decorators of the 1940's when wide latitude in selection of subject matter was permitted and modern design trends were introduced. Perhaps the most influential factor to the individual collector, however, is his own satisfaction. If, in his judgment, a piece has beauty in design and execution, that is the most important consideration.

Several factors detract from quality. Those pieces marked as "seconds" or "give-aways" have already been prejudged as inferior in quality because of some imperfection in manufacture. A missing lid from a box or jar also naturally lessens its value. And chips or cracks detract from the desirability of any piece.

Certain other factors too may well influence price. Specimens of the work of decorators who were at Rookwood for only a short period are naturally not as easy to find as pieces by those who were members of the staff for twenty, thirty, or fifty years. Shirayamadani, for example, was a Rookwood artist for over fifty years, during which time he decorated hundreds of pieces. Consequently, considerably more of his work is available than of some of the lesser-known artists. Yet because his name is better known, his work is often overpriced.

Some pieces marked with the name ROOKWOOD (1885 and earlier) were not decorated by Rookwood artists but by amateurs who bought the green or biscuit shapes for decoration. Collecting these might make an interesting specialty, but they are not true Rookwood.

Unfortunately, many antique dealers know relatively little about America's foremost art pottery. Some are not familiar with the system of marks, dating, and other identification. Others refer to those carrying only the *R-P* trademark as "signed pieces." The term "signed" should be reserved for pieces signed or initialed by the decorators. Another point not properly understood by many is the ware marked as second quality, and pieces so marked are often offered at first-quality prices.

But the informed collector, aware of the factors that determine Rookwood values, can be as discriminating as his taste and pocketbook permit, secure in the knowledge that his investment will appreciate and give increasing pleasure as the years go by.

Bibliography

BARBER, EDWIN ATLEE, *Marks of American Potters*. Philadelphia: Patterson & White, 1904.

———, *The Pottery and Porcelain of the U.S.* (Second Edition) New York: G. P. Putnam's Sons, 1901.

———, *Catalog of American Potteries and Porcelains*. Philadelphia: Pennsylvania Museum and School of Industrial Art, 1893.

BENJAMIN, MARCUS, "American Art Pottery." *Glass and Pottery World*, Chicago. Articles in February, March, April, and May 1907.

CLARK, EDNA MARIA, *Ohio Art and Artists* Richmond: Garrett & Massie, 1932.

COX, WARREN E., *The Book of Pottery and Porcelain*. New York: Crown Publishers, Inc., 1944.

CRUTCHER, JEAN, "The Art Pottery of America." *Antique News*, March 1965.

HARLOW, ALVIN F., *Serene Cincinnatians*. New York: E. P. Dutton & Co, 1950.

HASWELL, ERNEST BRUCE, "American Pottery." *The Art World*, October 1917.

HAYWOOD, MAUDE, "A View of the Rookwood Pottery." *Ladies' Home Journal*, October 1892.

HITCHCOCK, RIPLEY, "The Western Art Movement." *Century Illustrated Monthly Magazine*, August 1886.

HUNGERFORD, NICHOLAS, "The Story of Rookwood." *Arts and Decorations*, February 1911.

JERVIS, W. P., *A Pottery Primer*. New York: O'Gorman Publishing Co. 1911.

KINGSLEY, ROSE G., "Rookwood Pottery." *The London Art Journal*. December 1897.

KIRCHER, EDWIN J., *Rookwood Pottery—An Explanation of Its Marks and Symbols*. (No publisher given) 1962.

LANGENBECK, KARL, *The Chemistry of Pottery*. Easton, Pa.: The Chemical Publishing Co., 1895.

LAURENCE, STURGIS, "Architectural Faience." *The Architectural Record*, January 1907.

MENDENHALL, LAWRENCE, "Mud, Mind and Modelers." *Frank Leslie's Popular Monthly*, December 1896.

NEWTON, CLARA CHIPMAN, "Early Days at Rookwood Pottery." Handwritten papers in Cincinnati Historical Society archives. Circa 1901.

NICHOLS, GEORGE WARD, *Art Education Applied to Industry*. New York: Harper & Bros., 1877.

———, *Pottery*. New York: G. P. Putnam's Sons, 1878.

PERRY, MRS. AARON F., "Decorative Pottery of Cincinnati." *Harper's New Monthly Magazine*, May 1881.

ROOKWOOD POTTERY, *The Rookwood Book*.

———, *Architectural Faience Catalogs*, 1907, 1909, 1912.

———, *Rookwood Garden Pottery and Ornaments*. Undated catalogs.

———, *Rookwood Pottery*. Promotion pamphlets. Undated.

STILES, HELEN E., *Pottery in the United States*. New York: E. P. Dutton & Co., 1941.

STORER, MARIA LONGWORTH, *History of the Cincinnati Musical Festivals and of the Rookwood Pottery*. Paris: Herbert Clarke.

TAYLOR, WILLIAM WATTS, "The Rookwood Pottery." *The Forensic Quarterly*, September 1910.

TRIPPS, OSCAR LOVELL, *Chapters in the History of the Arts and Crafts Movement*. Chicago: Bohemia Guild of the Industrial Art League, 1902.

VALENTIEN, ALBERT R., "Rookwood." Unpublished manuscript.

Index